MAY WE ALL LIVE
TO BE A HUNDRED,
AND THE LAST
VOICE YOU HEAR
BE MINE.

FRANK SINATRA

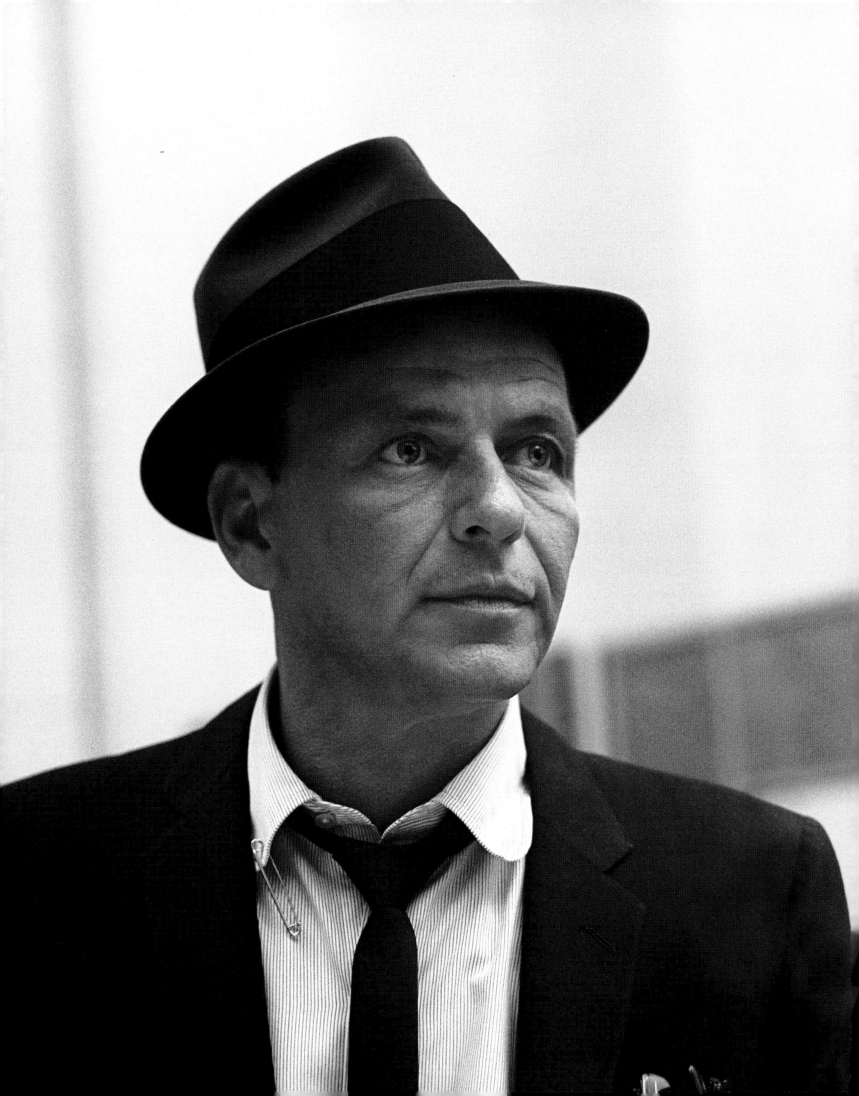

sinatra

By Andrew Howick
Foreword by Barbara Sinatra

Abrams, New York

Contents

007

011

014

096

184

220

222

Happy Birthday, Frank BARBARA SINATRA

Sinatra's Photographers ANDREW HOWICK

Fly Me to the Moon

Ring-a-Ding Ding!

A Man and His Music

Sources + Credits

Index

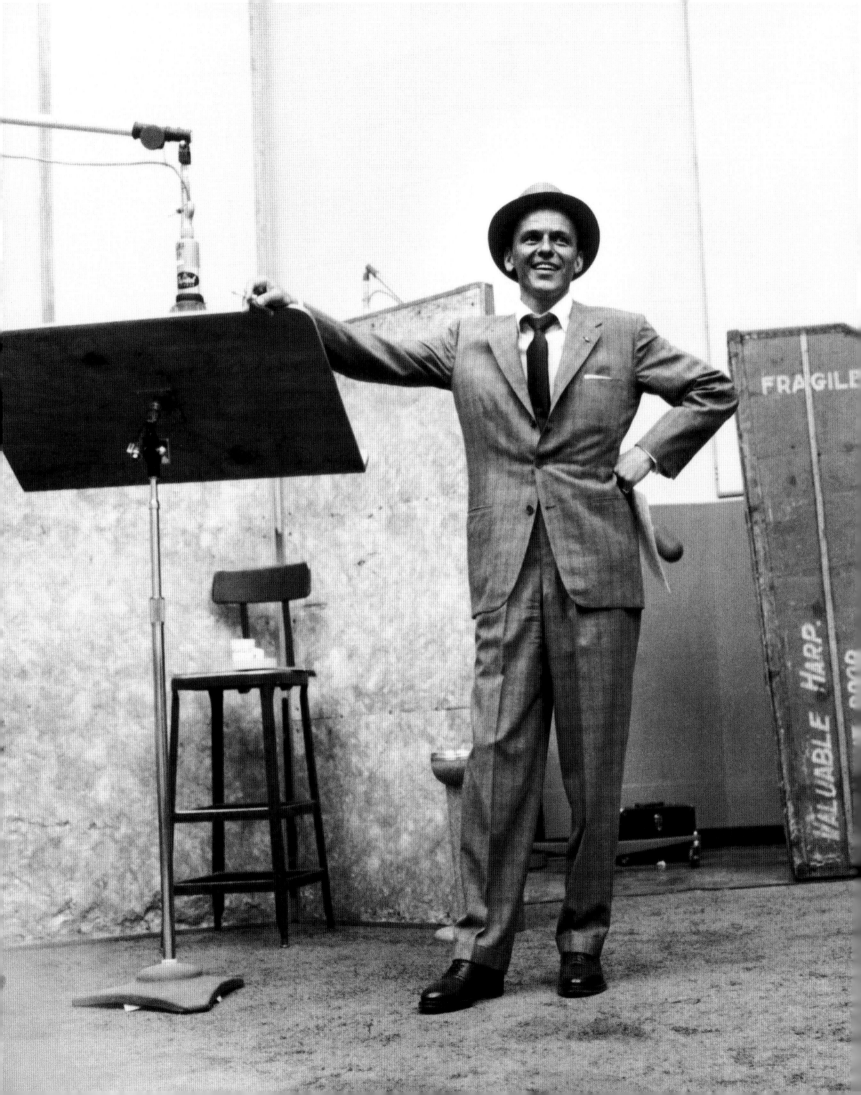

HAPPY BIRTHDAY, FRANK

BARBARA SINATRA

Foreword

Capitol Records
recording session, 1958.
PHOTO BY SID AVERY

Frank Sinatra would have so enjoyed reaching one hundred years of age. He'd have found it highly amusing to have defied the odds and lived so long.

The man rightly dubbed "the Entertainer of the Century" touched the lives of so many people over the years, and the music he made has become the soundtrack to the lives of generation after generation.

An actor, director, conductor, producer, songwriter, and, as he liked to say, saloon singer, Frank was one of the bestselling artists of all time, with more than 150 million records sold worldwide. He broke box office and *Billboard* records well into old age, as the hunger for the special brand of magic he possessed never diminished.

Hundreds of thousands of fans from around the world first learned to speak English listening to Frank Sinatra tunes. Whenever he visited those far-flung countries and took to the stage, he was always moved to tears by the throng of voices that rose as one to join him in a song.

Amazingly, Frank continues to reach people in this century too, and on the centenary of his birth that's something he would have been enormously humbled by. And oh, what a party he'd have thrown to mark the occasion! Nobody could throw a party quite like Frank.

There would have been Jack Daniel's whiskey, martinis, and champagne flowing, all served by white-gloved waiters, with the finest Italian food, the best pizzas and pastas, followed by cheesecake from New York.

Wearing an apron, he'd have stood at the stove and made his mother Dolly's special tomato "gravy" for the pasta (holding the garlic), and ensured that everyone's glass was permanently topped up.

He'd have made sure there was wonderful music, of course, a full orchestra rehearsed to perfection by the perfectionist, and—assuming his friends had made it that far too—there might have been Sammy Cahn or Jimmy Van Heusen on the piano while the likes of Tony Bennett, Rosemary Clooney, or Sammy Davis Jr. sang along.

Frank loved to laugh, so comedians would have been there in force—people like Pat Henry, Don Rickles, Tom Dreesen, and Dean Martin, perhaps the greatest natural comic of them all. Our dear friends such as Gregory Peck, Cary Grant, Grace Kelly, David Niven, Kirk Douglas, Henry Kissinger, and Ronald Reagan would have been guests of honor, along with family and other friends.

Frank considered presidents and statesmen his buddies, as much as his golfing partners or childhood friends were. A more disparate group of people you could never have met lounging around the pool or playing with Frank's model railway set in his cabana.

Smelling heavenly of lavender soap and always in the

Barbara and Frank Sinatra, Beverly Hills, 1990.
PHOTO BY HARRY LANGDON

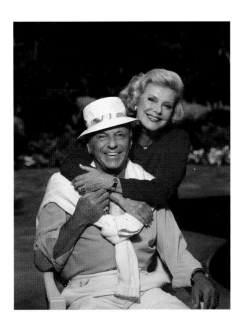

finest tailored suits and custom-made shoes, the inveterate romantic who'd married me in a mist of white orchids in 1976 would have found me some thoughtful gift—even though it was his birthday, not mine.

Generous to a fault, he loved to give and was never that comfortable receiving—unless you presented him with a dog, of course. Frank adored all animals, but especially our beloved dogs.

What else do you give the man who had everything? As Don Rickles once said, "Frank gets up in the morning and God throws money on him." I'm not sure about that, but I do know he worked tirelessly his whole life and that he spent what he earned—mostly on others. He couldn't care less about money, and I honestly think he planned on spending every dime he ever made—typically, on people who needed it more than he did. His tipping was legendary, as were his anonymous donations to charities and individuals as well as the benefit concerts that he'd throw at his own expense—for virtually any worthy cause.

Most of all he was generous with his love, and boy, did I receive that in bucket loads! It ranged from lavish gifts to the romantic little *billets-doux* he'd leave me around the house, usually signed "Your Italian Lover."

And how he loved to mark special occasions in some wonderful way—birthdays, anniversaries, Valentine's Day, and landmark dates known only to us. Mr. Romantic was quite a guy to be around. Twenty-four years after we'd first started dating, we were still together, still in love. Ours was a deep and lasting love, full of trust and loyalty.

There is no denying that Francis Albert Sinatra stole into my heart and changed my life. Over the next three decades, he flew me to the moon and back. Was he easy to live with, or to work with? Not always. Frank could be quite a handful. Was he calm? Rarely. Those of us around him never knew what drama each day might bring. But was it fun? Oh yes—a thousand times yes.

I was certainly never bored, and probably the bravest thing I ever did during my marriage was to organize a surprise sixty-fifth birthday party for Frank. The man who so enjoyed springing surprises on those he loved did not enjoy being surprised in return. In the months leading up to the big day, I asked him if he could have anything in the world, what it would be.

After much cajoling, he eventually said he'd like a fantastic jazz orchestra playing just for him. I decided to make that the finale to a party thrown in his honor, knowing there was always the risk that he'd walk out. He nearly did, but the sight of all our friends dressed up at a Western-style cookout on our ranch amused him enough to persuade him to stay. I never made that mistake again, though.

No, Frank's one hundredth birthday party would have been meticulously planned and organized by Ol' Blue Eyes himself, I'm certain. He'd have made sure that others were the center of attention. He would certainly have turned it into a charity event, which would have included the Barbara Sinatra Children's Center for Victims of Abuse, an organization for which we broke ground in Rancho Mirage, California, on his seventieth birthday.

Five years later, Frank celebrated his seventy-fifth birthday by performing at the Brendan Byrne Arena in East Rutherford, New Jersey. After the show, I threw a party for him at the Waldorf Astoria in New York City, with a hundred people attending from all over the world. It was quite the affair. Picking up my glass of champagne in a toast, I told him from the heart, "Frank, darling, to the world you've given your music, but to me you have given the world."

For Frank's eightieth birthday, the Empire State Building in New York was bathed in blue light, and he was the subject of an all-star televised tribute, *80 Years My Way*, which, of course, he insisted be in aid of charity. When he received a standing ovation on his arrival, he joked that he'd never before received a round of applause "just for being alive."

Although he died almost twenty years ago, Frank will always live on in people's hearts. Each year, I visit his desert grave site on his birthday, and I am always touched by the gifts left by his devoted following, including tiny bottles of Jack Daniel's, packs of his favorite Camel cigarettes, candies, posies of flowers, and tiny American flags next to his simple granite marker, which reads, "The Best Is Yet to Come." He'd have loved that.

The man with the electrifying personality said once that he wanted to be remembered as someone who had a wonderful time living life. Well, I am among many thousands who can vouch that he did just that.

When he first retired from performing in 1971, before his triumphant later comeback, he thought long and hard about what song he'd like to go out on. He chose "Angel Eyes."

A man who loved words, he selected it for the lyrics, which seem ever more appropriate as we mark the one hundredth anniversary of his birth. The message he so liked in this song gave him a chance to tell his fans to enjoy their lives and have fun, as the drinks and the jokes were on him.

Happy birthday, Frank.
Sleep warm.

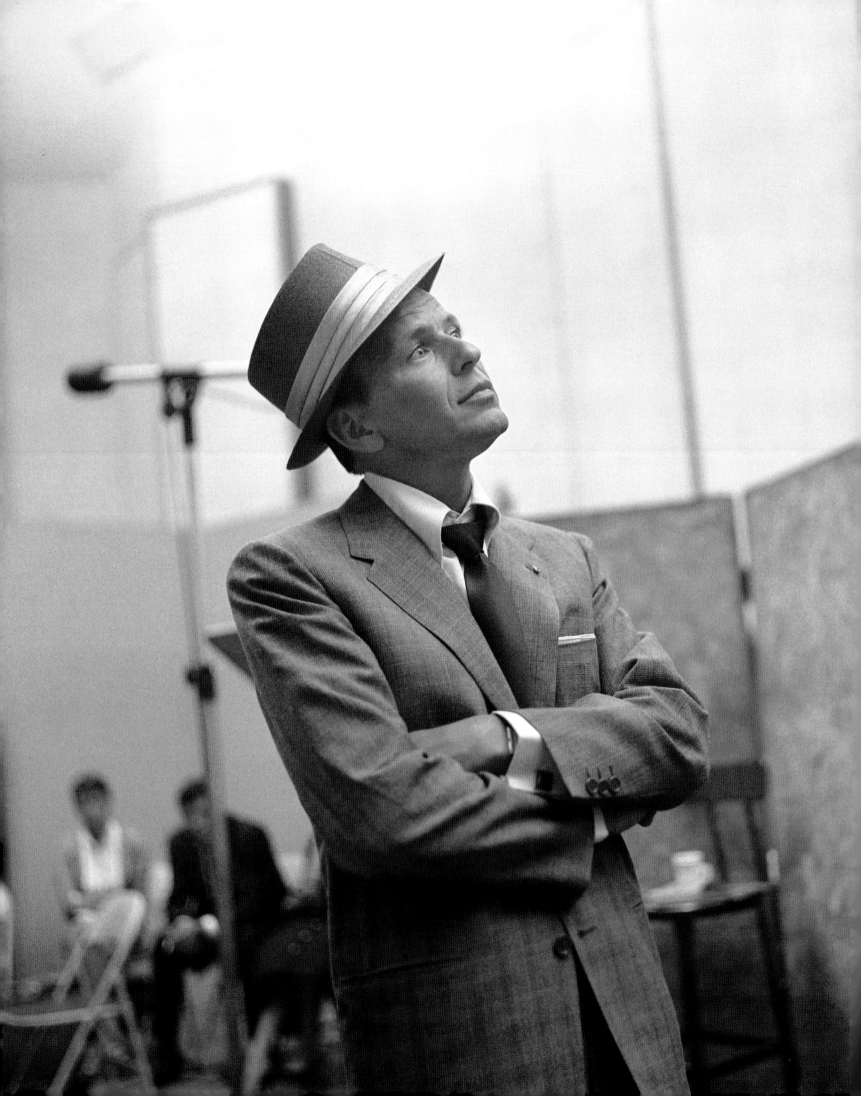

SINATRA'S PHOTOG- RAPHERS

ANDREW HOWICK

Introduction

Playback, Capitol Records
recording session, 1958.
PHOTO BY SID AVERY

In the spirit of another great, the Judeo-Christian God, Frank Sinatra sought to create through verbal utterance. And so, on the twenty-ninth evening of May in AD 1958, Francis Albert Sinatra sang "Angel Eyes" in Studio A of Capitol Records. And the man who would have been a scribe in 1958 BC was a photographer from Akron, Ohio, in AD, and the God in Genesis was a blue-eyed kid from Hoboken, New Jersey. And some will argue that the heavens and the earth and the winged creatures and the plants are more important than Frank Sinatra cutting a track at Capitol Records in Hollywood, California. And I will argue back: Have you ever heard Frank Sinatra sing? Did you watch Felix Slatkin conduct Nelson Riddle's arrangement that night or see Frank listen to the playback of take one of "Master #E-19241" with his head cocked and the arms of his impeccably tailored gray suit crossed? For if you had, you would have been converted. Your conversion experience would have been as real as the fruit of the trees that bear fruit. You would believe because you would have seen close-up the concentration on the voice's face and the sweat on the conductor's brow. Lucky for posterity, Sid Avery was there that night to capture some of the evening's light and photographically record a series of album sessions that future generations will scarce believe were only created over the course of several nights during the middle of 1958. This book is full of such bright moments.

In the album notes to *No One Cares*, columnist Ralph Gleason writes that it "remains a fact that [Frank Sinatra] can take a song which, in the hands of a lesser artist, would be banal and make it beautiful." There are few men of the twentieth century who were photographed more than Frank Sinatra, yet the men who shot the images in this book transform the practical, austere, and utilitarian work environments of a recording studio or rehearsal hall into magical spaces: cathedrals of creativity and artistry. With their individual perspectives, and like thoroughbreds with blinkers on, they focus our attention onto what's important—moments that in some way help to shed light on a certain aspect of the complex man that is Frank Sinatra and, in so doing, reveal the private world of a public figure and give us the view from within: his elation, his perfectionism, his work ethic, his love, his anger, his artistry, his humor, his cadence, his charisma, his style, his loneliness, and on and on and on...

Ted Allan was one such man. He was handpicked by Frank to capture some of his most important concerts, recording sessions, charity trips, films, and family gatherings. Dubbed "Farley Focus" by Sinatra, Allan became the official "Court Photographer" for Frank and his associates: Dean Martin, Sammy Davis

Jr., Peter Lawford, and Joey Bishop. Allan once recalled how Frank had a "good picture sense and would tip him off to an event in the offing which could provide interesting photos." Well, those good tips paid off in spades, allowing Allan to photograph performances at the Sands Hotel in Las Vegas; recording sessions with Count Basie and Quincy Jones; and benefit shows in Mexico, Japan, Hong Kong, Israel, Greece, Italy, Great Britain, France, and Monaco.

Photographer Bob Willoughby, "the Hollywood Special," ten years to the day after Frank passed away and fifty-five years after first photographing him, would recall, "There was only one Sinatra . . . no one close." The same, however, can be said of Willoughby, Hollywood born and raised. His revealing images of Sinatra were perfectly described in Ilford's International Calendar in 1986: Bob "show[ed] the stars behind the mirror, beyond the spectacle or any theatrical glitter. Close to their own truth . . . quiet and honest reflections of the real person." Lucky for us, Bob's career as a "special" photographer brought him in contact with Frank on several important occasions, including during the making of *From Here to Eternity*, *Ocean's Eleven*, and *The Man with the Golden Arm*, to name just a few of those encounters. His perceptive eye would give us an intimate glimpse of Frank at work, at play, and all alone. Not an easy task, but with Willoughby, just another day on the job.

Ed Thrasher, who moved with Sinatra from Capitol Records to his Reprise label at Frank's request, went on to become the art director and photographer for some of Sinatra's most memorable albums and recording sessions over nearly three decades. While Sinatra had many nicknames and phrases attached to him over his storied career, Ed came up with one of the most memorable, "Ol' Blue Eyes Is Back." The phrase became the title and ad hook to Frank's 1973 comeback album, the first he recorded after coming out of retirement. Former Warner Brothers Records president Joe Smith later recalled, "Ed showed the artwork to Frank, and he just flipped." Smith added, "Ed had the talent with getting along with the talent, especially with a Frank Sinatra, who could get very cranky. With Ed, Frank was a pussycat. He never gave Ed any trouble."

Akron's own, Sid Avery, photographed Sinatra during what many consider his creative peak, his Capitol Records days. When it came to subjects with a reputation for being difficult, Sid was the go-to photographer, making potentially volatile subjects comfortable in front of the camera, by understanding when to approach, when to back off, and, most importantly, when to expose the film at just the right moment. Although Sid's first book, *Hollywood at Home*, showcases stars like Humphrey Bogart and Steve McQueen relaxing in their Hollywood estates, Sid captured Sinatra where perhaps he was most comfortable of all, in the recording studio. The photos he created during this period would end up in millions of households worldwide, from his album cover for *Nice 'n' Easy* to the one for *Come Swing with Me!*, and many more. It is these photos that defined what many would come to associate with the classic swingin' Sinatra image of the 1950s and 1960s.

Los Angeles native Bernie Abramson's career, fortuitously, began as an aerial cameraman in the United States Navy. This high-altitude training would serve him well as he became a favorite of the jet-setting "Rat Pack," always welcome, camera in tow, to private functions that involved deep imbibing. No doubt, his ability to share in the fun helped to build the wonderful rapport Bernie had with Frank over the years, disarming the man so he could let his guard down and do what he did best, enjoy life. Bernie's pictures are a testament to that, whether shot on the sets of *Ocean's Eleven* or *Sergeants 3*, or on the floor of the Democratic National Convention in 1960. Years later, when Bernie would sign fine-art prints of one of his most iconic shots, a photo of Frank and Nat King Cole giving an impromptu performance at the Villa Capri, he would marvel at how sharp the focus was, implying he may have had one too many when he clicked the shutter that night. Then, with a wink and a smile, you knew that Bernie was all too well aware of his photographic technique and the magic he was recording that evening.

Were you there? Well, if you weren't, don't give it a second thought; the pictures that follow will convince you that you were, as these men take you on a trip through the life of a singular man, via the medium of photography.

"Ladies and gentlemen, it is post time."

Fly Me to the Moon

An Academy Award in 1954; an introduction to a former Tommy Dorsey trombonist and arranger named Nelson Riddle; a contract with Capitol Records. All are cited as the major contributing factors to Sinatra's comeback after a devastating divorce and a big dip in popularity since his meteoric rise less than a decade earlier. Luck. Magic. Call it what you will. Destiny may be your best bet.

1.

The Voice gets momentarily
silenced as kissing fans
swarm the singer for autographs,
June 27, 1943.

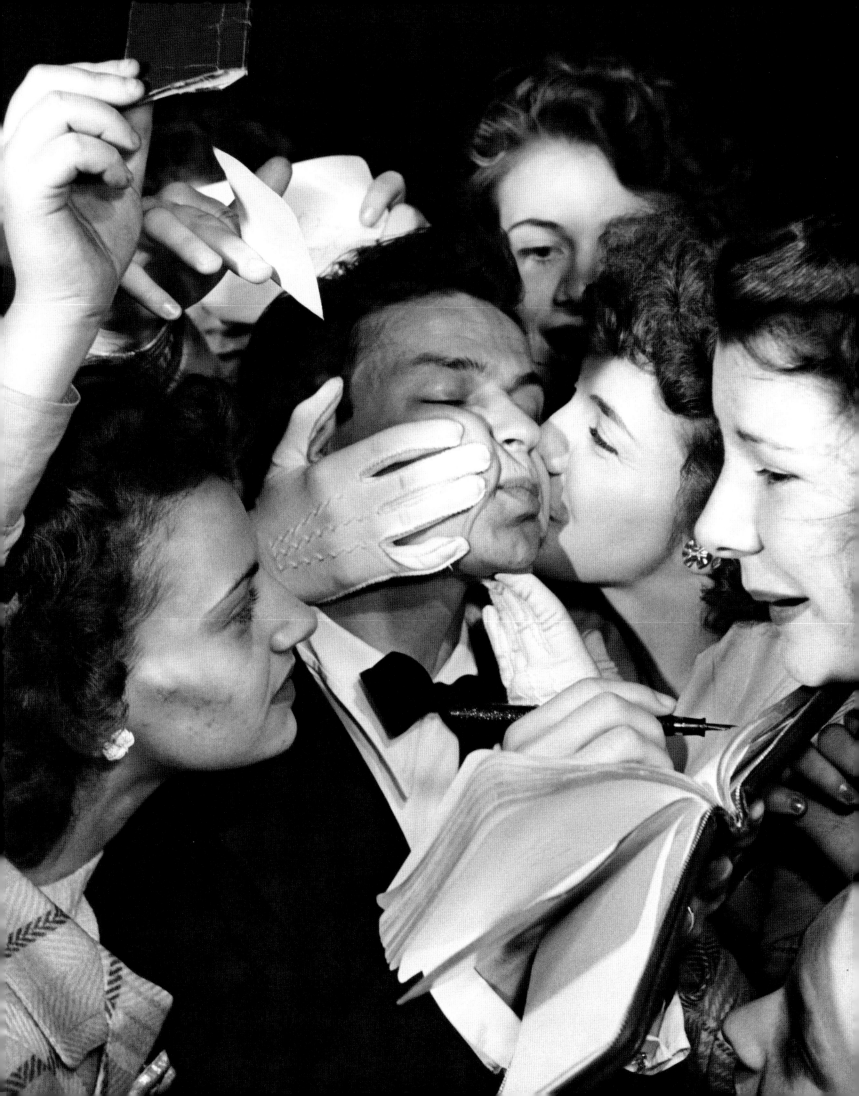

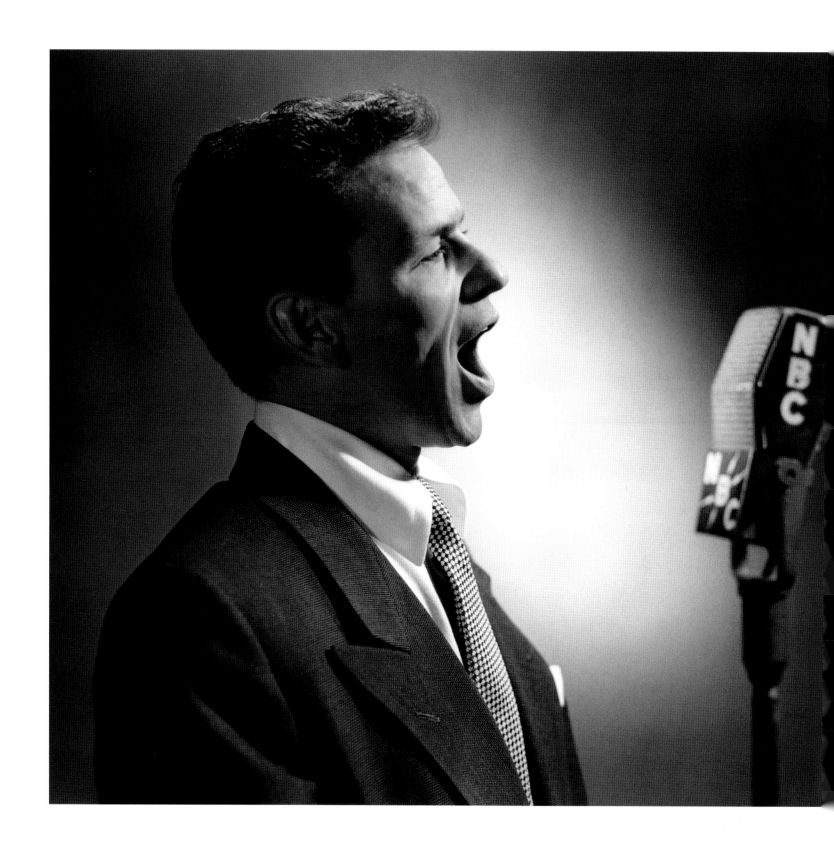

Sinatra, c. 1945.
PHOTO BY PAUL HESSE

Photographer Bill Dudas gets Frank to pose
sitting in a chair that bears one of his first
nicknames to catch on, The Voice, c. 1943.
Writer James Kaplan described it: "Simple.
Instantly recognizable. You didn't have to ask
whose. Accept no substitutes. This was it,
now and for all time."

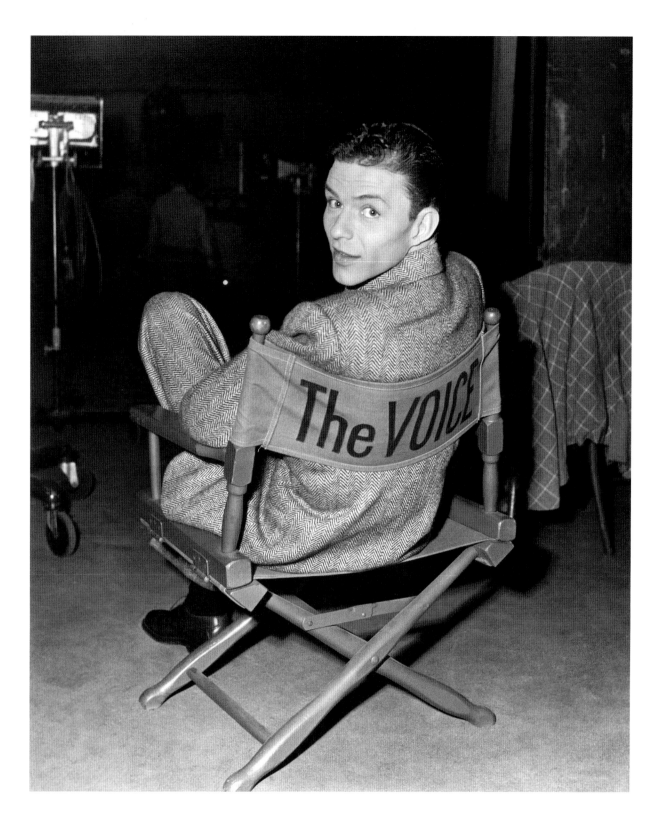

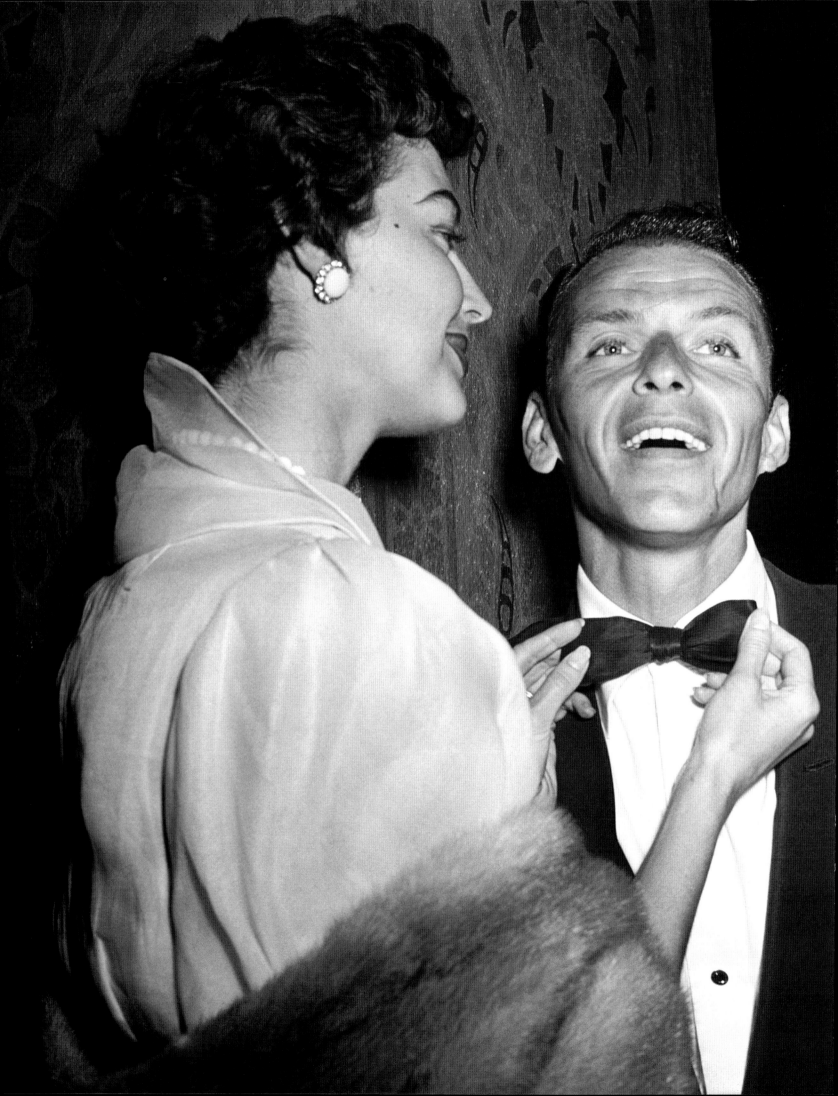

As a couple, Frank Sinatra and Ava Gardner made a certain kind of sense to their contemporaries. As Ezra Goodman wrote in *Time* in 1955, "The Barefoot Venus of Smithfield, North Carolina, was in some respects a perfect match for the Little Lord Fauntleroy of Hoboken. They had both come from well below the salt, and they loved the high life at the end of the table." The marriage lasted six stormy years, until 1957, and when it was over, Gardner was still certain of one thing: "Frank was one of the greatest singers of this century," she wrote in her memoirs. "He had a thing in his voice I've only heard in two other people—Judy Garland and Maria Callas. A quality that makes me want to cry for happiness, like a beautiful sunset or a boys' choir singing Christmas carols."

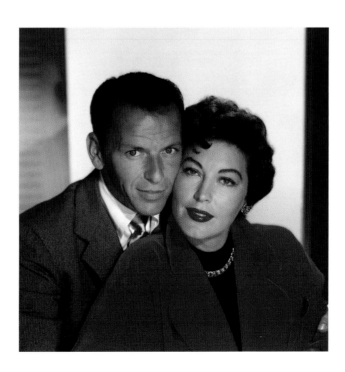

Frank Sinatra and Ava Gardner on May 24, 1952.

Sinatra and Gardner, c. 1951.
PHOTO BY PAUL HESSE

In *From Here to Eternity,* Sinatra found a style of acting that was true to his nature and resonated with the public. Reviewers singled him out for praise: "Frank Sinatra scores a decided hit as Angelo Maggio, a violent, likeable Italo-American GI," wrote *Variety's* William Brogdon. To prepare for the role, Sinatra spent no little time with Bogie, learning from the master. As film historian Tom Santopietro parsed the performance: "By blending small parts of Cagney's toughness with Bogart's jaded but vulnerable wiseguy, and overlaying the mix with his own distinctly Italian-American physicality—a lovable underdog with a chip on his shoulder—Sinatra arrived at an entirely original screen persona."

On assignment for *Collier's* magazine, photographer Bob Willoughby captures Frank in his dressing room on the Columbia Pictures lot in 1953. The role: Private Angelo Maggio. The film: *From Here to Eternity,* based on the best-selling novel by James Jones. The mirror: a looking glass through which Frank was about to step, into a world that would include Oscars, gold records, and none of the heartache the previous several years plagued him with.

OVERLEAF

Sinatra with Montgomery Clift on the set of *From Here to Eternity.*
PHOTO BY BOB WILLOUGHBY

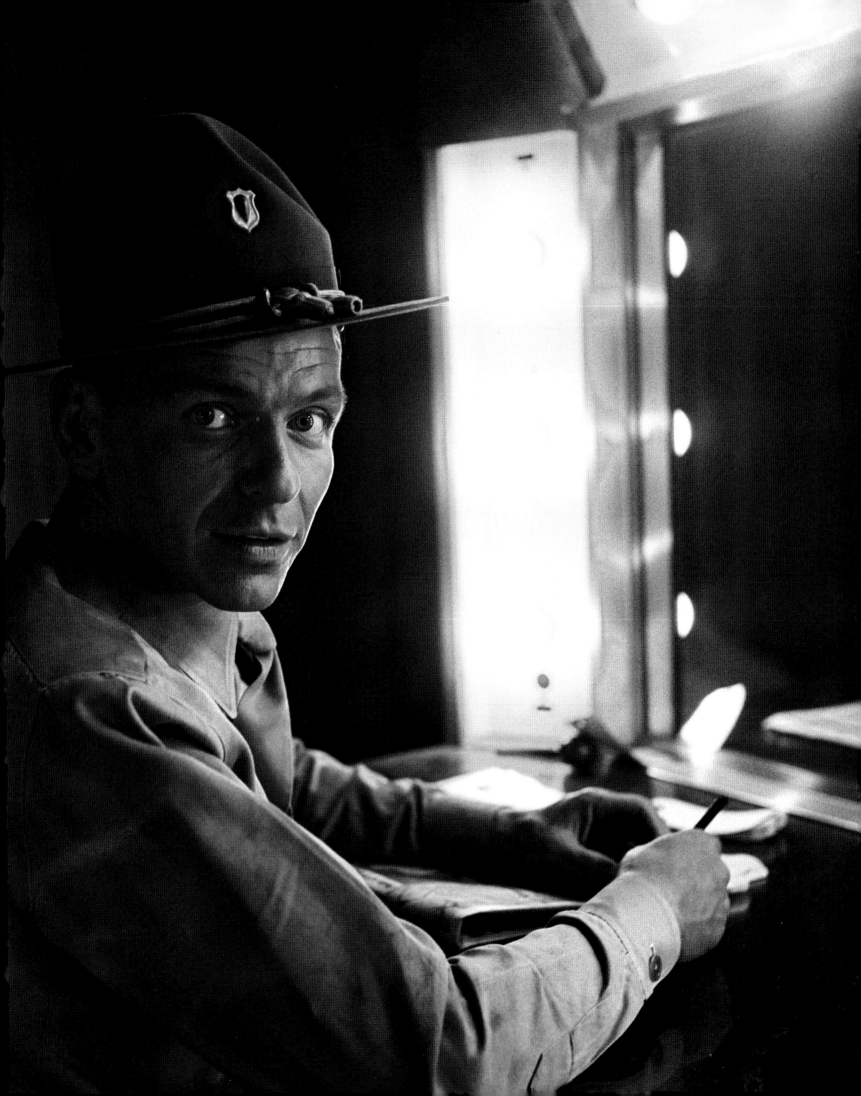

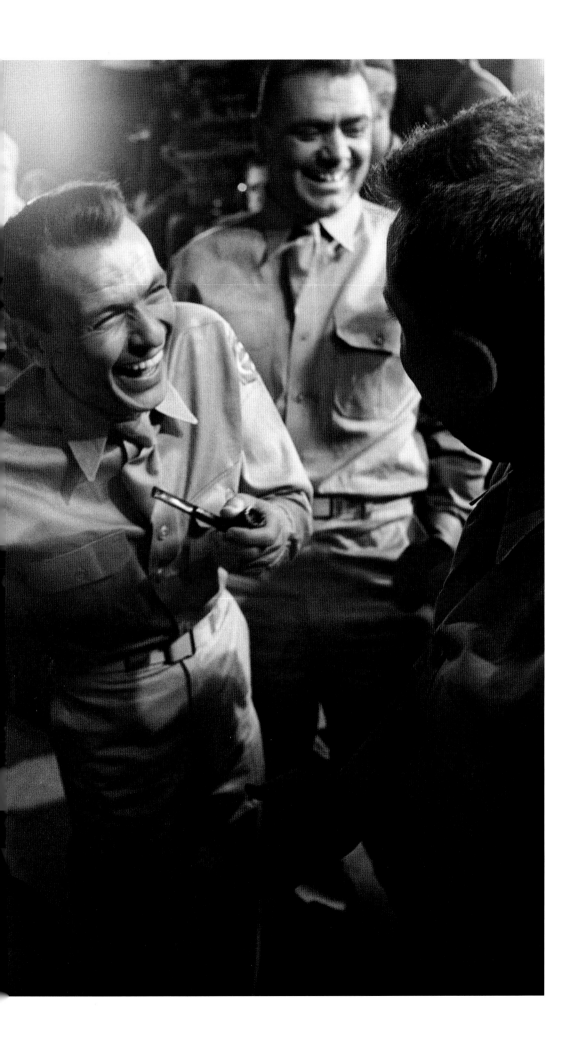

"I felt my photographic guardian angel was watching over me that day for sure," photographer Bob Willoughby would remember years later. In this shot, Frank plays around in front of the camera, turning his hat sideways, while on the Columbia Pictures lot for *From Here to Eternity*, 1953.
PHOTO BY BOB WILLOUGHBY

Sinatra in his dressing room on the Columbia Pictures lot, where filming for *From Here to Eternity* was under way, 1953.
PHOTO BY BOB WILLOUGHBY

Frank shares a much-needed laugh with costars Burt Lancaster, Ernest Borgnine, and Mickey Shaughnessy in between takes of one of the tensest scenes in *From Here to Eternity*, 1953.
PHOTO BY BOB WILLOUGHBY

OVERLEAF

Tough monkey: Frank waits for director Fred Zinnemann to yell, "Action!" as his character, Private Angelo Maggio, gets ready to seal his fate by striking "Fatso" Judson, the stockade sergeant, with a stool, for making a remark about his sister. Maggio would end up in Judson's stockade later in the film.
PHOTO BY BOB WILLOUGHBY

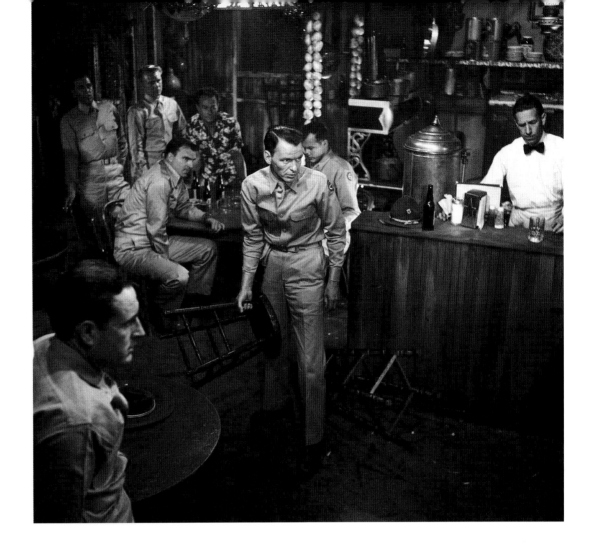
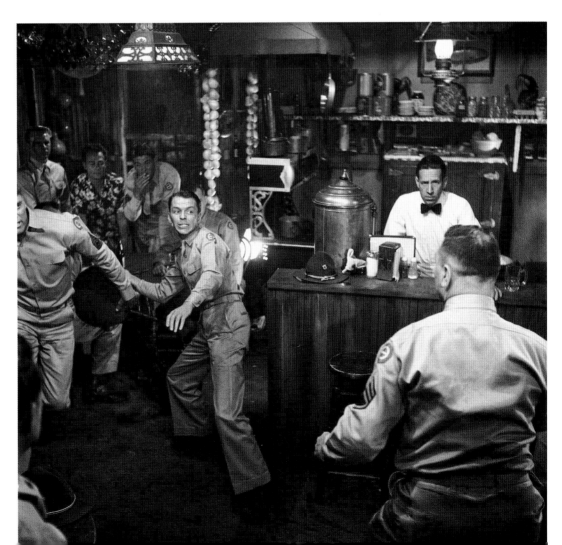

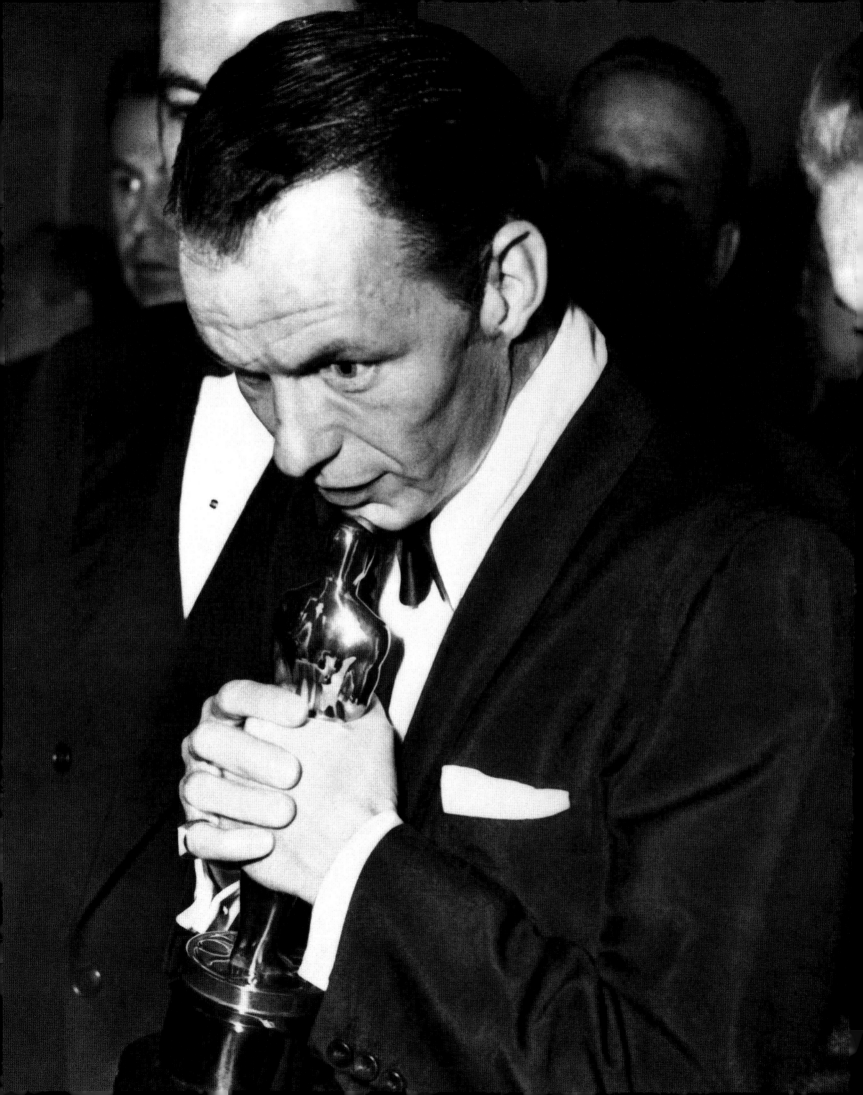

According to Burt Lancaster, Montgomery Clift had predicted Sinatra's Academy Award after watching rushes for *From Here to Eternity,* long before the film's release. Sinatra's costars understood that he had succeeded in channeling the chaos and disappointments of his private life into the portrayal of Maggio: "You knew that this was a raging little man who was, at the same time, a good human being," said Lancaster. The night of the ceremony, Sinatra felt blessed. "I ducked the party, lost the crowds, and took a walk," he told a reporter. "Just me and Oscar!"

On March 25, 1954, Mercedes McCambridge asks the following question on stage at the Pantages Theater in Hollywood, California, at the 26th Academy Awards ceremony: "And who, please, is the winner?" Then, with a jump and a gasp, she answers her own question: "The winner is Frank Sinatra, in *From Here to Eternity.*" And with that, Frank runs up on stage, gives a brief but marvelous speech, and blows everyone a kiss after saying, "I'm absolutely thrilled. Thank you." Army Archerd's *Daily Variety* column would read the next day: "Even cool Frank Sinatra's bones shook as his hand was clasped after he got his award."

Sinatra's stellar run at Capitol Records began in 1953, a year after he was dropped by his former label. According to Alan Livingston, the executive who signed Sinatra, the deal went down easy: "He was at the lowest ebb of his life. . . . He was glad to have a place to make records." For Sinatra, it clicked. Photographer Sid Avery watched the singer listening to playback for "I've Got the World on a String" that year and heard him exult, "Jesus Christ, I'm back. I'm back, baby, I'm back." A year later, *Swing Easy!* was *Billboard*'s Album of the Year, and in 1955 he made *In the Wee Small Hours*, which the celebrated radio host Jonathan Schwartz called "the greatest album of music I've ever heard of any kind."

Capitol Records
recording session, 1954.
PHOTO BY SID AVERY

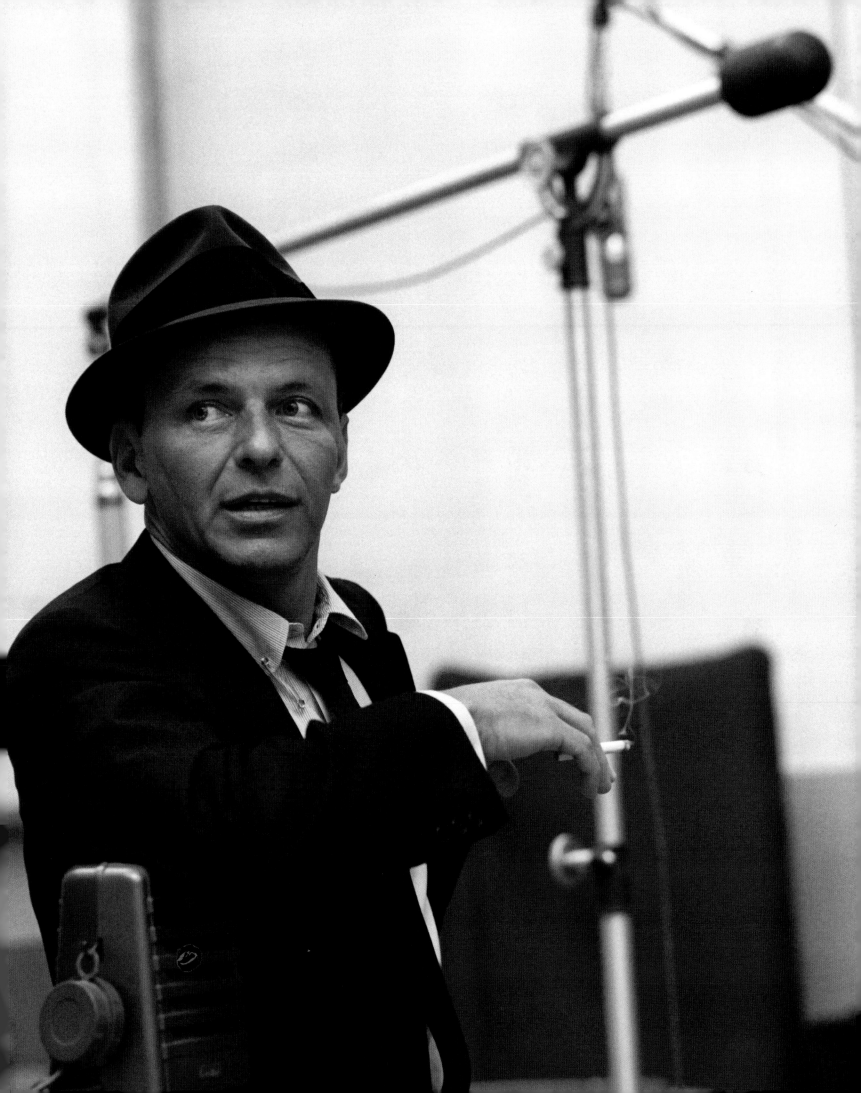

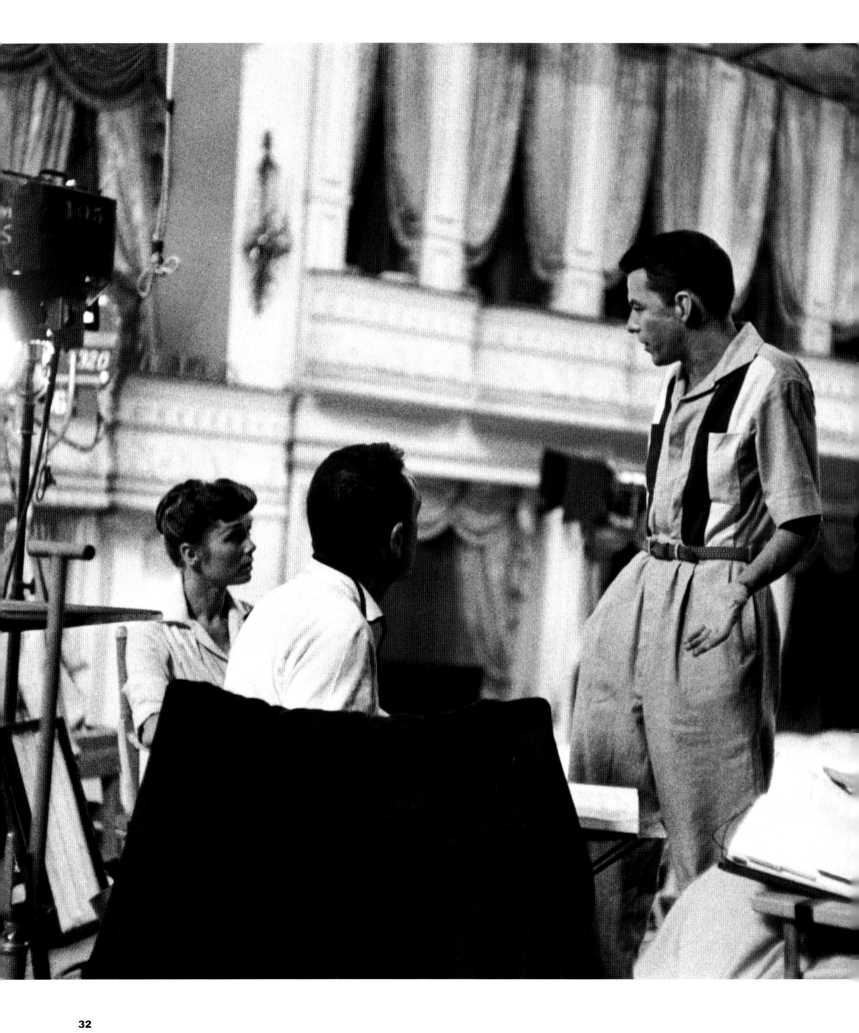

Sinatra became a style icon who would certainly make the short list of best-dressed men of the postwar era. Taking his cue from his friend Humphrey Bogart, he favored sharp tailored suits, fine Italian sweaters, English wingtips, and, of course, the signature fedora. In the Rat Pack era, he lived in his tux. He was punctilious, too. He once told Bill Zehme in a 1996 *Esquire* interview, "Try not to sit down, because it wrinkles the pants," and he was known to change into a new pair if he broke a crease. All of which is to say that the sight of Sinatra in blowsy pegged trousers is to be savored. More typical was his remark to an interviewer who commented on his stylishness in 1977, "I don't wear funny clothes. I am not demonstrative. I do my job and go home."

Sinatra talking to costar Debbie Reynolds
on the set of *The Tender Trap*, 1955.
PHOTO BY BERNIE ABRAMSON

When asked by Johnny Carson in 1976 to list some of the high points of his career, Frank would single out his "being a part of a film called *The Man with the Golden Arm*" that he called "a milestone in the motion picture business." Writing in 1955, movie critic Arthur Knight was especially acute about Sinatra's achievement in the film: "The thin, unhandsome one-time crooner has an incredible instinct for the look, the gesture, the shading of the voice that suggest tenderness, uncertainty, weakness, fatigue, despair." Knight identified qualities in Sinatra—"a shade of sweetness, a sense of edgy indestructibility"—that were becoming central to his appeal.

Reading the script on the set of
The Man with the Golden Arm, 1955.
PHOTO BY BOB WILLOUGHBY

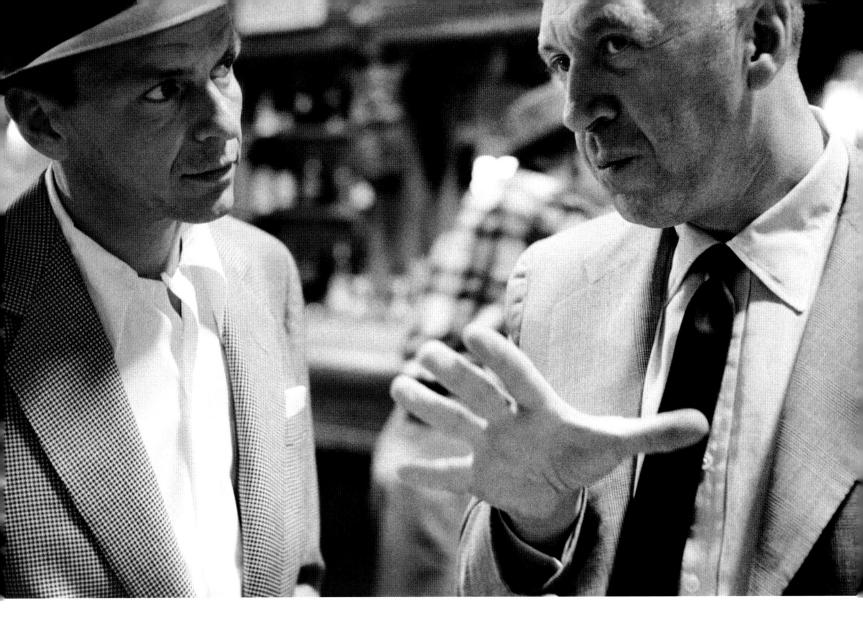

Preminger shows Frank around the set
of the film on the RKO Studios lot.
PHOTO BY BOB WILLOUGHBY

The script read-through for *The Man with
the Golden Arm* at RKO Studios, 1955.
Director Otto Preminger, back to camera,
sits at the head of the table. From left
to right: Eleanor Parker, Robert Strauss,
Doro Merande, John Conte, Darren
McGavin, Arnold Stang, Kim Novak, and
Frank Sinatra.
PHOTOS BY BOB WILLOUGHBY

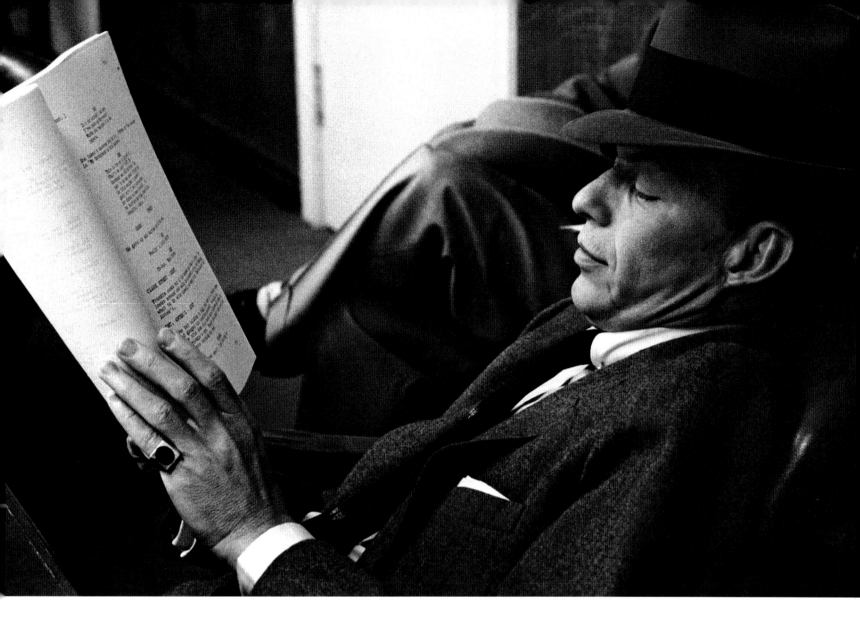

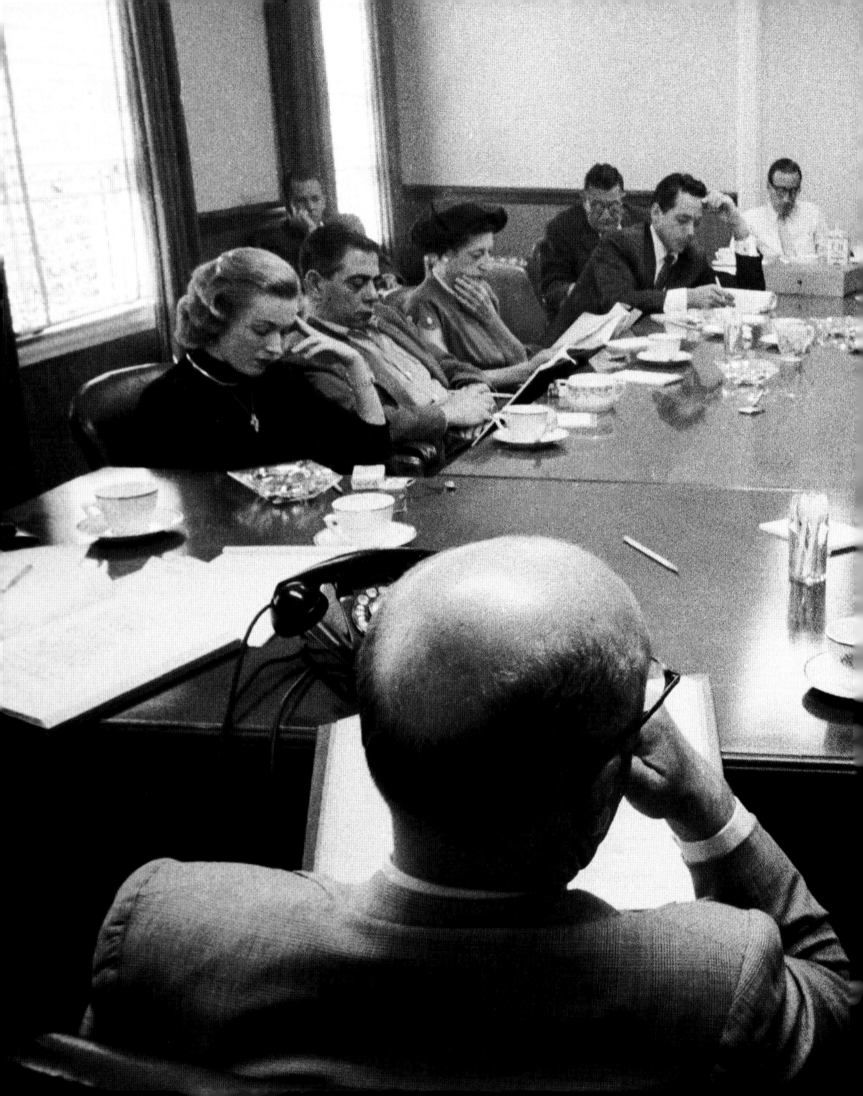

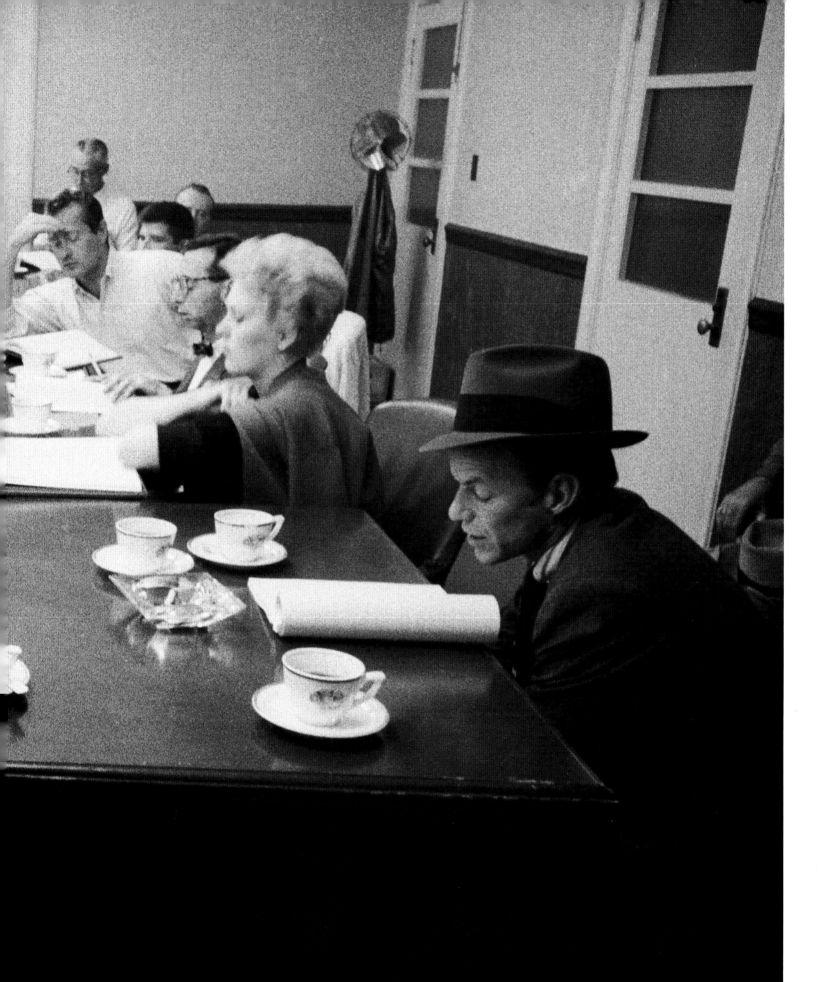

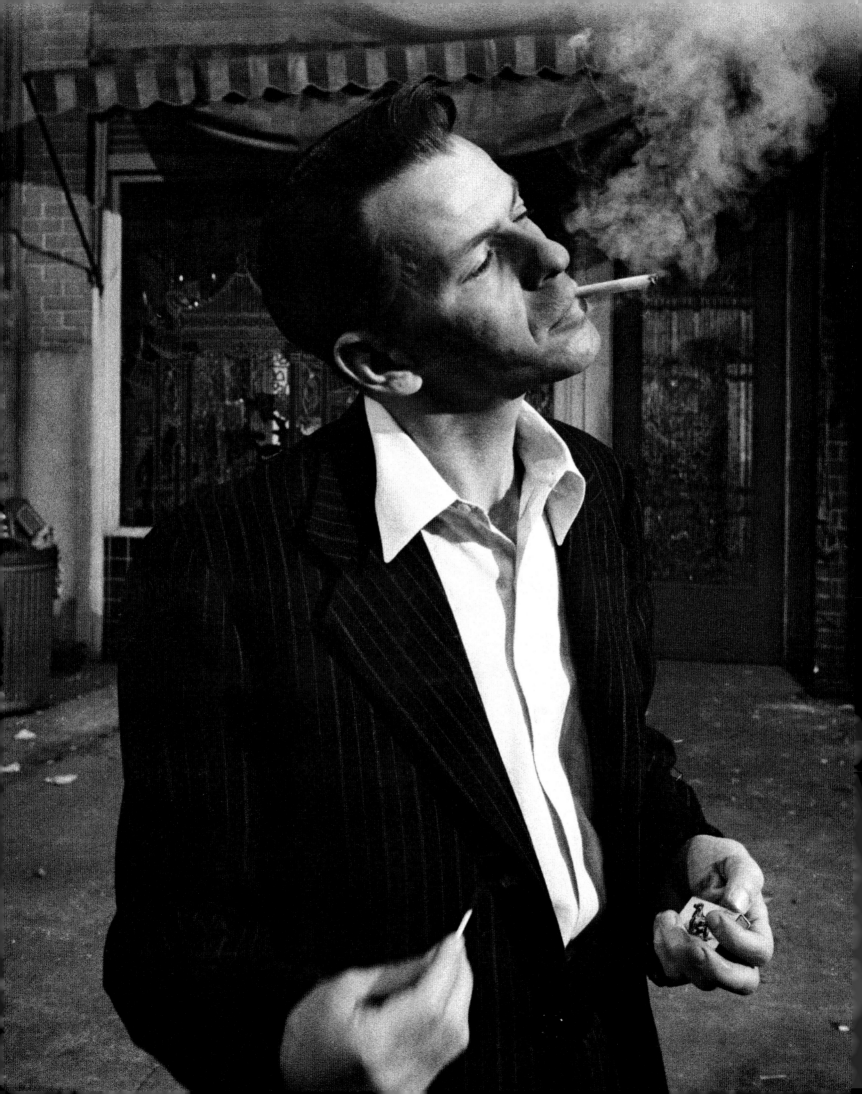

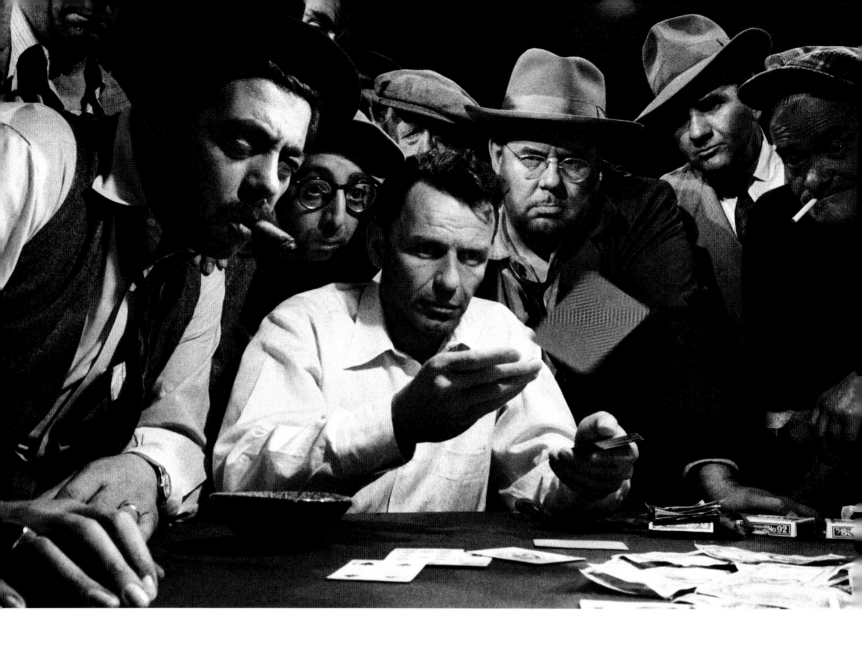

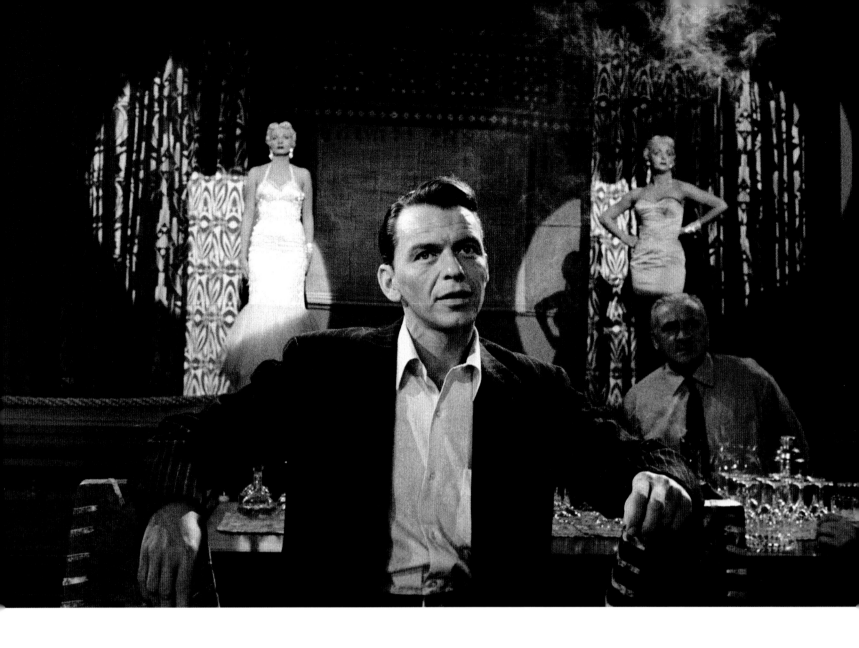

Photographer Bob Willoughby wrote, "It was interesting to see Frank, seemingly tentative in rehearsals or when studying the script by himself, become suddenly confident when he stepped into the role. It was as if someone else had taken over, and he became that character."

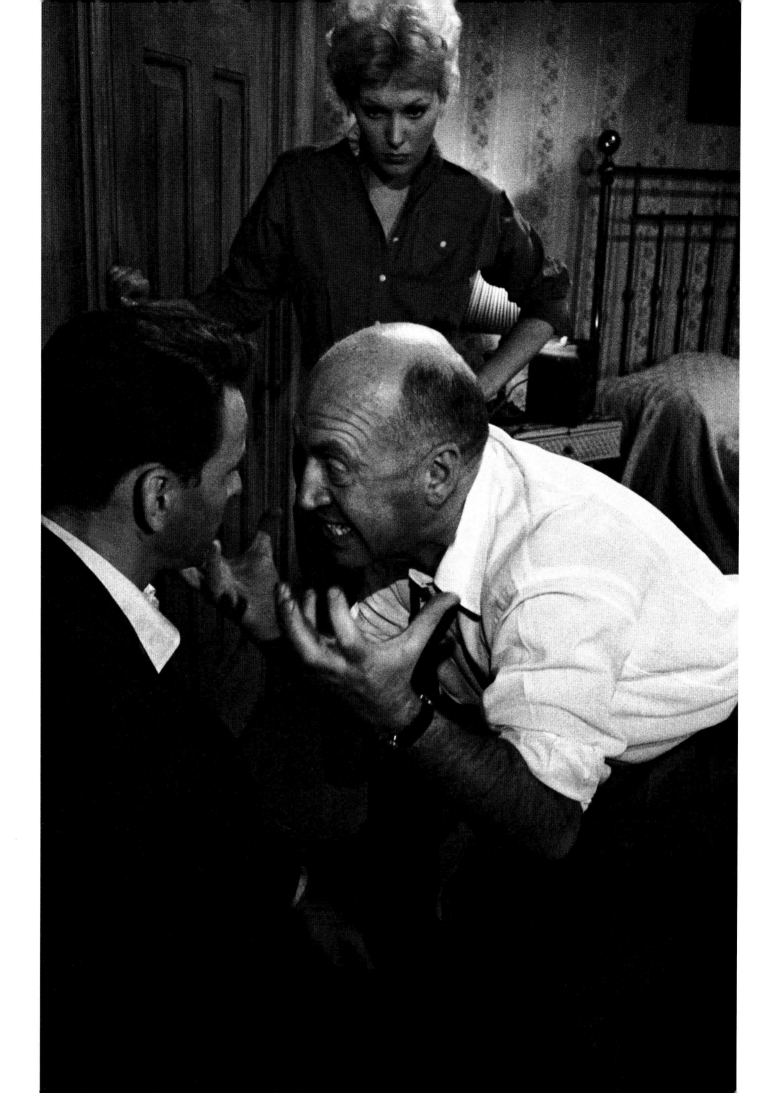

For Sinatra as an actor, the high point of the film was the sequence where his character, Frankie Machine, goes cold turkey to kick his heroin addiction. He went so far as to research the role. "I got permission to watch a kid who was in the dryout position in a padded cell. I advise anybody never to go look at that. I left with tears streaming down my face." His friends Jerry Lewis and Dean Martin were on set the day the scene was shot, and they were electrified by Sinatra's intensity in front of the camera. "Then," Lewis recounted, "Preminger yelled 'Cut!' and Frank got up off the floor and lit a cigarette."

PREVIOUS SPREAD, LEFT

Director Otto Preminger steps in for Kim Novak to show her how he wants her to play her part during Frank's drug-withdrawal scene in *The Man with the Golden Arm*, 1955.
PHOTO BY BOB WILLOUGHBY

PREVIOUS SPREAD, RIGHT

The withdrawal scene, where Frankie Machine tries to quit heroin cold turkey.

Serving time for drug addiction.
PHOTOS BY BOB WILLOUGHBY

OPPOSITE PAGE

Sinatra holds a match up to his dilated eyes, right before a scene where Kim Novak's character does the same to him, checking to see if Frankie Machine is still using.
PHOTO BY BOB WILLOUGHBY

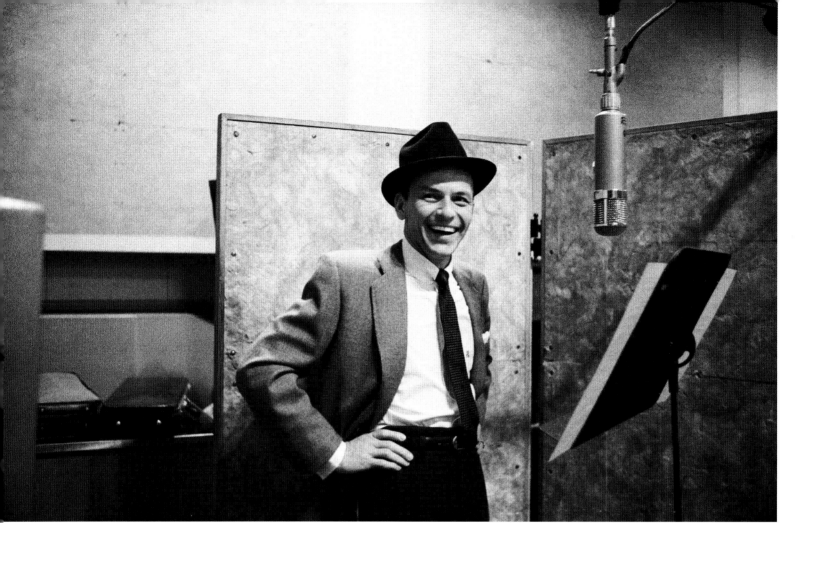

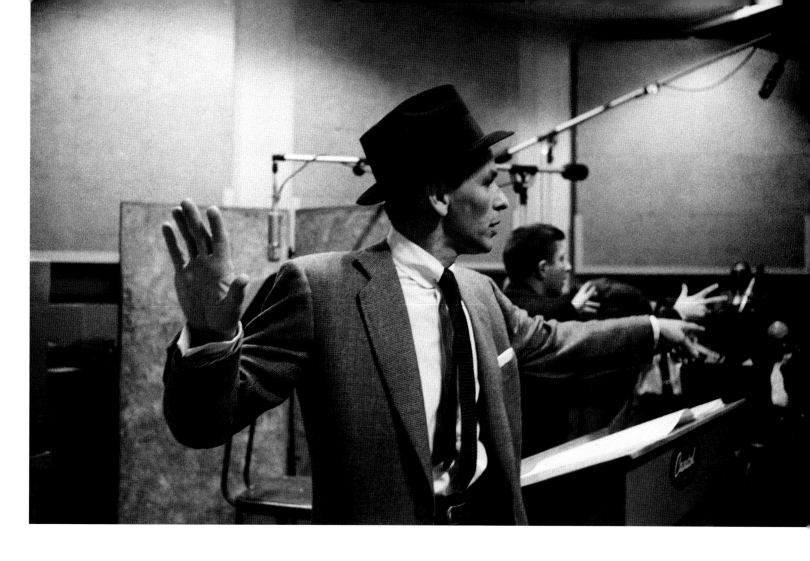
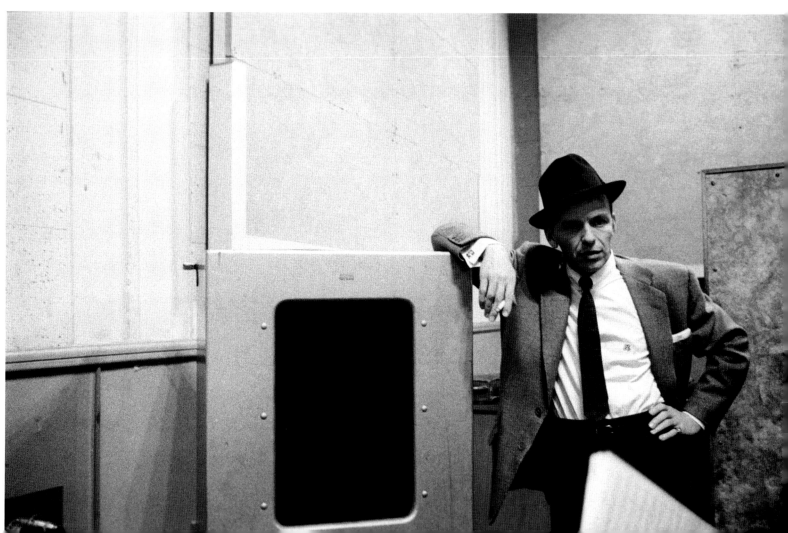

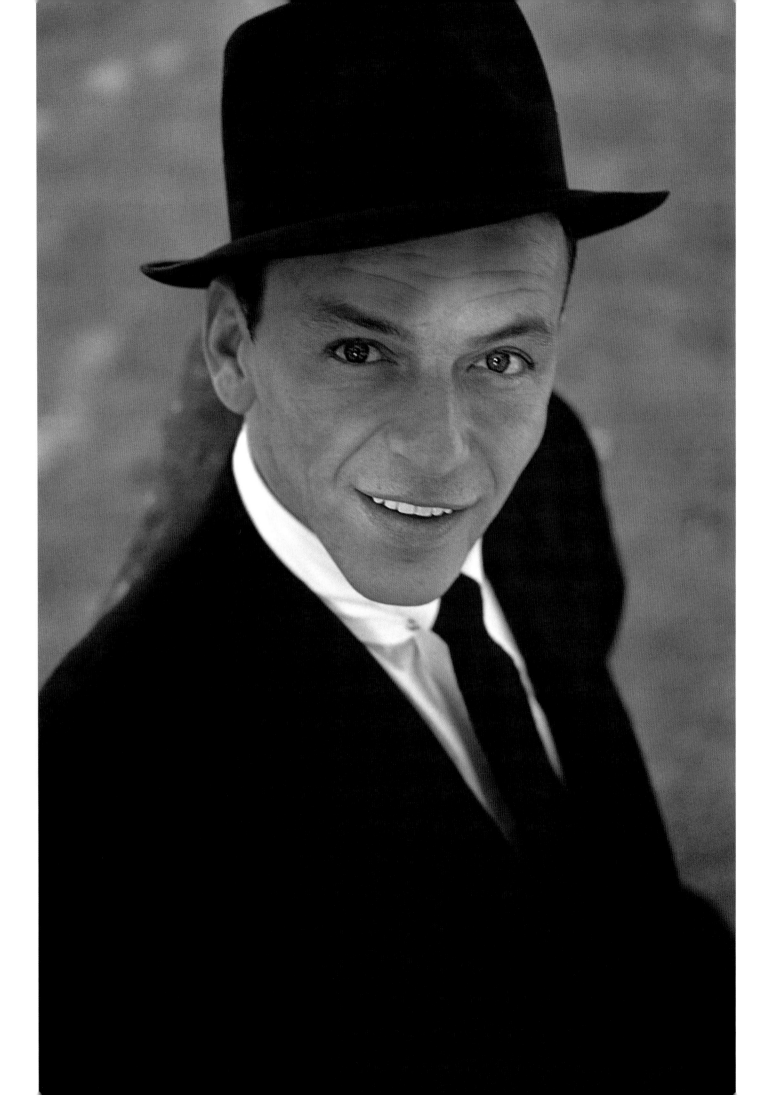

Over the years, writers found themselves zeroing in on Sinatra's contradictions to explain his appeal. To Arnold Shaw, "He was a high-liver and a giver, enigmatic as well as outspoken, intemperate and the acme of courtesy, a swinger and a sad-sack, hurt as well as hurting." Leo Rothstein saw "an animal tension, a suggestion of violence," that was undercut by "that unexpected and disarming grin." John Lahr discerned a style that "had the immanence of the hip combined with the articulateness of the traditional," bridging two scenes that were at odds in the fifties and sixties. It was an irresistible bundle of masculine qualities, and, as Pete Hamill said, "Thousands of us appropriated the pose of the Tender Tough Guy from Sinatra."

PREVIOUS SPREAD

After filming was completed on *The Man with the Golden Arm*, Frank commenced recording the score for it at a Hollywood studio in 1955. Relaxed, laughing, and in his element, he said to photographer Bob Willoughby, who remarked on the change in demeanor, "Bobby, this is what I do!" At one point, he took over for the Juilliard-trained composer Elmer Bernstein while they recorded the score. "Well, musically speaking," Sinatra once said, "do you know what I really am? A frustrated conductor."

PHOTOS BY BOB WILLOUGHBY

OPPOSITE PAGE

After the recording session for *The Man with the Golden Arm*, Willoughby coaxed Frank to pose for a handful of color portraits on a park bench just outside of the recording studio, 1955. As Bob recalled years later, "He was still in a happy and relaxed mood, as the session had gone well. He posed for a few minutes, gave me a wink and then was gone."

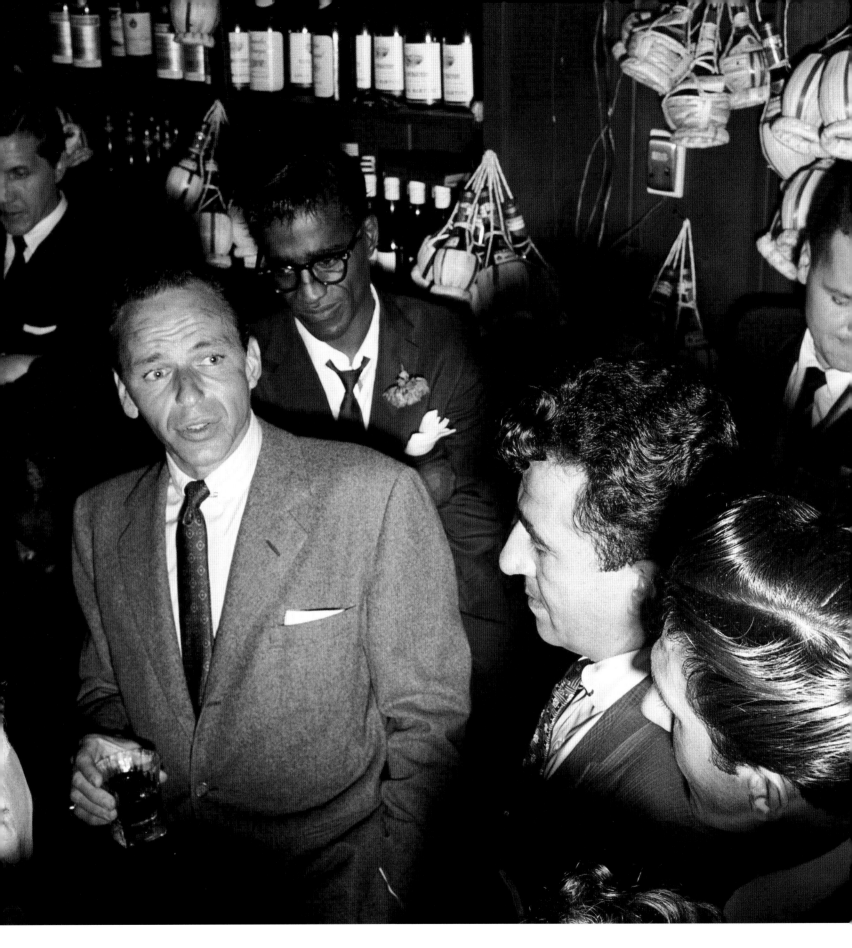

Frank inscribed a print of Bernie Abramson's photo to Sammy Davis Jr.: "The same goes for me Sam—all the way. Affectionately, Frank." The venue is the Villa Capri, the year is 1955, and the occasion a bon voyage party for owners Patsy and Rose D'Amore, whose restaurant was a Sinatra hangout. In attendance this night, along with Davis, are Lauren Bacall, Dean Martin, and James Dean, to name just a few of the star-studded diners. "I was never intimidated by stars, just in awe," photographer Abramson would say years later during an interview.

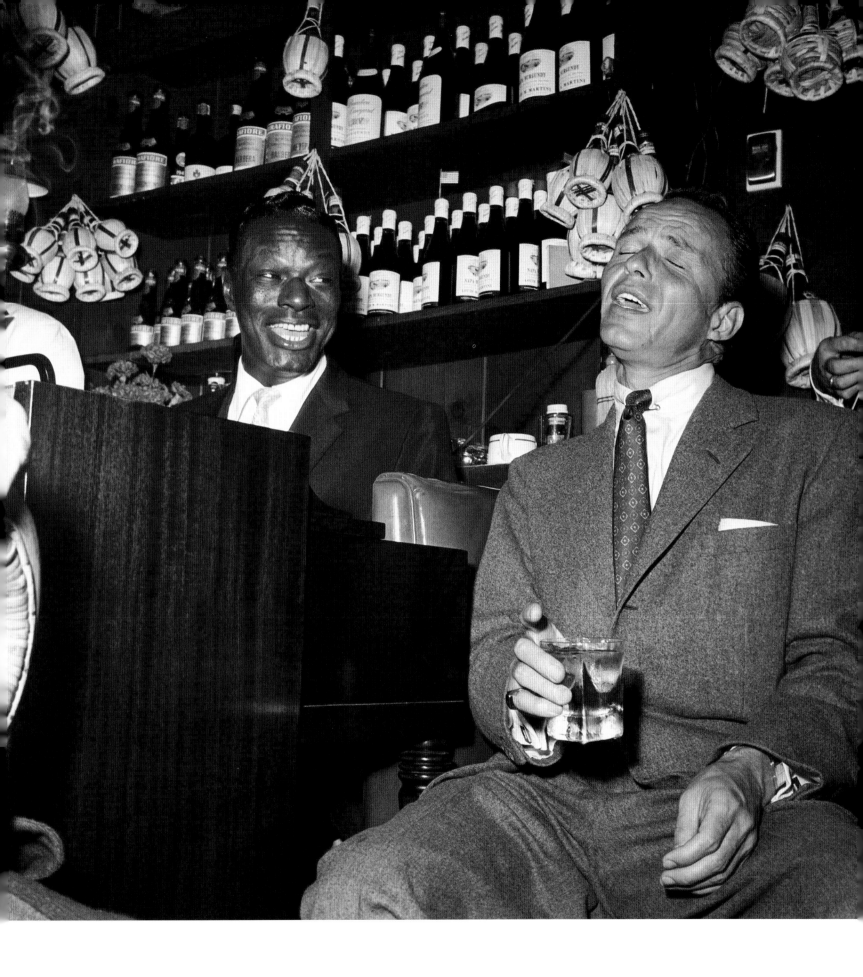

The mood is celebratory as Nat King Cole and
Frank Sinatra belt out a tune at the party.
PHOTO BY BERNIE ABRAMSON

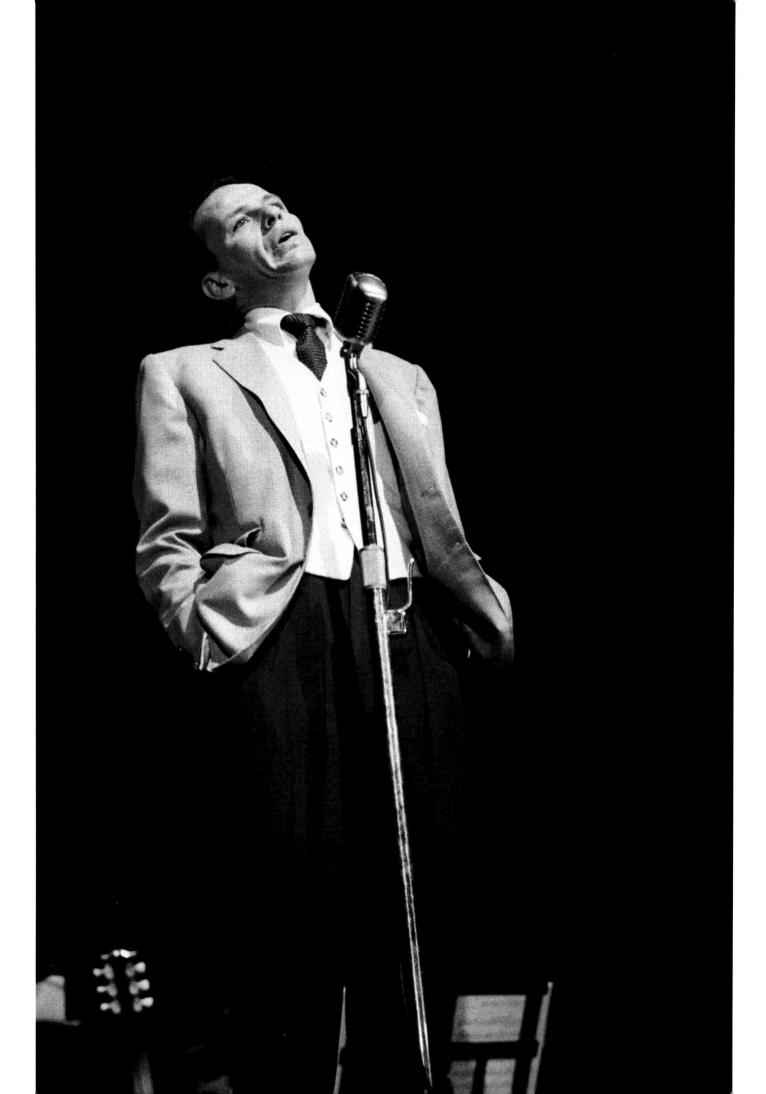

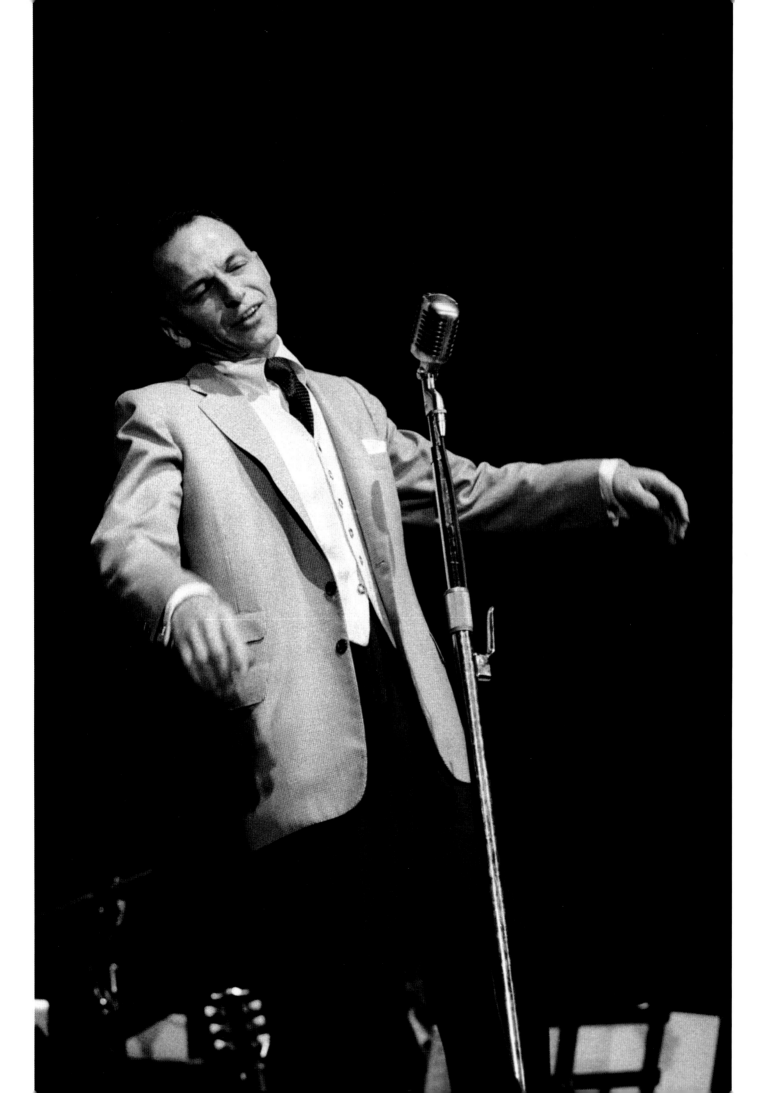

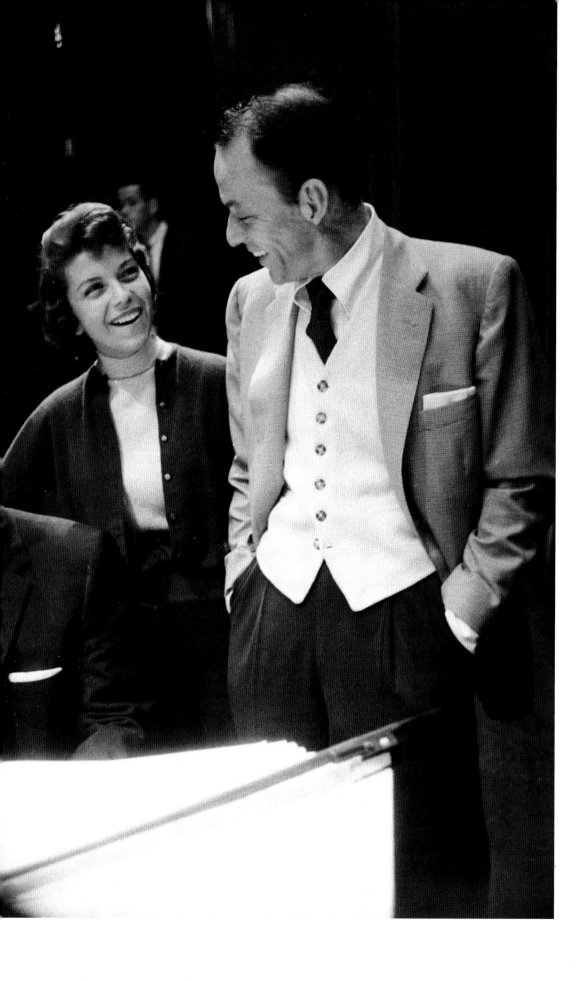

Sinatra takes a moment with his
daughter Nancy before the performance.
PHOTOS BY BOB WILLOUGHBY

Sinatra visits Paul
Newman during the
making of *Somebody
Up There Likes Me* in
1956. Months earlier,
Frank had acted
with Newman in a live
television production
of *Our Town*.
PHOTO BY SANFORD ROTH

Jazz pianist and Sinatra biographer Robin Douglas-Home described the singer's total absorption in his work: "When he controlled his breathing he shuddered, almost painfully—shoulders shook, neck muscles twitched, even his legs seemed to oscillate. His nostrils dilated and his eyes closed dreamily, then opened again as sharp as ever as he watched a soloist, then closed again and his face contorted into a grimace, and his whole frame seemed to be caught up in a paroxysm..." Sinatra's emphasis on a song as a seamless performance, even in the recording studio, placed a burden on his producers. As George Schlatter said, "If he had a clam in the last three bars, you took it from the top. He was a perfectionist." This explains arranger Nelson Riddle's lament, after a late-night 1953 session when Sinatra insisted on twenty-eight takes of the song "Rain": "I'm not much of a Frank Sinatra fan this morning."

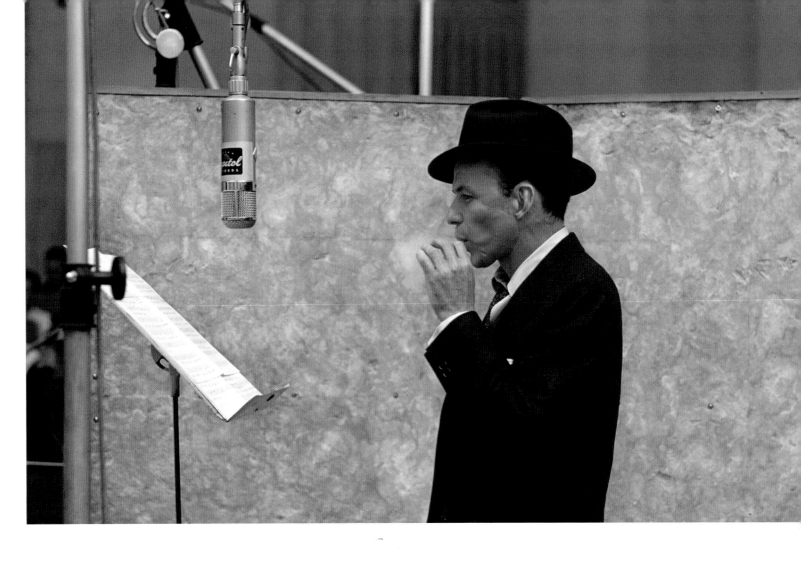

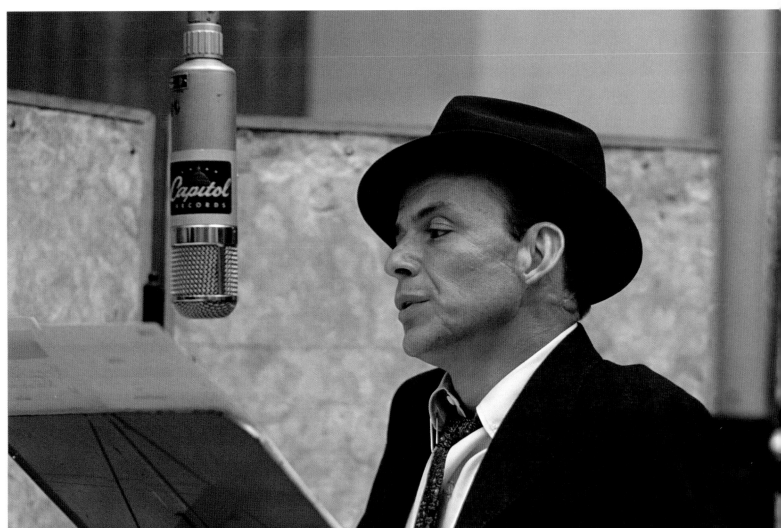

PREVIOUS SPREAD AND RIGHT

A Capitol Records recording
session in the then-new
Capitol Studios on Vine Street,
Hollywood, c. 1957.
PHOTOS BY SID AVERY

64

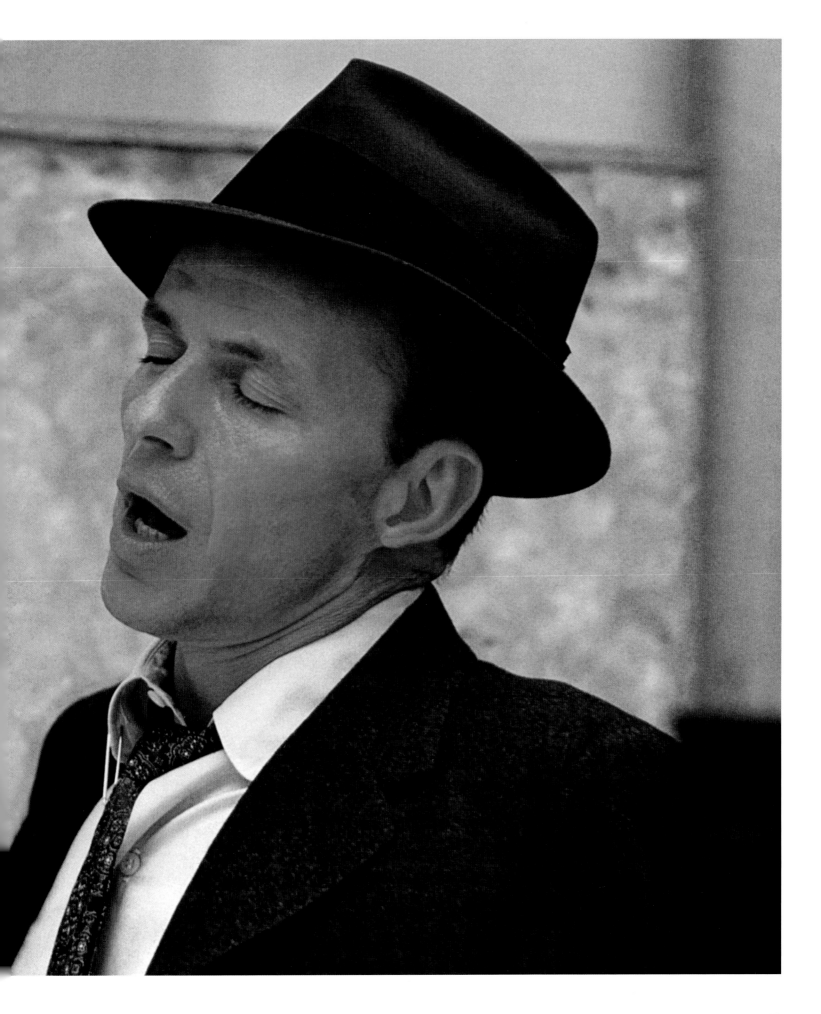

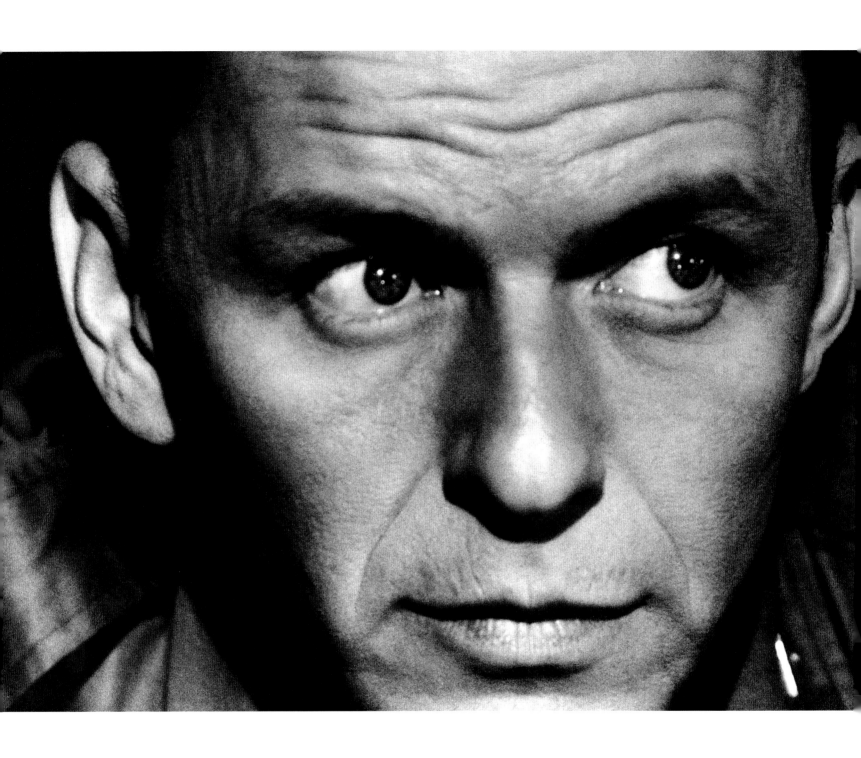

On the set of *Kings Go Forth*, 1958.
PHOTO BY BILL AVERY

Between takes on the
Hollywood set of *Suddenly*, 1954.
PHOTO BY BOB WILLOUGHBY

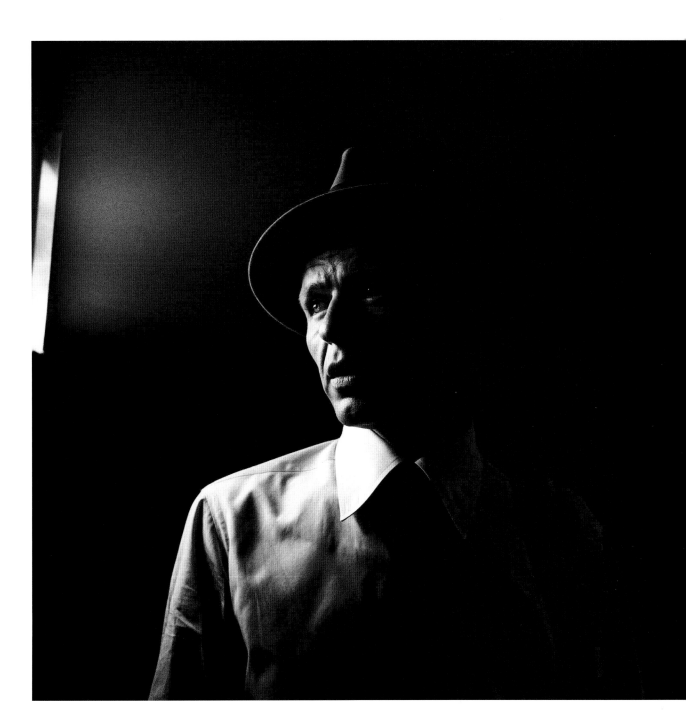

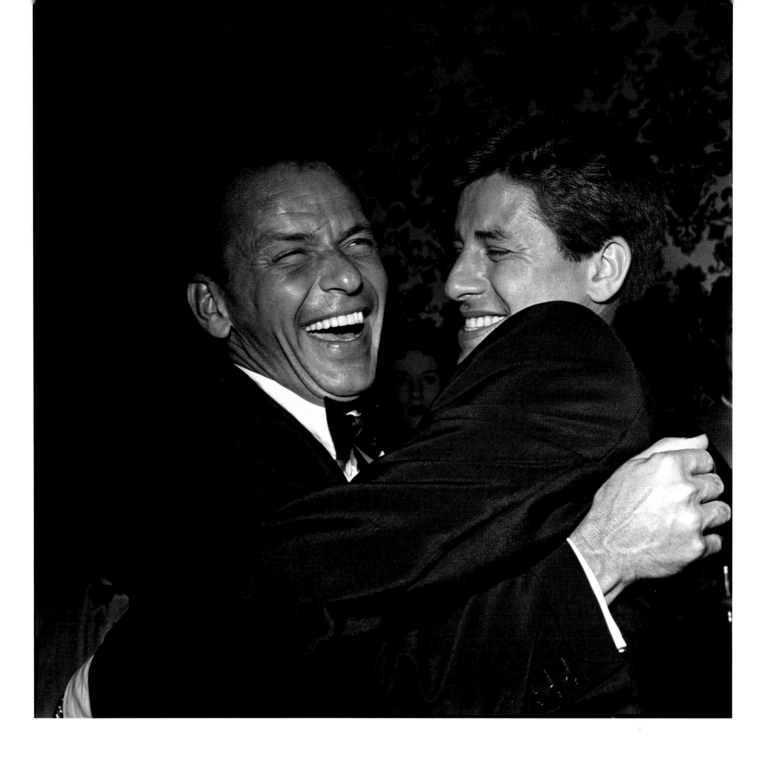

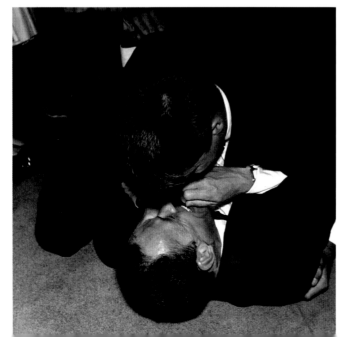

Producer George Schlatter describes his first encounter with Sinatra: "My first week at MCA I was delivering mail. I was about eighteen years old and I was wearing a light gray gabardine suit, with a flowered tie, argyle socks, and oxblood shoes, so I looked like a traffic warning. Everybody else was in black except me. And he walked into the building to sign his contract and everybody just followed him like a tidal wave, you know, into Larry Barnett's office. I was just standing there. They gave him the contract, and he turned and handed it to me and said, 'Is this okay?' And I said, 'Yah.' And he said, 'Okay,' signed the contract, started to leave, and then he turned around and he said, 'I have ties older than this guy.'"

Frank Sinatra and Jerry Lewis,
September 19, 1958.

"Let's be real," said Quincy Jones. "He had the best songs ever written in America, he had the best arrangers, and he had the best bands, man, and he's got the best voice. He couldn't lose. He could not lose, you know."

Sammy Cahn and Jimmy Van Heusen: two men whose words and music would bring Frank some of his most enduring hits, including "All the Way," "Come Fly with Me," and "The September of My Years." Here they're photographed together backstage in 1959 during an ABC television special. "Sammy's words fit my mouth the best," Frank once told producer George Schlatter.
PHOTO BY SID AVERY

"Lefty," aka Gordon Jenkins, with Frank in the studio during a Capitol Records recording session, c. 1957. Arranger Jenkins would work with Sinatra for more than two decades, until 1981.
PHOTO BY SID AVERY

Born less than six years apart and twenty-five miles away from each other in New Jersey, arranger Nelson Riddle and Frank Sinatra would create some of the twentieth century's greatest music together while at Capitol Records. "Frank undoubtedly brought out my best work," writer Robin Douglas-Home would quote Riddle as saying. "The man himself somehow draws everything out of you." Here they are at a Capitol Records recording session for "Come Dance with Me!" 1958.
PHOTO BY SID AVERY

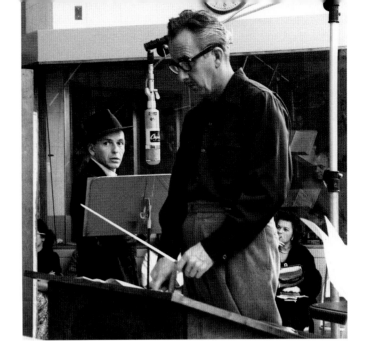
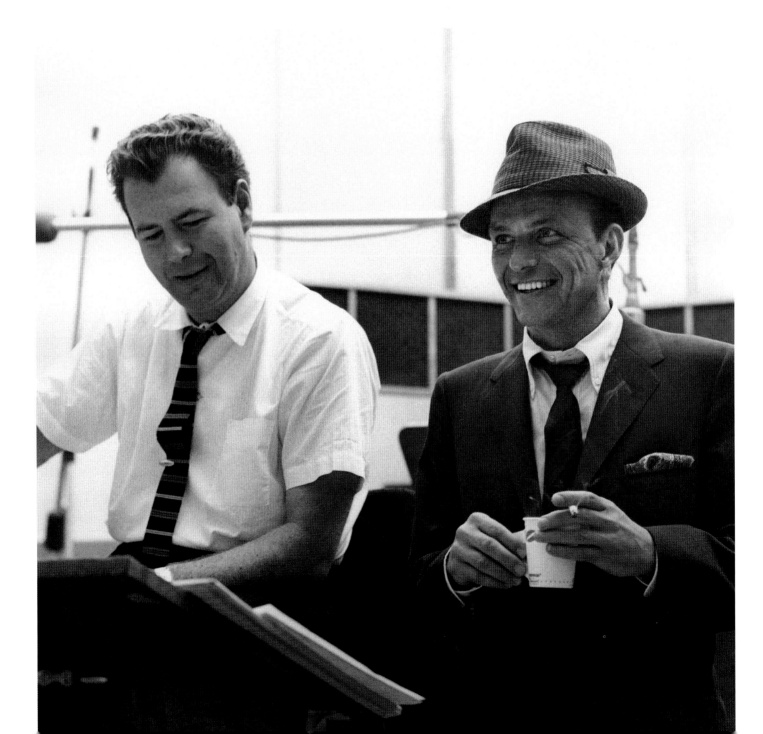

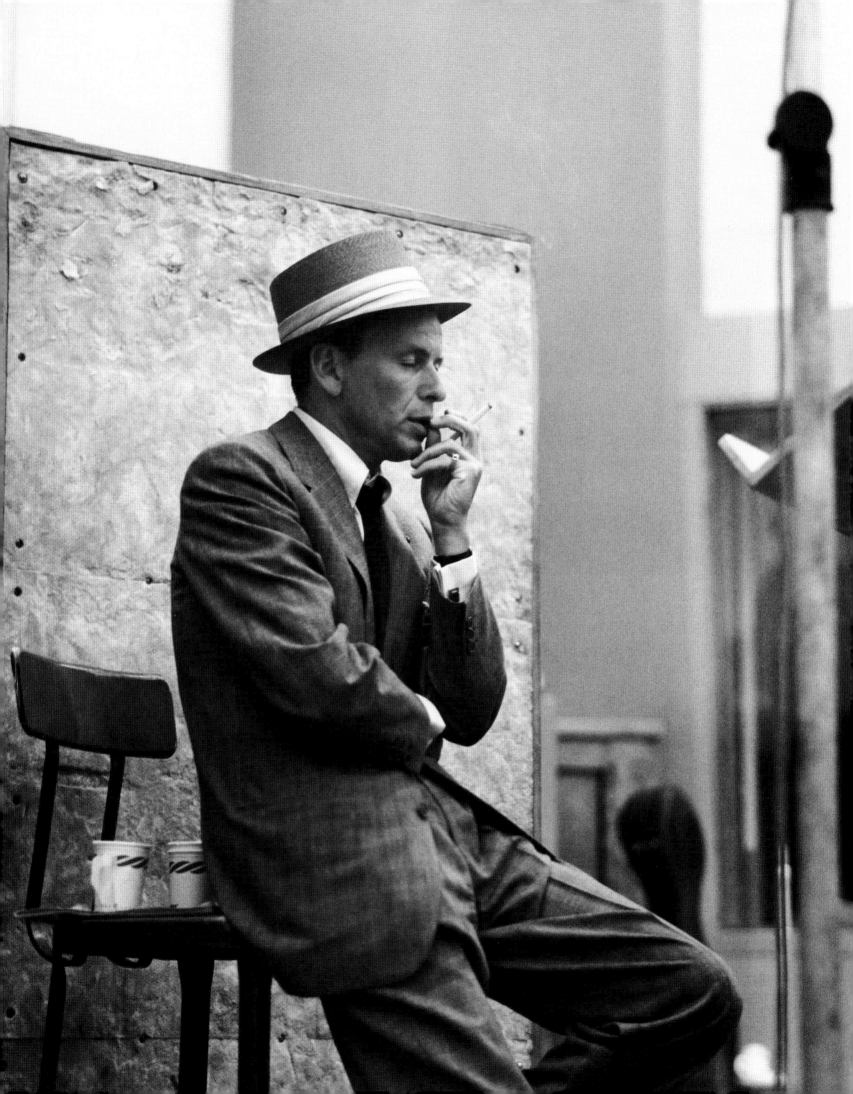

Sinatra's performances and recording sessions in the 1950s were steeped in romance for the men who lived them. Nelson Riddle often used sex, with its variable heartbeat and climax, as a metaphor to describe his vision of a song's tempo, and he built his arrangements around the life of the bedroom: "I always have some woman in mind for each song I arrange; it could be a reminiscence of some past romantic experience, or just a dream-scene I build in my own imagination." Writing in the *New Yorker* in 1952, E. B. White brilliantly condensed this trope into the well-known aphorism, "To Sinatra, a microphone is as real as a girl waiting to be kissed."

Frank listens to playback during a
Capitol Records recording session, 1958.
PHOTO BY SID AVERY

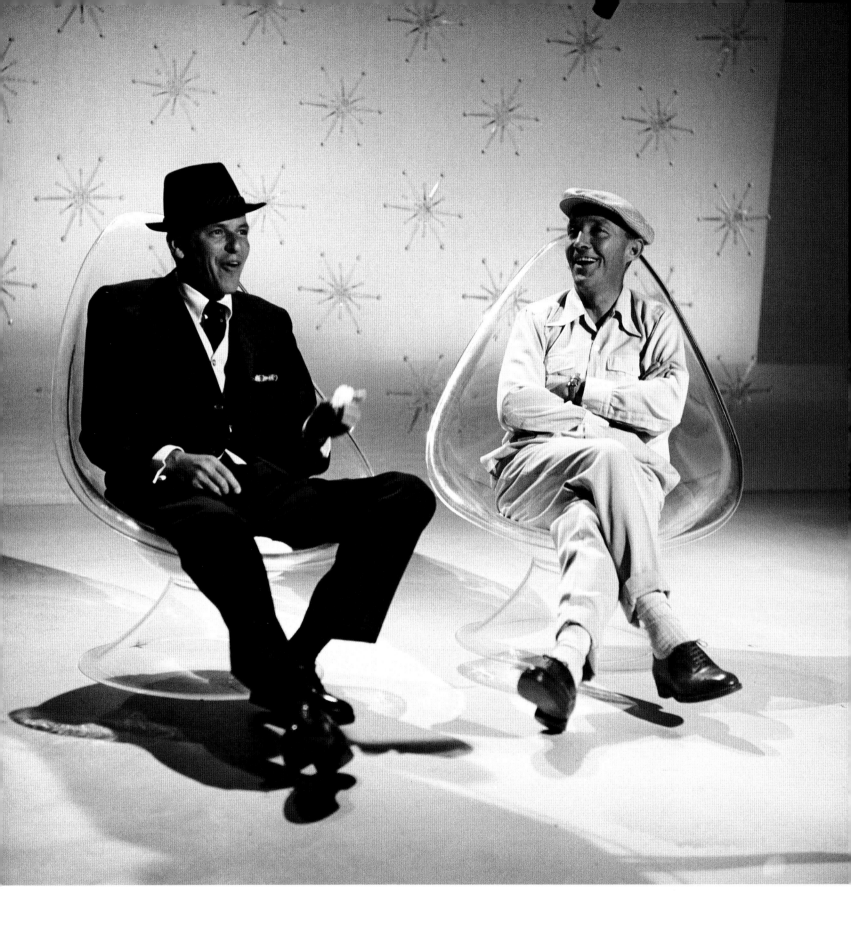

Frank and Bing during rehearsals for a Bing
Crosby television special that would also star
Peggy Lee and Louis Armstrong, 1959.
PHOTO BY SID AVERY

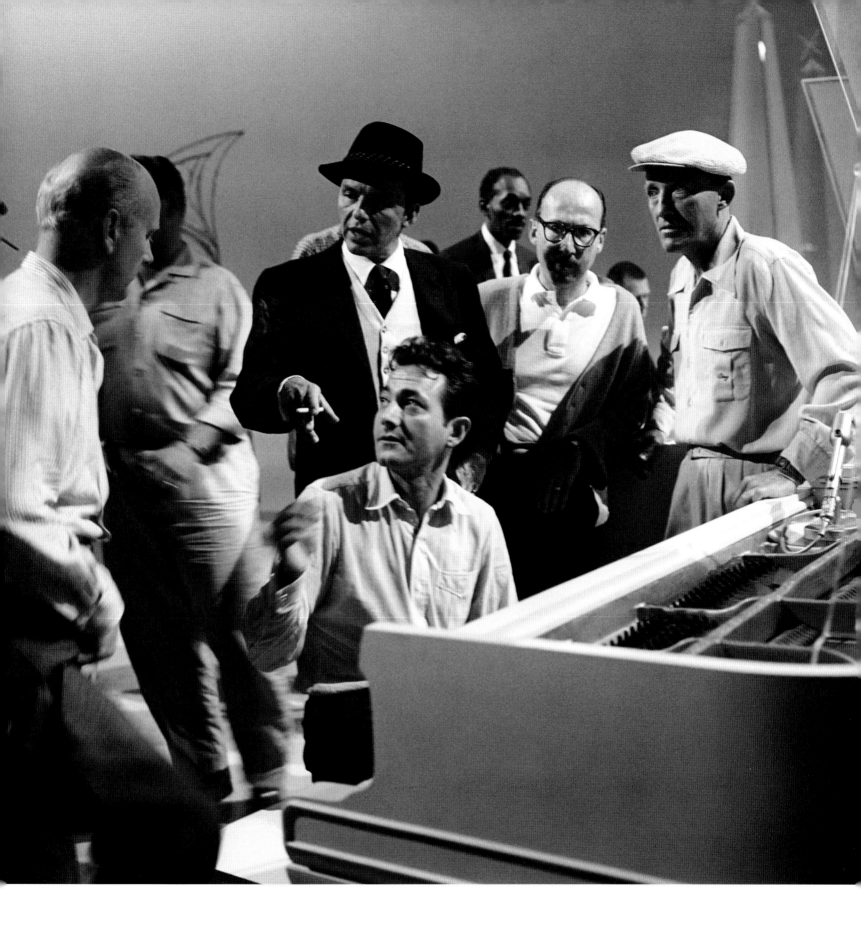

Axel Stordahl, Joe Bushkin, Frank Sinatra, Sammy Cahn, and Bing Crosby rehearsing for *The Bing Crosby Show*. Stordahl was an arranger who worked with Sinatra at Columbia. Bushkin was a jazz pianist who cowrote Sinatra's first hit song in 1941.
PHOTO BY SID AVERY

"His life was a creative tsunami," said producer George Schlatter. "When you think about it, when Sinatra sang a song, no matter who had done it before, it became Sinatra's song." Sinatra, however, didn't believe that every song could be his; according to George Jacobs, he pulled his single of "I Left My Heart in San Francisco" off the market in deference to Tony Bennett's definitive version. His accompanist, Bill Miller, described the care with which Sinatra selected songs, focusing first on the melody and construction, and then on the lyrics, with great discernment: "Occasionally, if he likes the melody that well, maybe he'll try to convince the lyric writer to rewrite it." The tsunami also tossed out ideas for songs—lyricist Sammy Cahn reported that it was a phone call from the singer requesting a song "about taking a flying trip" that resulted in the classic, "Come Fly with Me."

Sinatra rehearses for *The Frank Sinatra Timex Show* on ABC, October 1959.
PHOTO BY GENE HOWARD

When Bob Dylan released his album *Shadows in the Night* in 2015, which was widely recognized as a tribute to Sinatra, it evidently reflected decades of engagement with the singer. In his memoir, *Chronicles*, Dylan recounted the experience of listening over and over again to Sinatra's recording of "Ebb Tide" during his early days in Greenwich Village: "When Frank sang that song, I could hear everything in his voice—death, God and the universe, everything."

Frank opens *The Frank Sinatra Timex Show* with the Rube Bloom and Johnny Mercer tune "Day In—Day Out," before going on to perform with the evening's guest stars: Bing Crosby, Dean Martin, Mitzi Gaynor, and Jimmy Durante, October 1959.
PHOTO BY GENE HOWARD

OVERLEAF

Recording session, c. 1959.

Between takes on
the 1959 film *A Hole in the Head*.

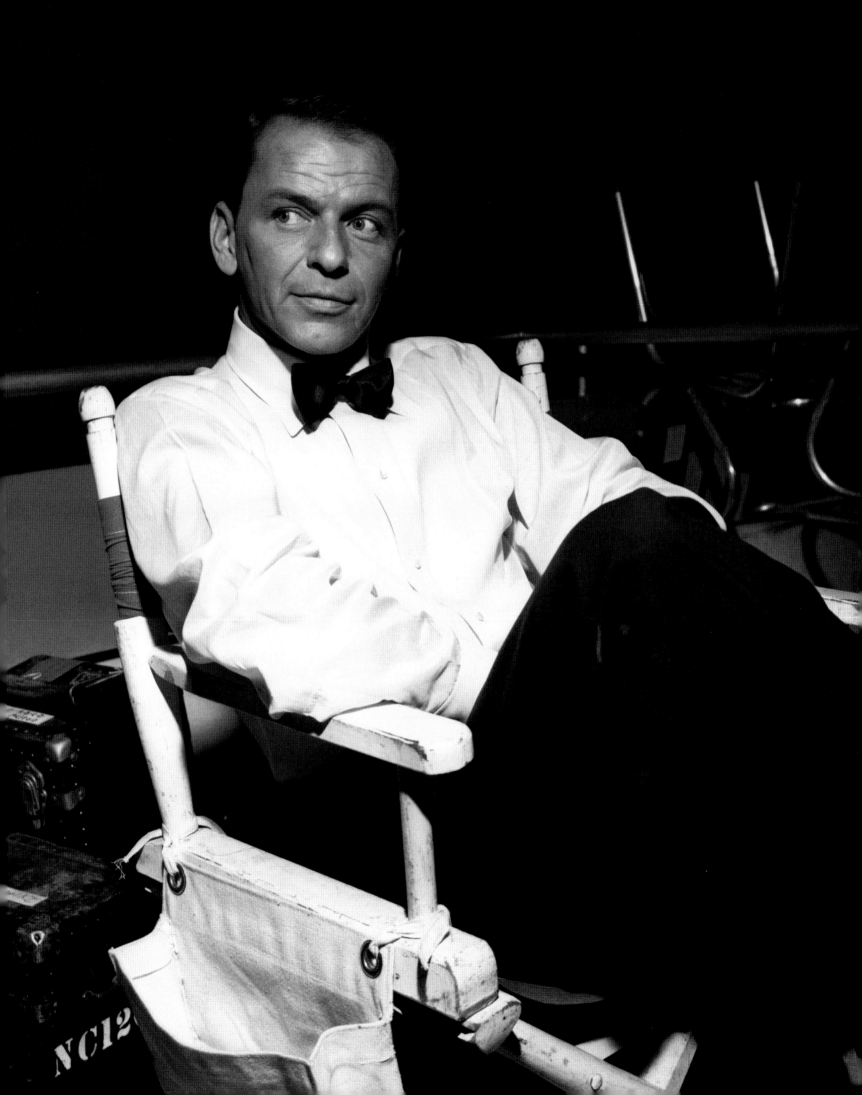

Sinatra's formidable costar in *Can-Can*, Shirley MacLaine, worked and played with the Rat Pack—the press dubbed her "Mascot"—and was one of the singer's better friends. She was an astute observer of his unsettling impact on the powerful men who surrounded him: "I loved to watch him in the presence of real gangsters, men who killed people when they wanted to. They might have felt they held the lives of others in their hands, but Frank *moved* the lives of others with his acting and singing. He employed the universal language of music to touch the hearts of killers and he knew it." Ironically, the journalist Pete Hamill, who knew both of them well, thought that perhaps Sinatra was "a little afraid of her."

Frank studies the script for *Can-Can* on the
20th Century Fox lot, 1959.
PHOTO BY BOB WILLOUGHBY

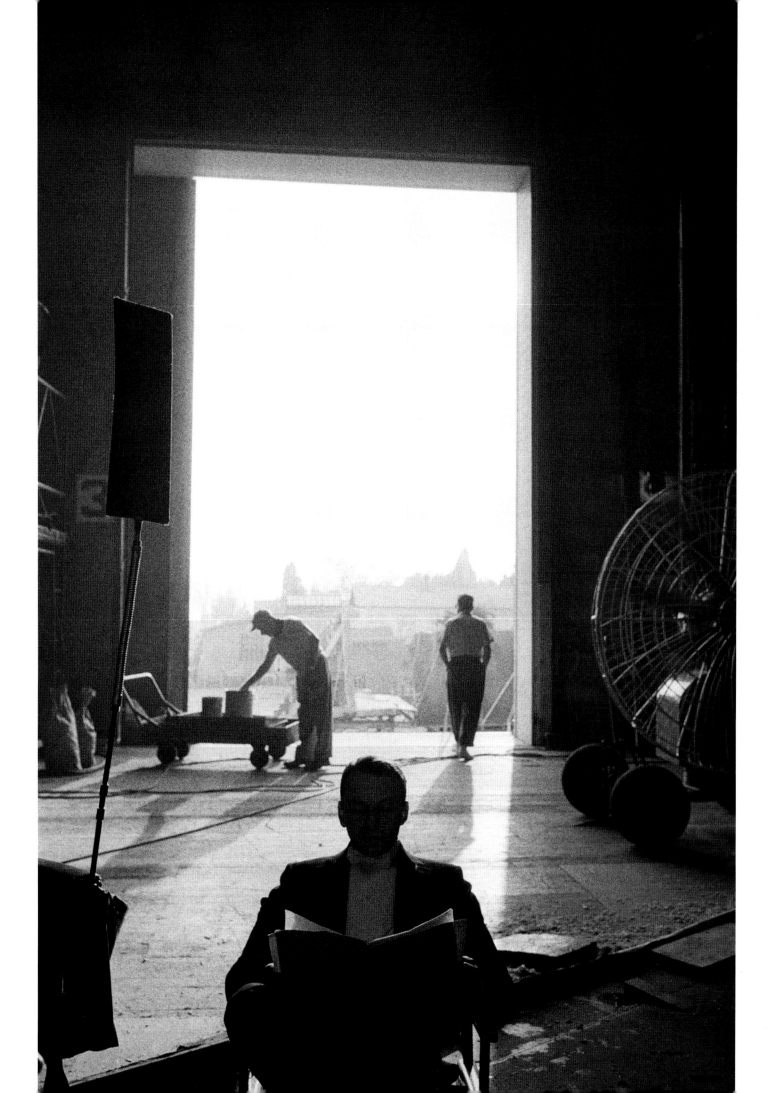

During a pre-recording session
for the 1960 film *Can-Can*,
Frank discovered a problem
with the music, and as Bob
Willoughby would recall, "That's
when the evening began to
fall apart." In this photo, producer
Jack Cummings has a heart-to-
heart with Frank; however, as
you can see, Frank isn't having it.
PHOTO BY BOB WILLOUGHBY

Nelson Riddle and Frank
attempt to resolve the dispute,
while Maurice Chevalier
sits back and stays out of it.
PHOTO BY BOB WILLOUGHBY

Maurice Chevalier in the
recording booth with Frank.
PHOTO BY BOB WILLOUGHBY

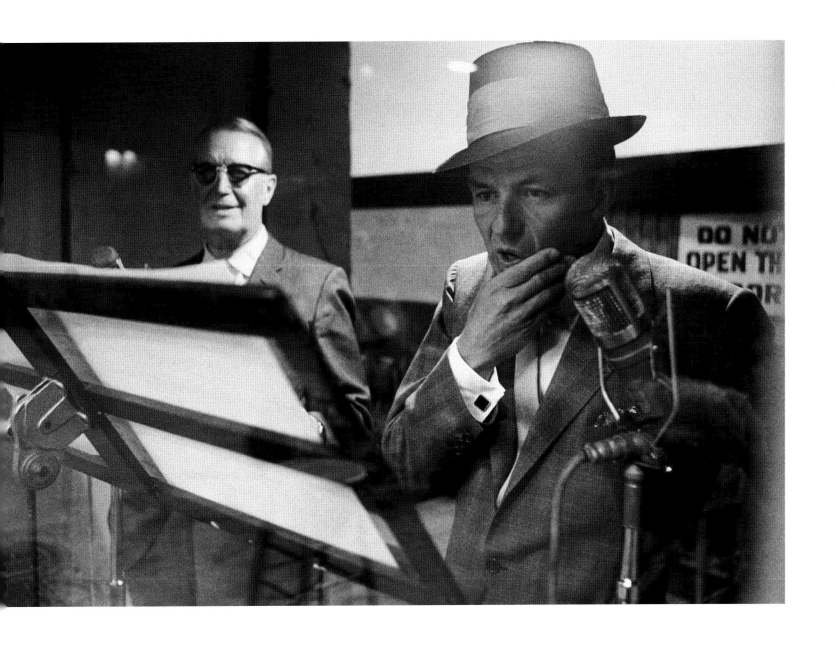

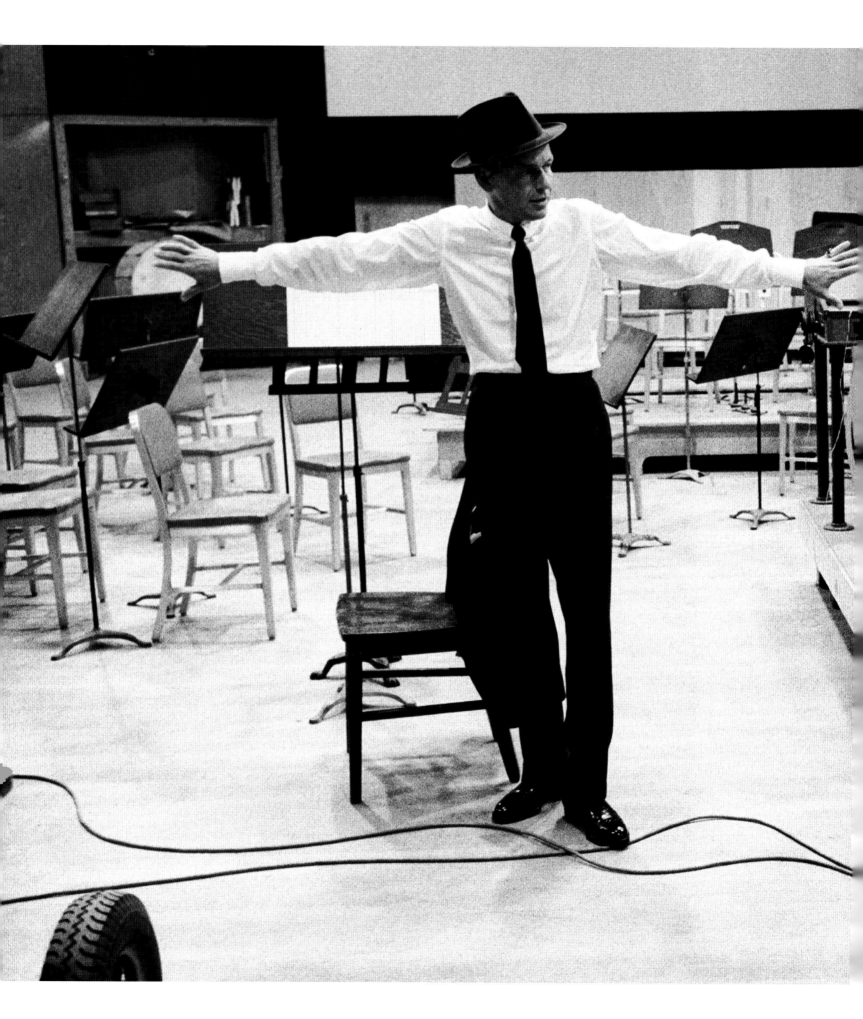

Frank Sinatra, Shirley MacLaine,
and Saul Chaplin after a
recording session for *Can-Can*.

Bing Crosby and Frank Sinatra were the Paul McCartney and John Lennon of the 1940s, and the two made the most of their contrasting appeal to fans in that decade. Crosby's widely quoted chestnut about Sinatra— "Frank is a singer who comes along once in a lifetime, but why did he have to come in my lifetime?"—is best viewed in the context of their mock feud. In a letter to the jazz scholar and drummer George Simon, Crosby wrote about his friend in a more serious vein: "After a meteoric beginning, he had every conceivable reversal and disappointment, socially, professionally, and privately. Very few people in our business can rally from something like this."

Bing Crosby visits Frank on the set of *Can-Can*.
PHOTO BY BOB WILLOUGHBY

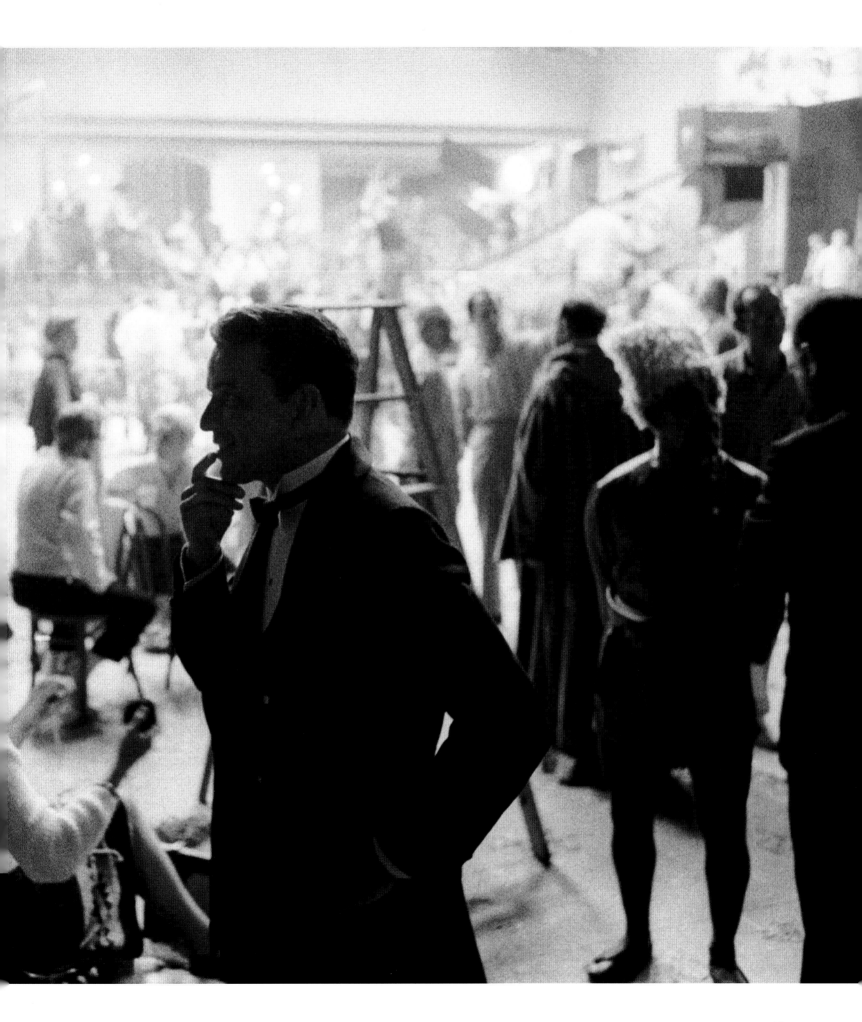

Boxers were the kings of the world Sinatra grew up in—his father was a prizefighter—and none was more regal than Rocky Marciano, the undefeated heavyweight champion of the world and, like the singer, the child of Italian immigrants. However, when journalist Pete Hamill told Sinatra a story of Marciano's that, "when he first knocked out a man in a gymnasium when he was a kid, it was like discovering he could sing opera," Sinatra instinctively countered by invoking a greater boxer still: "'Hey,' Sinatra said, 'when I first realized I could sing a song, I felt like I'd just knocked out Jack Dempsey.'"

Campione del mondo e bel canto:
Two heavyweight champs,
Rocky Marciano and Frank Sinatra,
enjoy a laugh on the elaborate
20th Century Fox set of *Can-Can*, 1959.
PHOTO BY BOB WILLOUGHBY

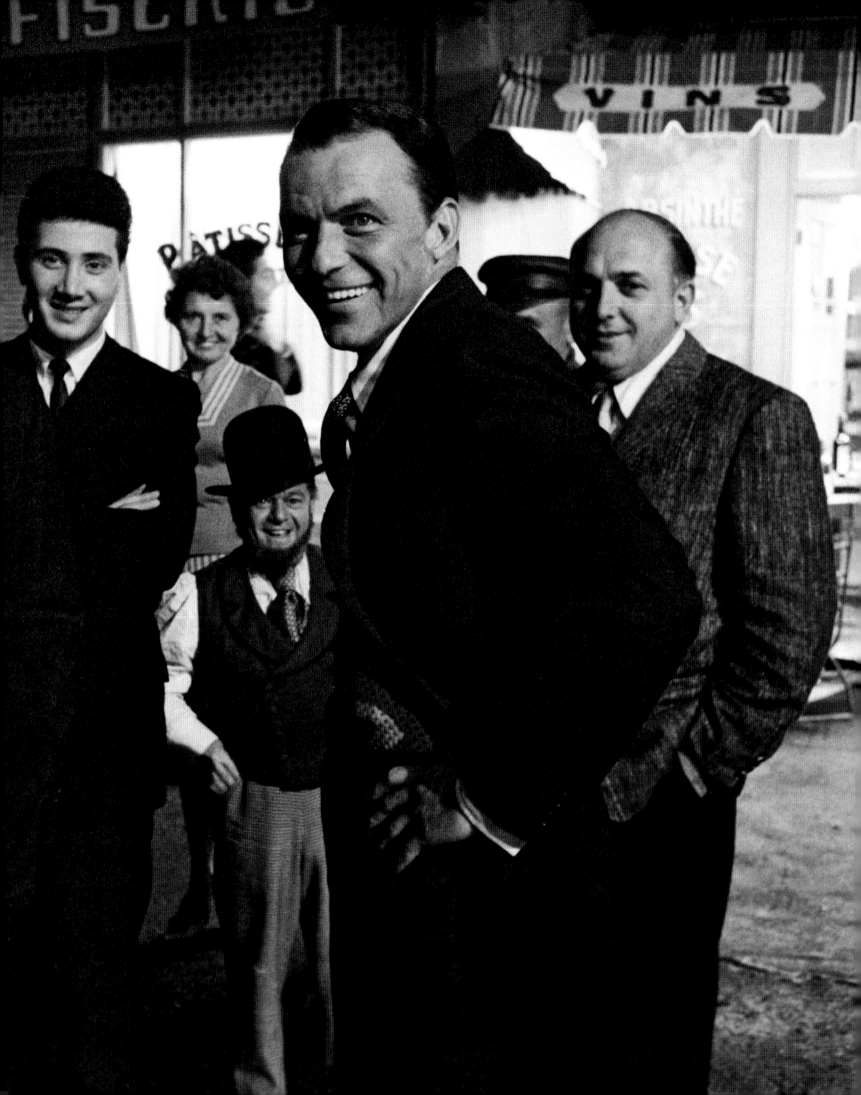

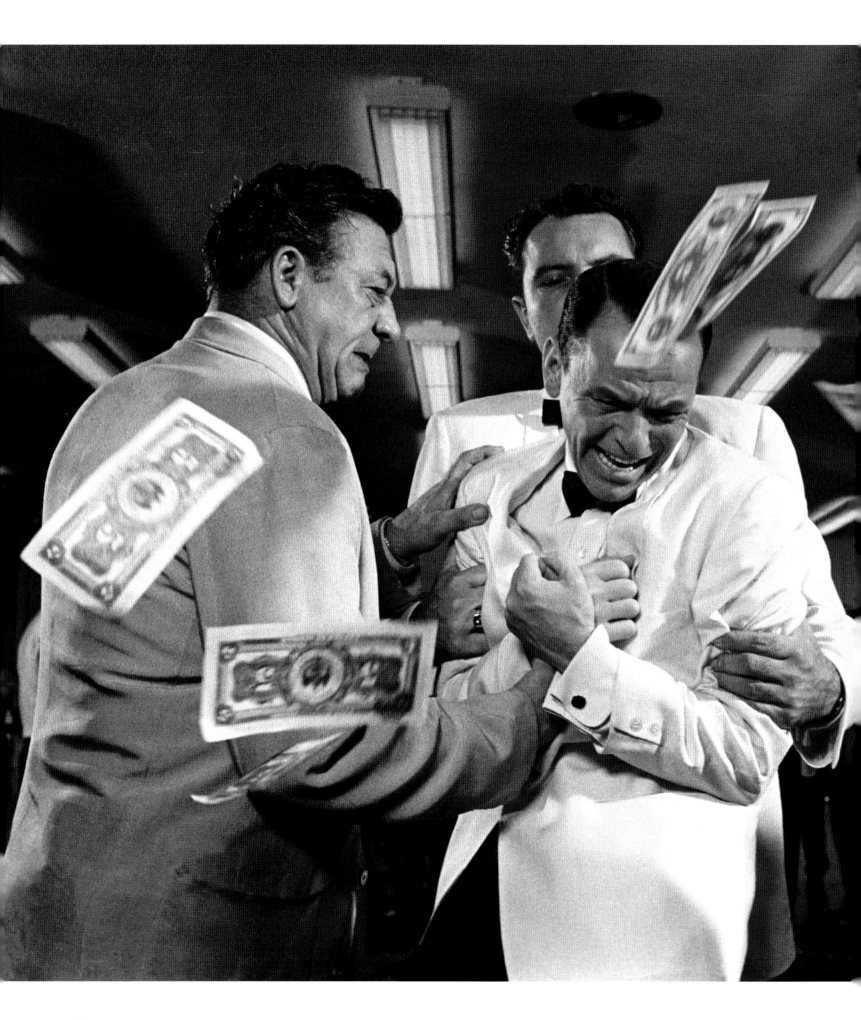

Sinatra's tendency to be involved in violent altercations was grist for many comedy routines. Comedian Don Rickles recalled, "Dolly [Sinatra's mother] was a very strong woman, and so was mine, and so when they got together I knew that good things could happen. My mother said, 'Please tell Frank to see my son,' down at this little nightclub I was working in, and she said, 'Absolutely!' And sure enough, a couple days later, he walked in with three of his friends, and I said, 'Hi Frank, be yourself, stand up and hit somebody.' And from that day on we became, somehow, great friends." Shecky Greene worked a Sinatra beating into his routine: "Frank Sinatra once saved my life. These guys were beating me up, and Frank said, 'Enough.'"

Frank takes a punch during the making of Frank Capra's *A Hole in the Head*, 1959.

Sinatra startled and delighted audiences by drinking on stage. His friend Tony Curtis said, "He's trying to demean his gift, he just wants to show you—like a juggler or a guy who works the tightrope, he goes up there with a drink in his hand and a cigarette butt—that he can still do it." But George Jacobs, his valet, who ought to have known, testified, "He only drank tea with honey the day before concerts, and the glass he carried on stage that everyone thought was his trademark Jack Daniel's was actually Lipton's." Whatever was in the glass, Sinatra was happy to extol the virtues of alcohol: "We feel sorry for people who don't drink because when you get up in the morning that's as good as you're gonna feel for the rest of the day."

An outtake from a 1959 Capitol Records shoot for the *No One Cares* album cover (a slight variation would make the cut for the final cover). Over Frank's right shoulder is Ed Thrasher, who would move from Capitol in 1964 to become the art director of Frank's newly formed Reprise label.
PHOTO BY SID AVERY

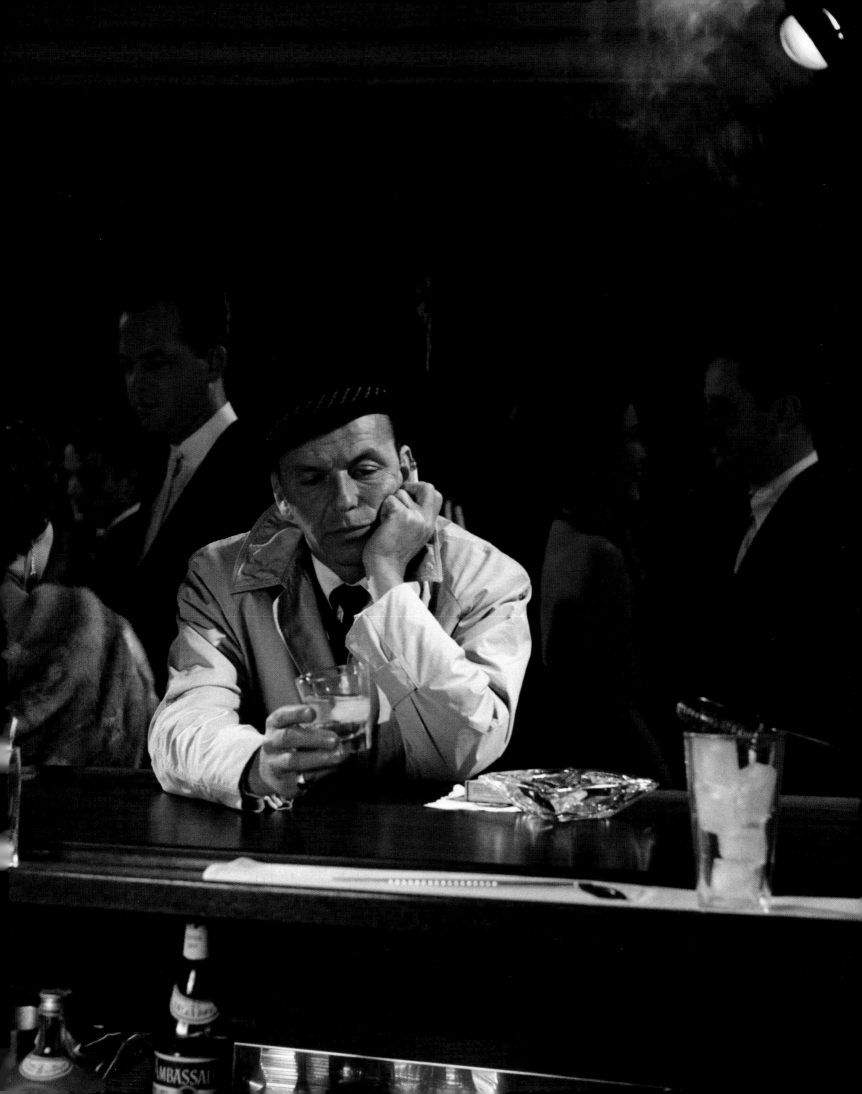

Ring-a-Ding Ding!

An association with a pack of talent, a man who would become president, and his own record company. A city in the desert named Las Vegas would be the setting for much of the high living, but it wouldn't stop there for the Chairman of the Board, who conquered the world, bringing the American songbook, and his inimitable vocal interpretations of it, to every corner of the globe.

2.

A Place in the Sun: Four men at their creative and physical peaks pose in front of the marquee that their pack would become synonymous with: the Sands Hotel, Las Vegas. Here they take a brief break from their breakneck schedule to allow photographer Bob Willoughby to click one off in 1960.

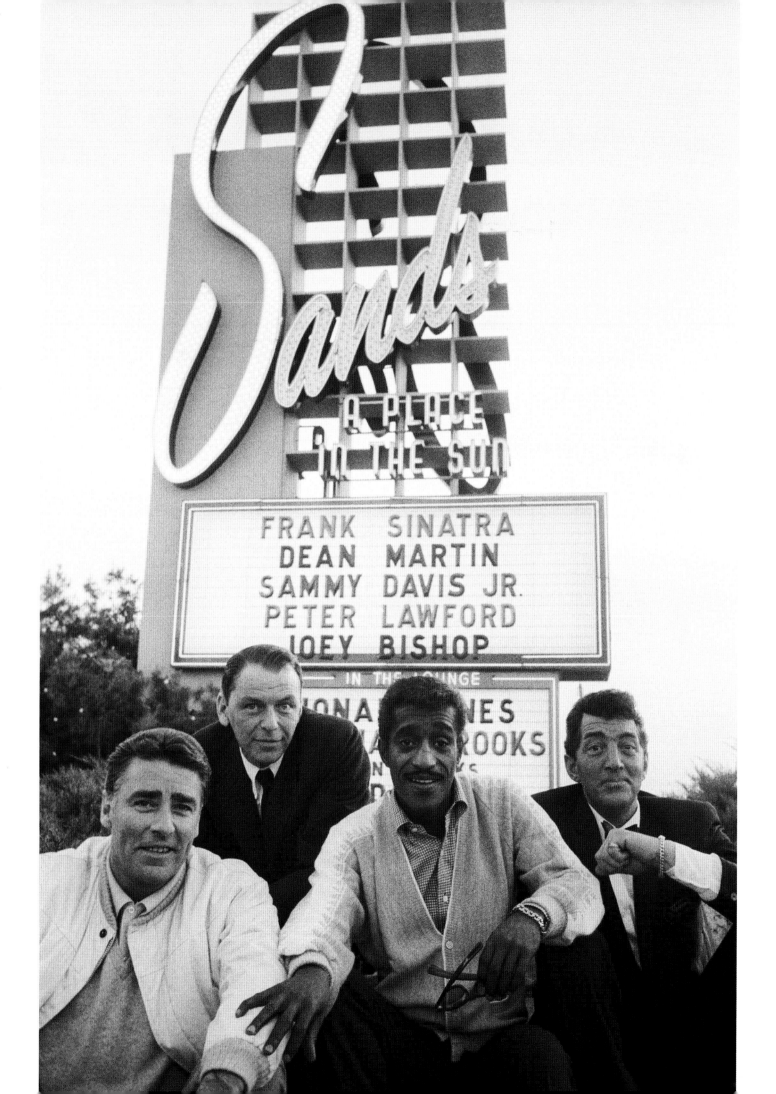

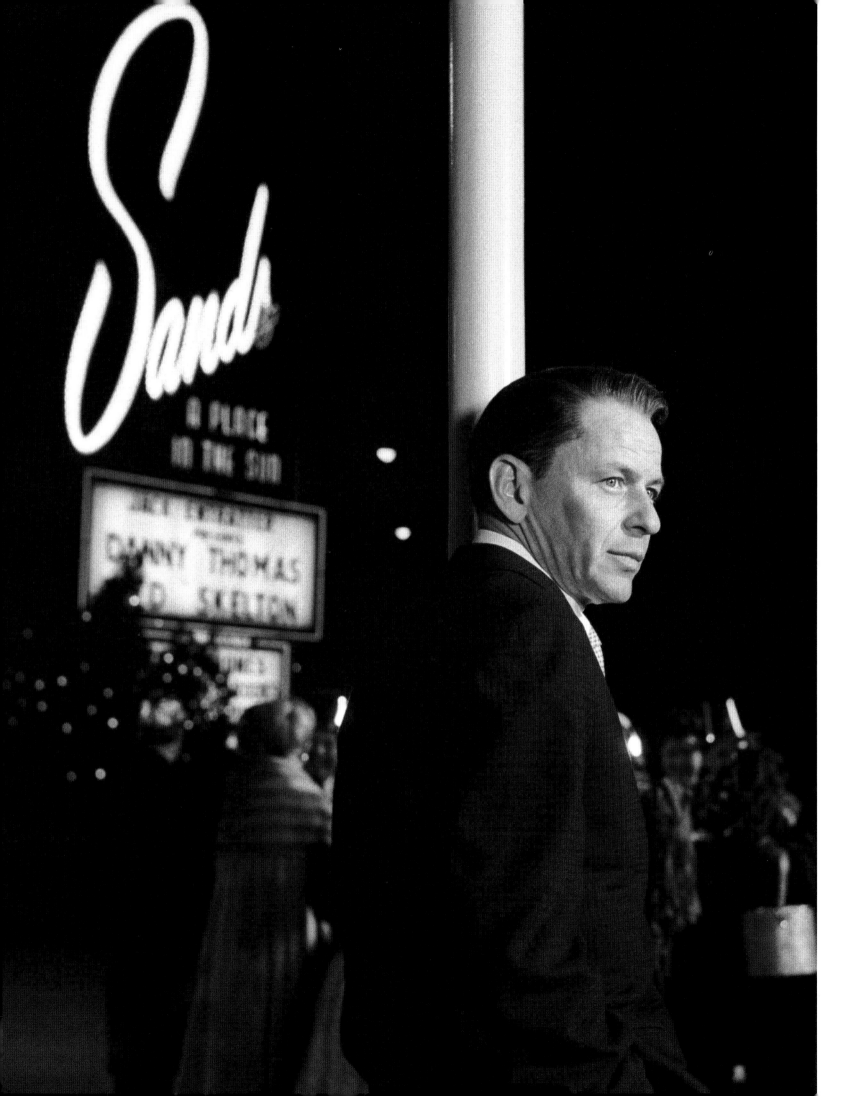

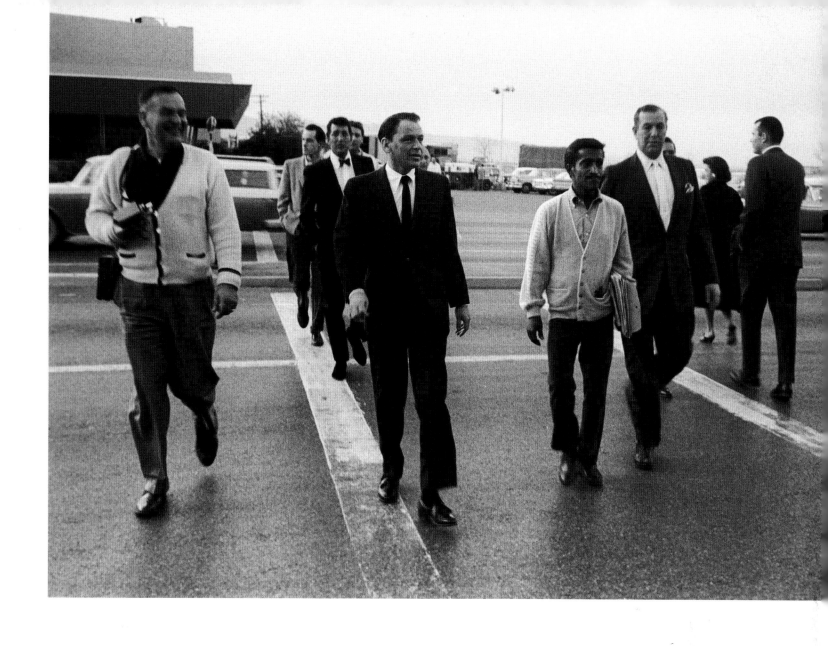

The house that Frank built, 1960.
PHOTO BY BOB WILLOUGHBY

Dean, Frank, Sammy, and Jack
Entratter, the entertainment director
of the Sands Hotel, in Las Vegas, 1960.
PHOTO BY BOB WILLOUGHBY

From the vantage point of 1960, it looked like Sinatra would own the new decade. The Rat Pack—Sammy Davis Jr., Dean Martin, Peter Lawford, and Joey Bishop—had coalesced around him, and the ballyhoo over the Eisenhower-Khrushchev Camp David meeting the previous September inspired Sinatra to plan a Summit meeting of his own in January. The venue: the Sands Hotel, Las Vegas. The rush was on. "We'd been in Vegas for a week," Davis reported, "and still people were pouring into town, arriving without hotel reservations, sleeping in lobbies, cars, anywhere, hoping to get rooms." Rat Pack chronicler Shawn Levy adroitly summoned the mood of the moment: "It was sauce and vinegar and eau de cologne and sour mash whiskey and gin and smoke and perfume and silk and neon and skinny lapels and tail fins and rockets to the sky."

The Rat Pack—Frank, Dean, Peter, Joey, and Sammy—cracking up while they pose for publicity shots during the making of *Ocean's Eleven*, 1960.
PHOTO BY SID AVERY

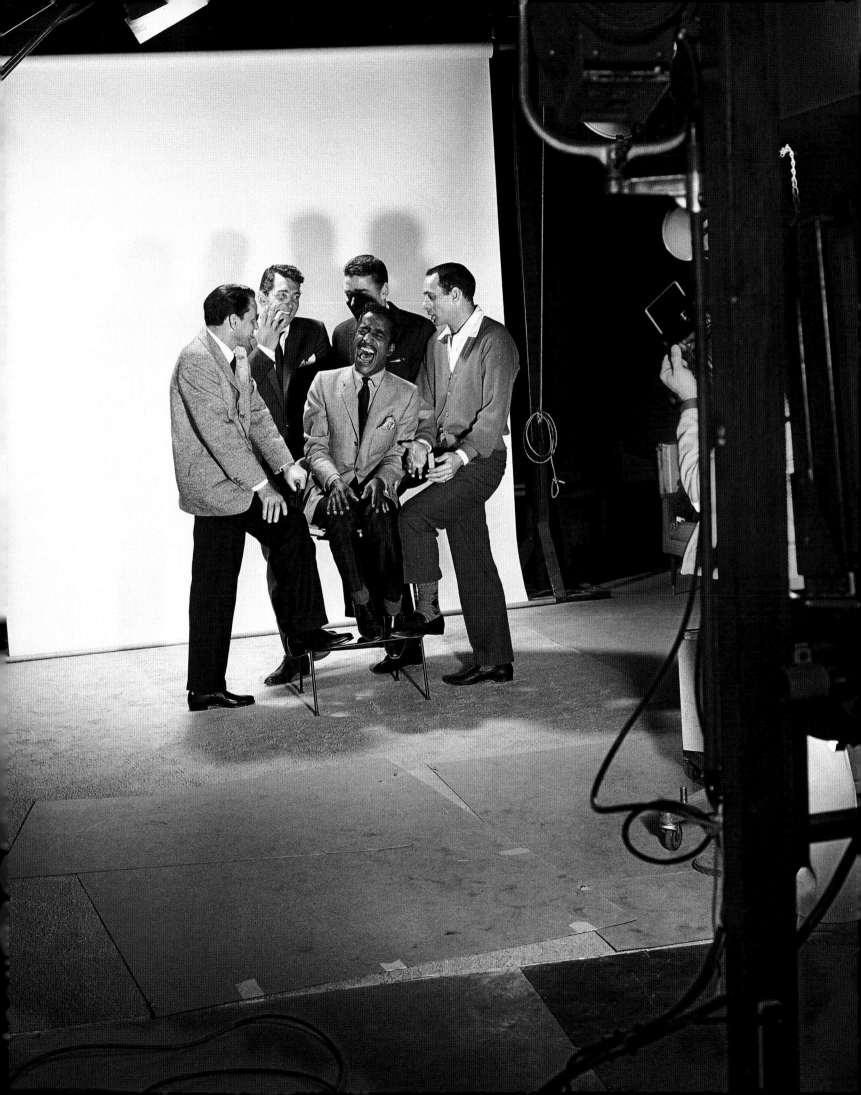

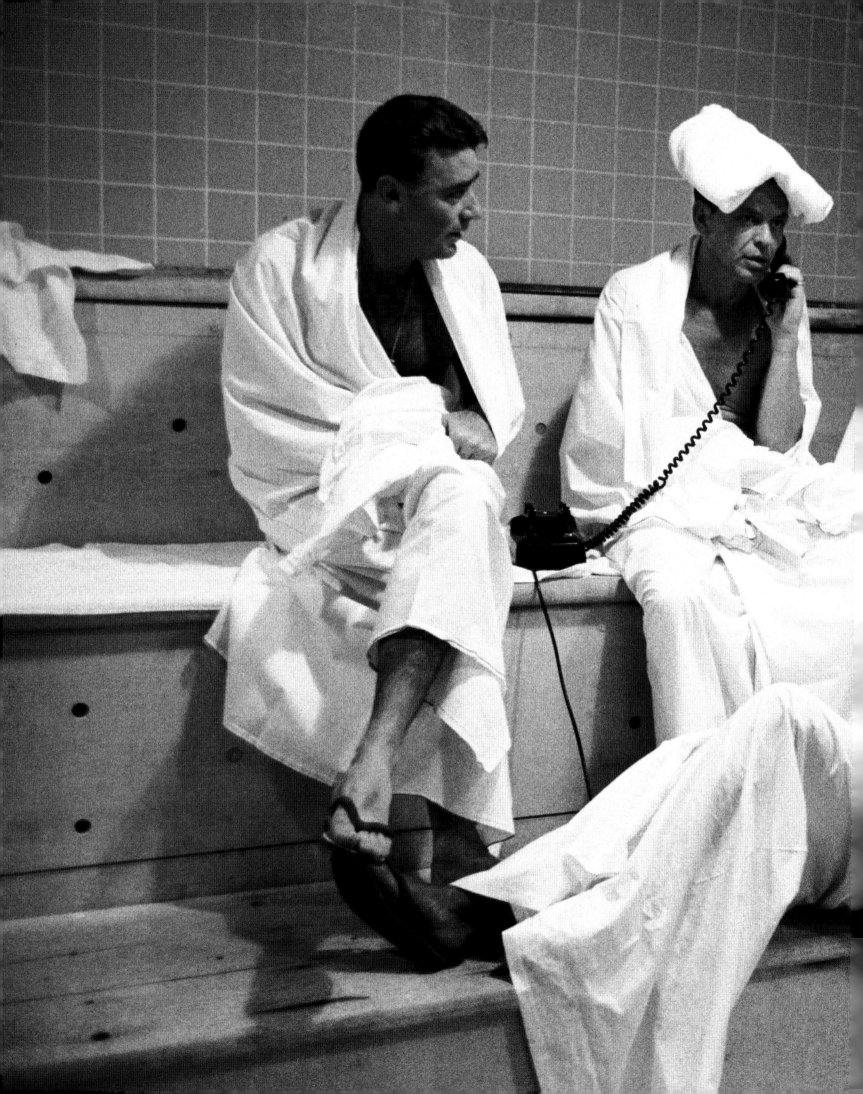

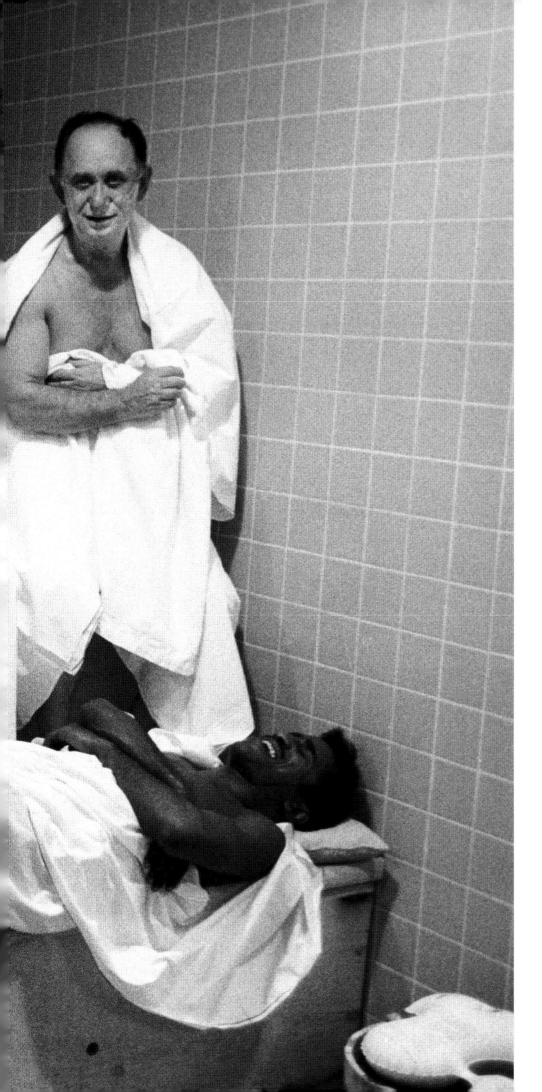

Frank talks on the phone in the steam room he had built for the Sands Hotel, as his banker, Al Hart, and *Ocean's Eleven* costars Peter Lawford and Sammy Davis Jr. sweat out the 100-proof desert air toxins. Photographer Bob Willoughby captured this daily ritual of Frank's while on a 1960 assignment in Las Vegas.

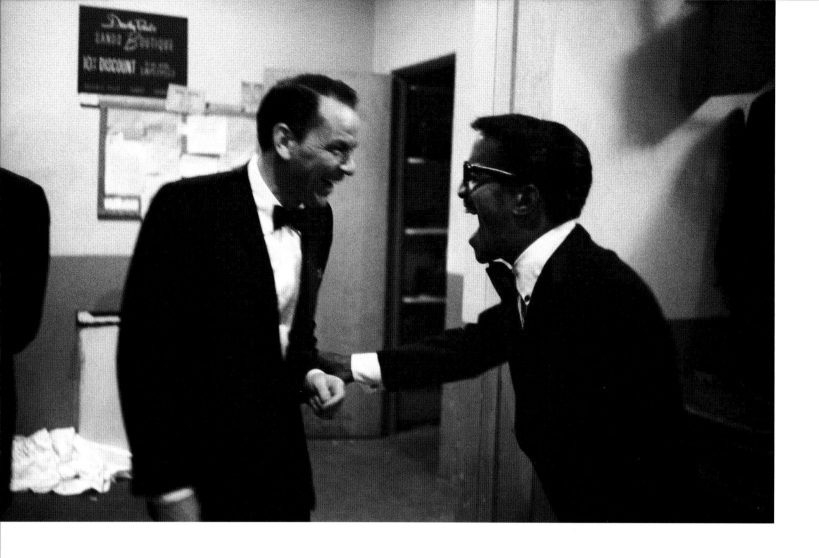

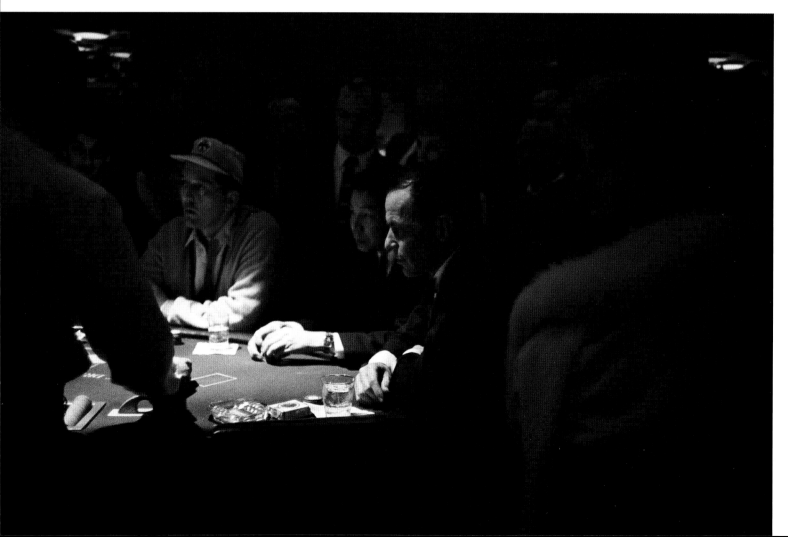

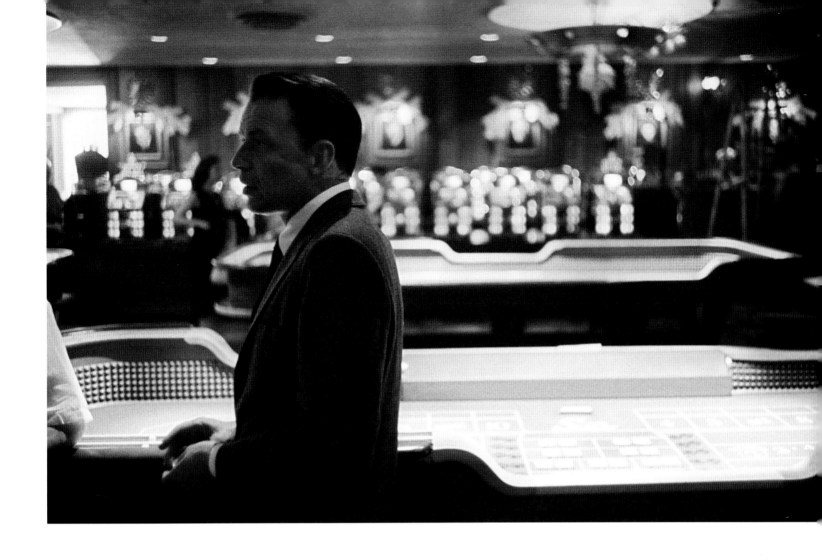

Frank and Sammy having a bit of fun backstage
of the Copa Room at the Sands Hotel, 1960.
PHOTO BY BOB WILLOUGHBY

It's 3 AM. The Sands Hotel. Frank plays a little
blackjack after the last show, 1960.
PHOTO BY BOB WILLOUGHBY

Sinatra at the Sands, shooting *Ocean's Eleven*, 1960.
PHOTO BY BOB WILLOUGHBY

OVERLEAF

As the Sands chorus girls finish up their rehearsal in
the Copa Room, Frank takes some time in the early
afternoon of February 15, 1960, to run through
some material he will use in an upcoming television
special with Lena Horne.
PHOTO BY BOB WILLOUGHBY

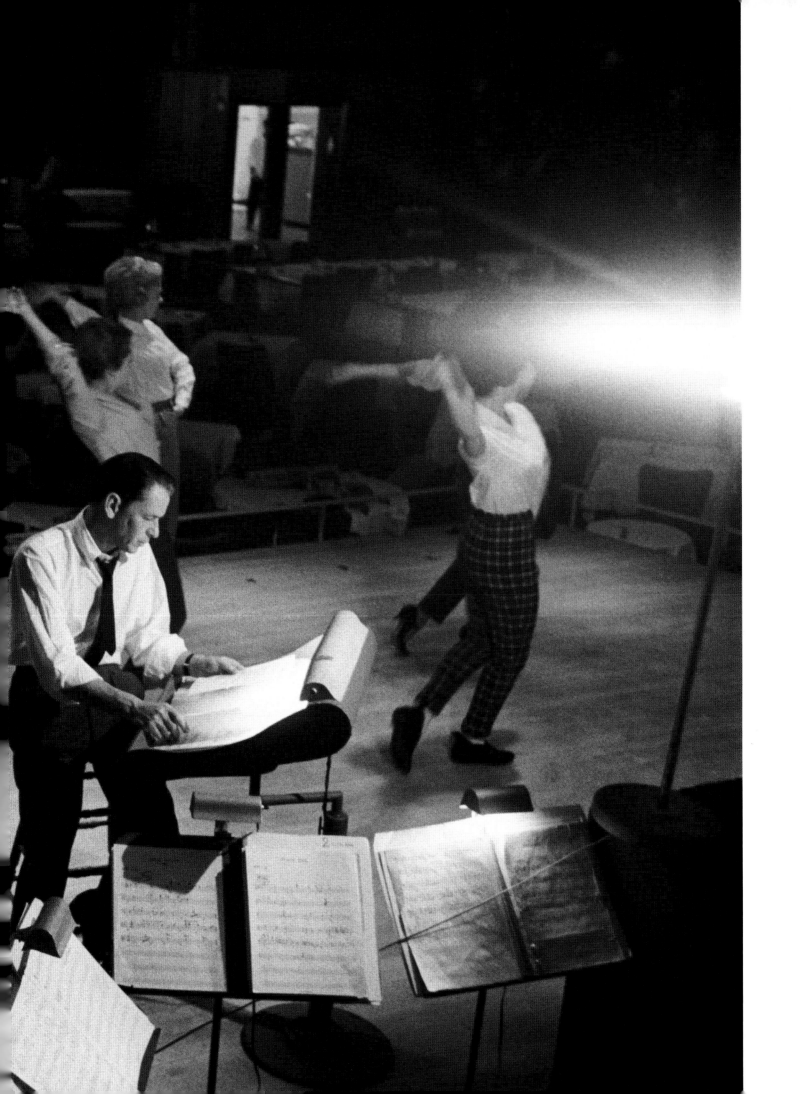

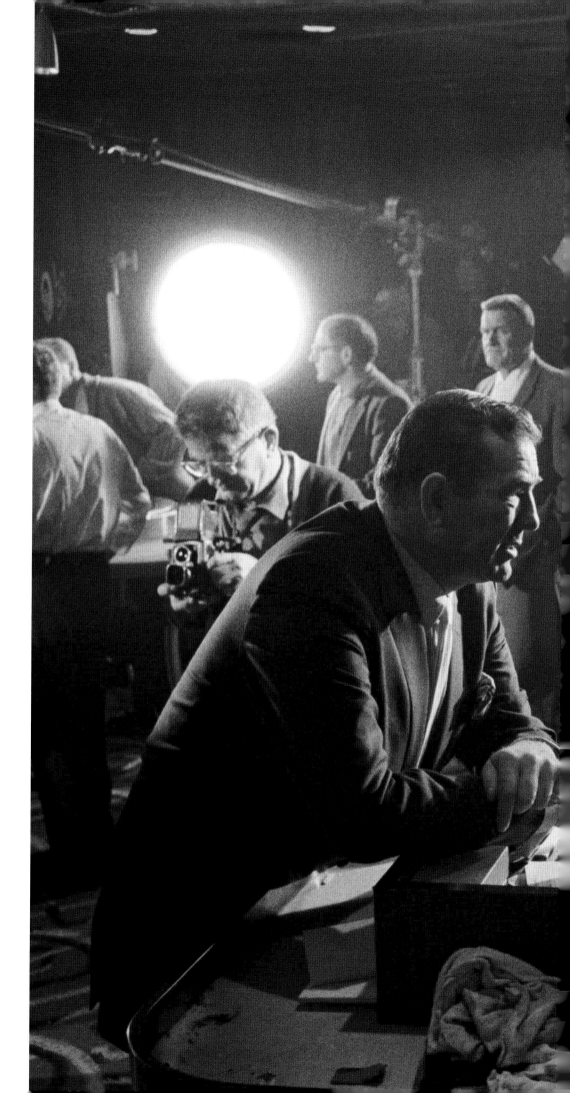

Jack Entratter and Frank discuss business while waiting for the setup at the Sans Souci Hotel, across the street from the Sands, where the film *Pepe* was being made (Frank had a guest cameo appearance in the film), 1960.

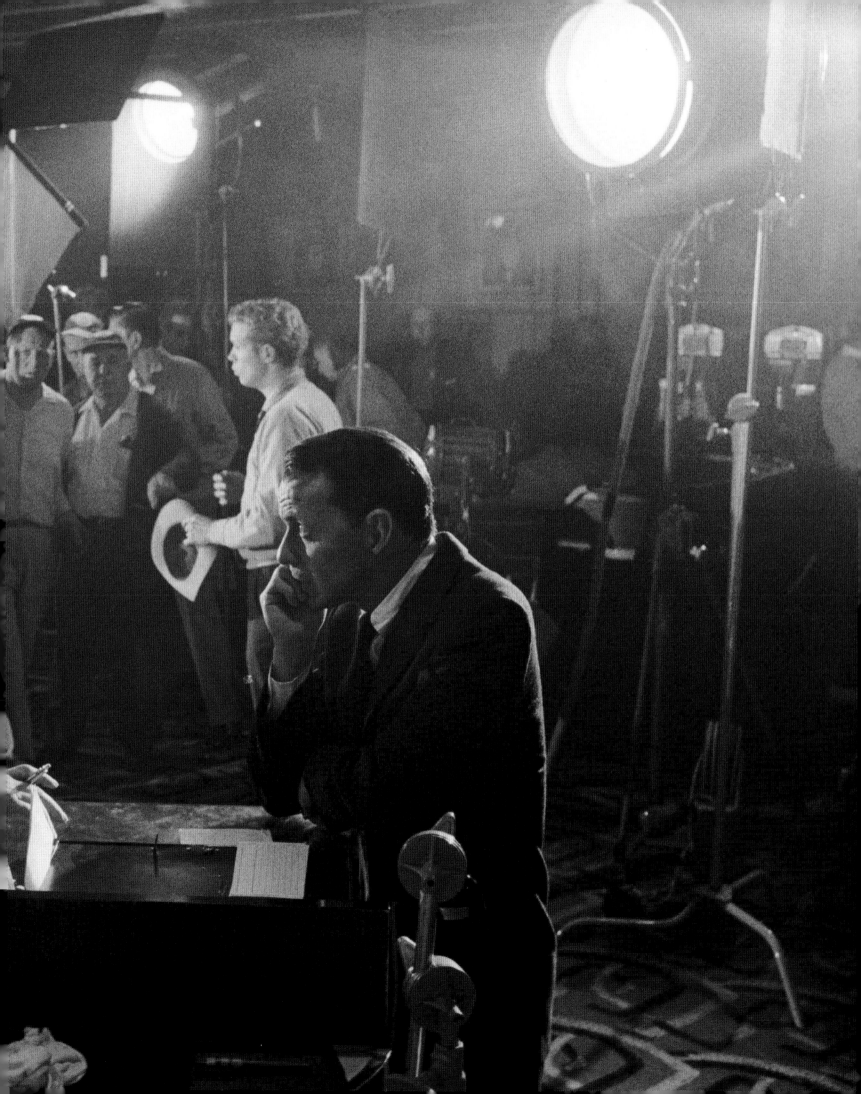

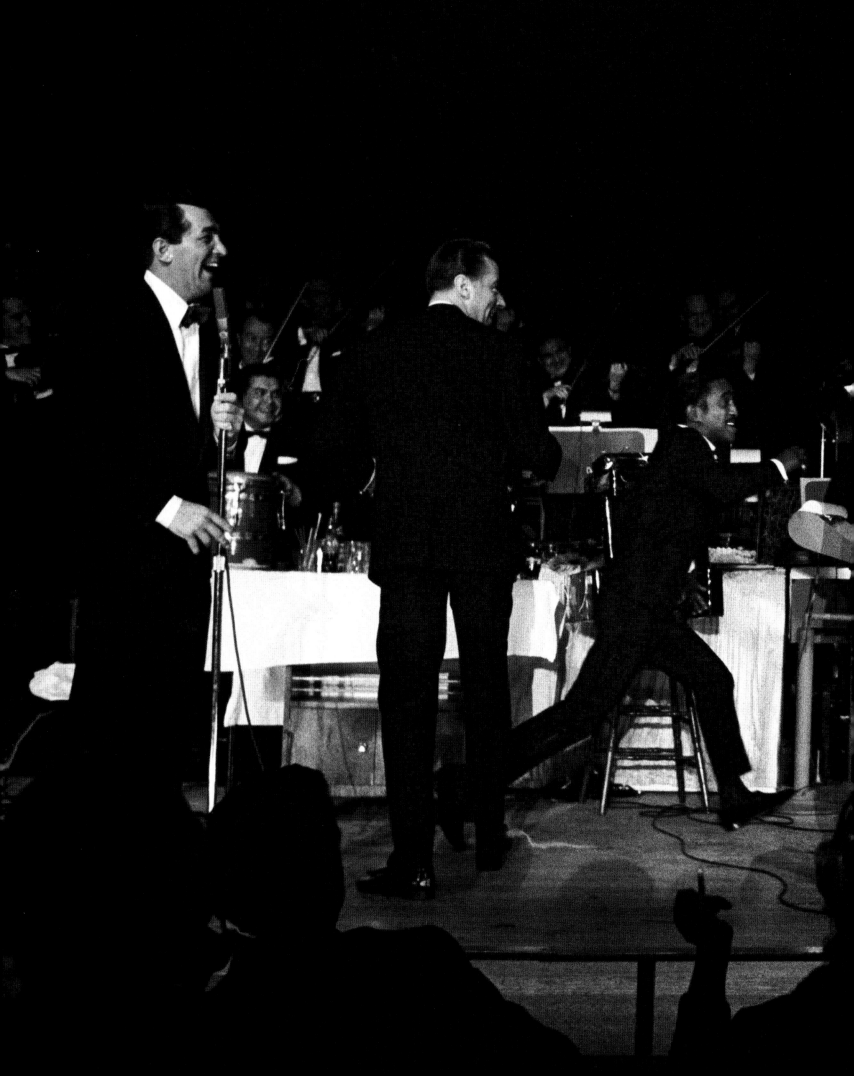

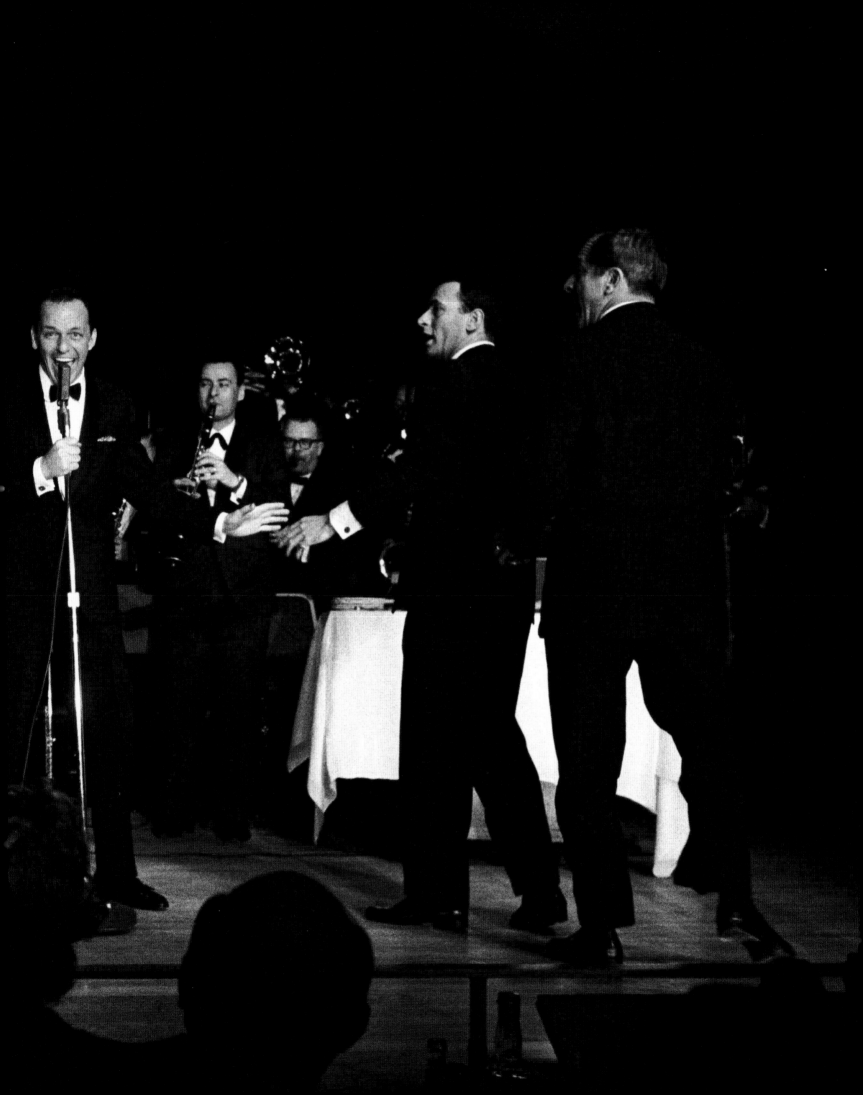

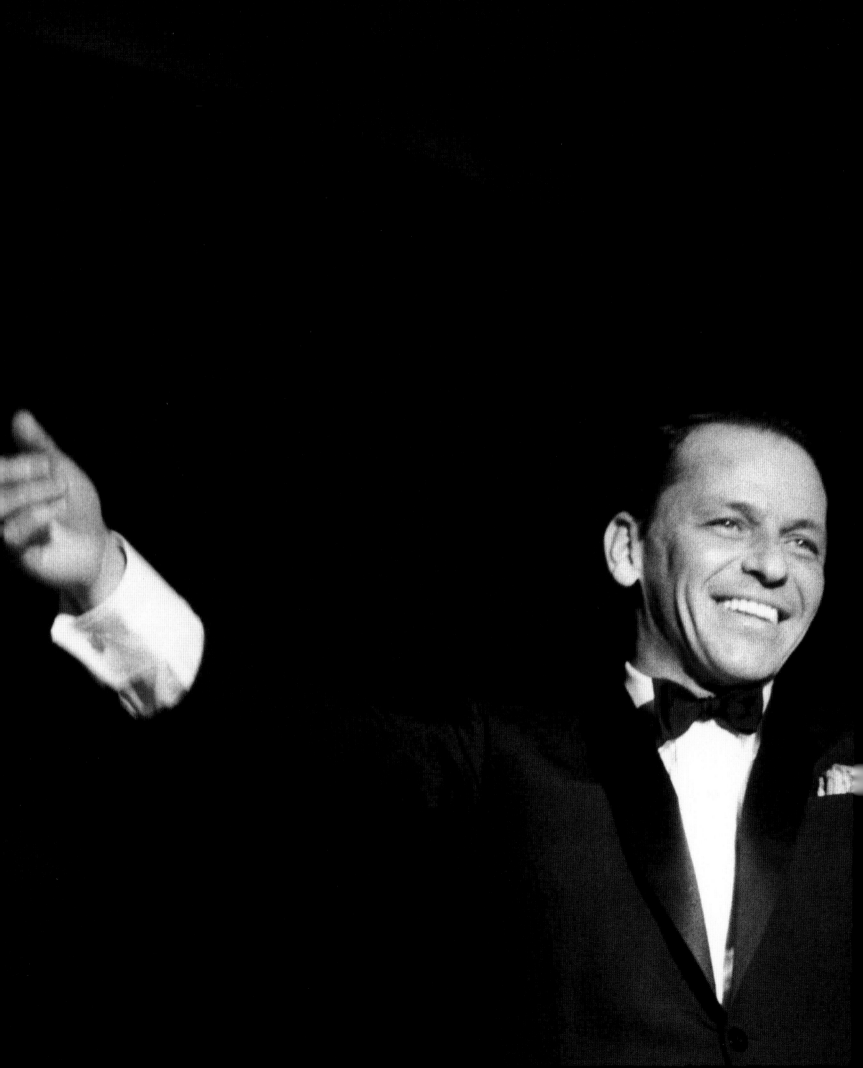

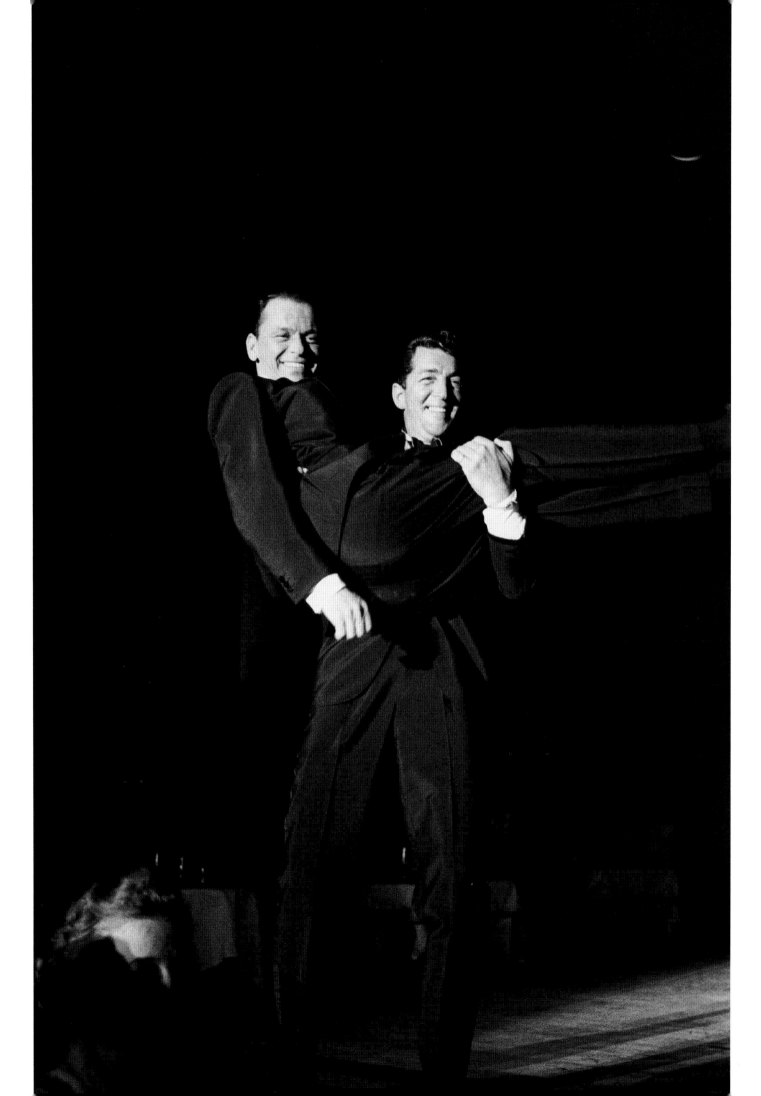

Describing the "Summit" performances, photographer Bob Willoughby wrote, "It was the greatest accumulation of talent *in one show* that Las Vegas has ever seen. Each person in turn would come on singly, introduced by Joey Bishop, and then off stage, with mikes turned on so the audience could hear the dialogue, they would heckle the one singing or trying to perform, and each night they would bring in new material and try to break the person up on stage. . . . They would figure out sight gags, and often everyone would be on the stage at once." Dean Martin's daughter, Deana, recalled the chemistry: "To watch them together on stage. It's almost like they each knew what the other was thinking. They were very in tune, and they were just sharp, and for me, in the sixties, at the top of their game."

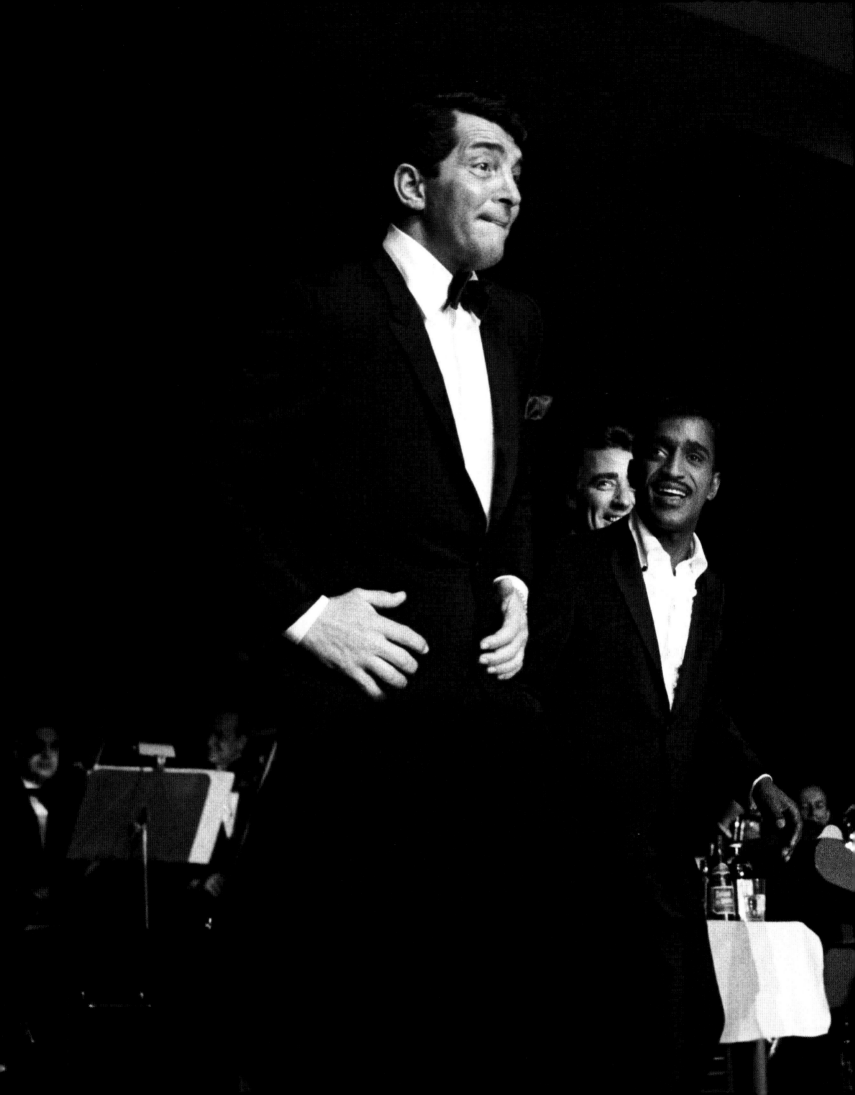

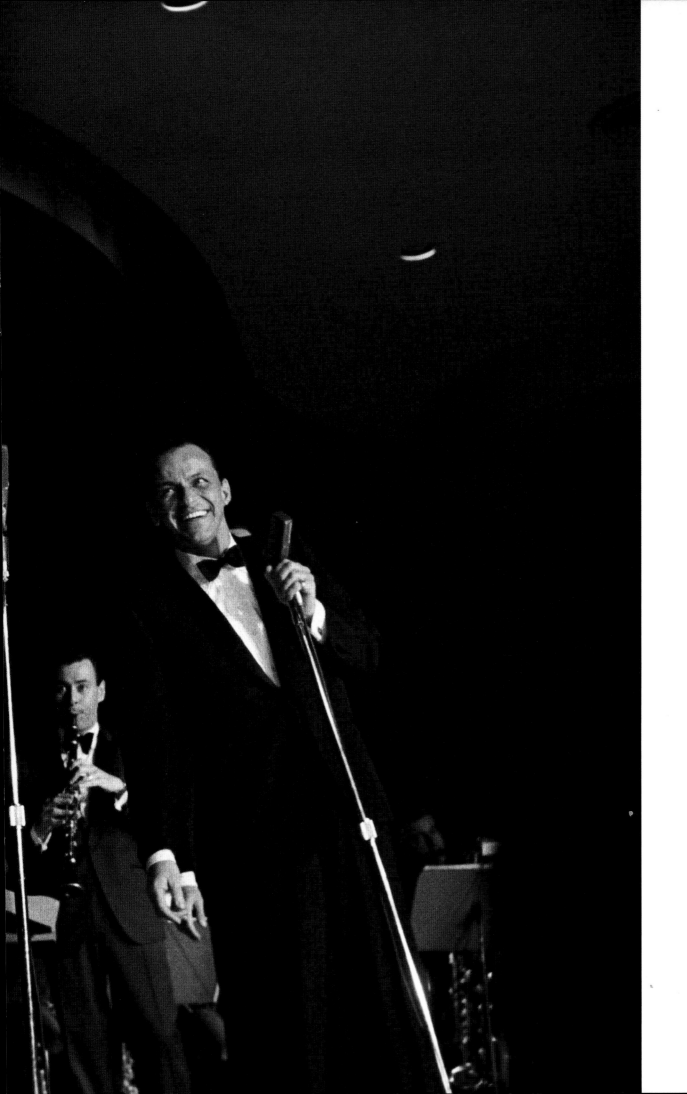

Dean, Peter, Sammy,
and Frank.
PHOTO BY BOB WILLOUGHBY

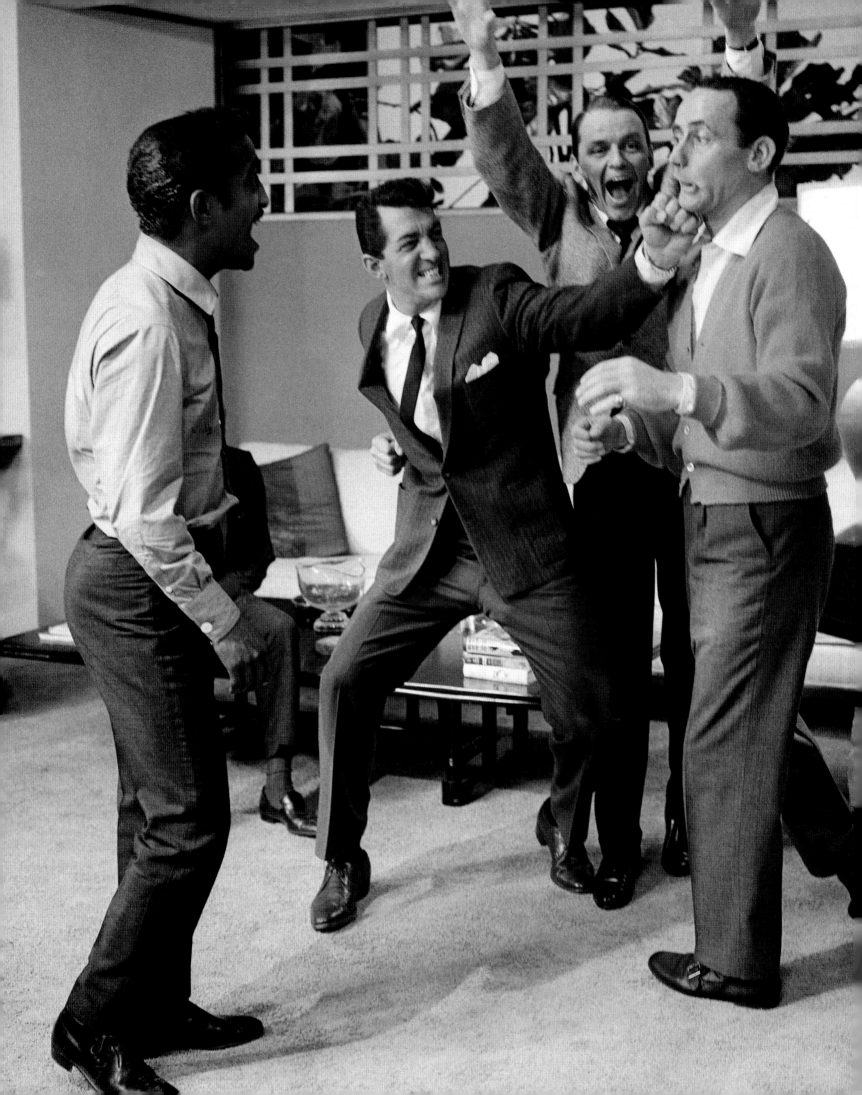

Three memorable epithets attached themselves to Sinatra over his career: The Voice, Chairman of the Board, and Ol' Blue Eyes. The first and last were launched by Sinatra's people, but Chairman of the Board was the 1950s coinage of New York disc jockey William B. Williams, who thought about the royal court of jazz, with its Duke (Ellington) and its Count (Basie), and cannily came up with a title for Sinatra that resonated in a decade that revered executives as heroes. Williams later recalled, "I was at the bar at Danny's Hideaway and there was a gal there who was somewhat drunk and she recognized my voice and said to me, 'I love what you call Sinatra—you know, he really is the Chairman of the *Broads*!'"

Sammy, Dean, Frank, and Joey stage a fight on the Warner Brothers set of *Ocean's Eleven* in 1960. Photographer Sid Avery, on assignment for the *Saturday Evening Post*, would recall the shoot years later: "I watched them doing all their hokey stuff. They go crazy. They're like a fraternity group."

NEXT SPREAD

Frank allowed Sid Avery to fire off only two exposures before he yelled, "That's a wrap!" on the Warner Brothers set of *Ocean's Eleven* in 1960. From left to right: Richard Conte, Buddy Lester, Joey Bishop, Sammy Davis Jr., Frank Sinatra, Dean Martin, Peter Lawford, Akim Tamiroff, Richard Benedict, Henry Silva, Norman Fell, and Clem Harvey.

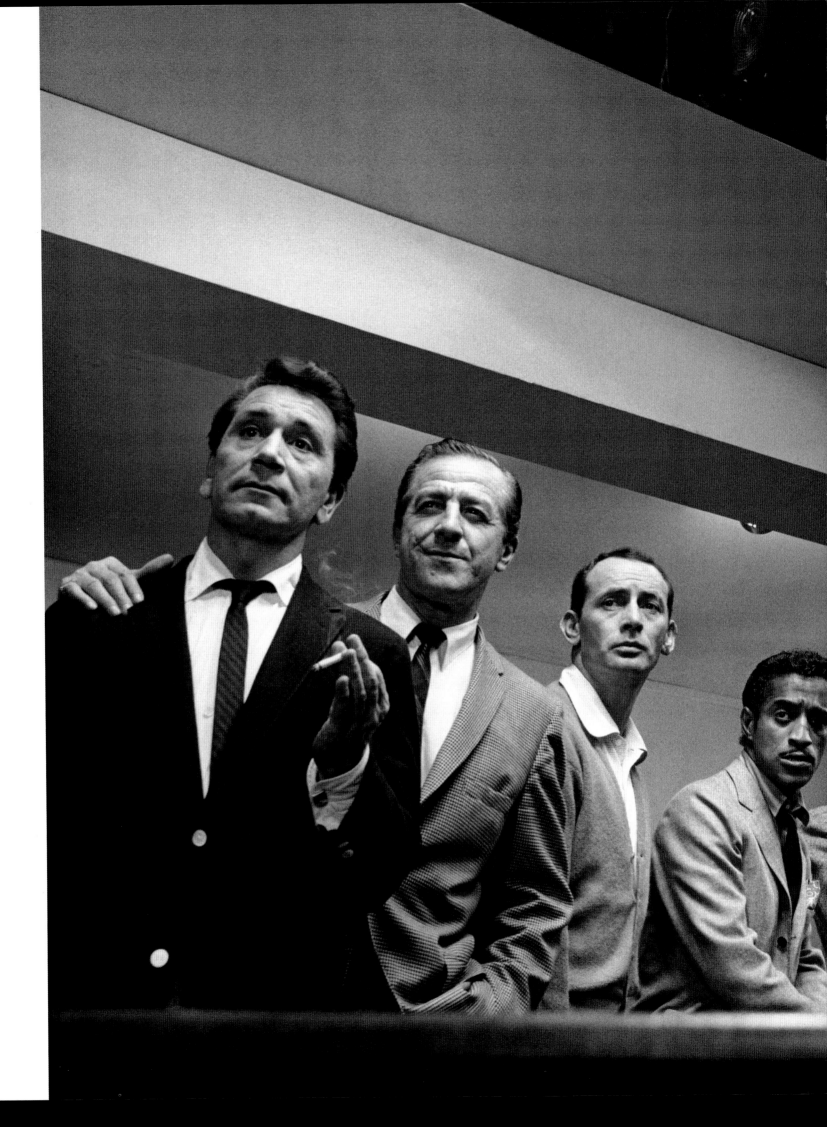

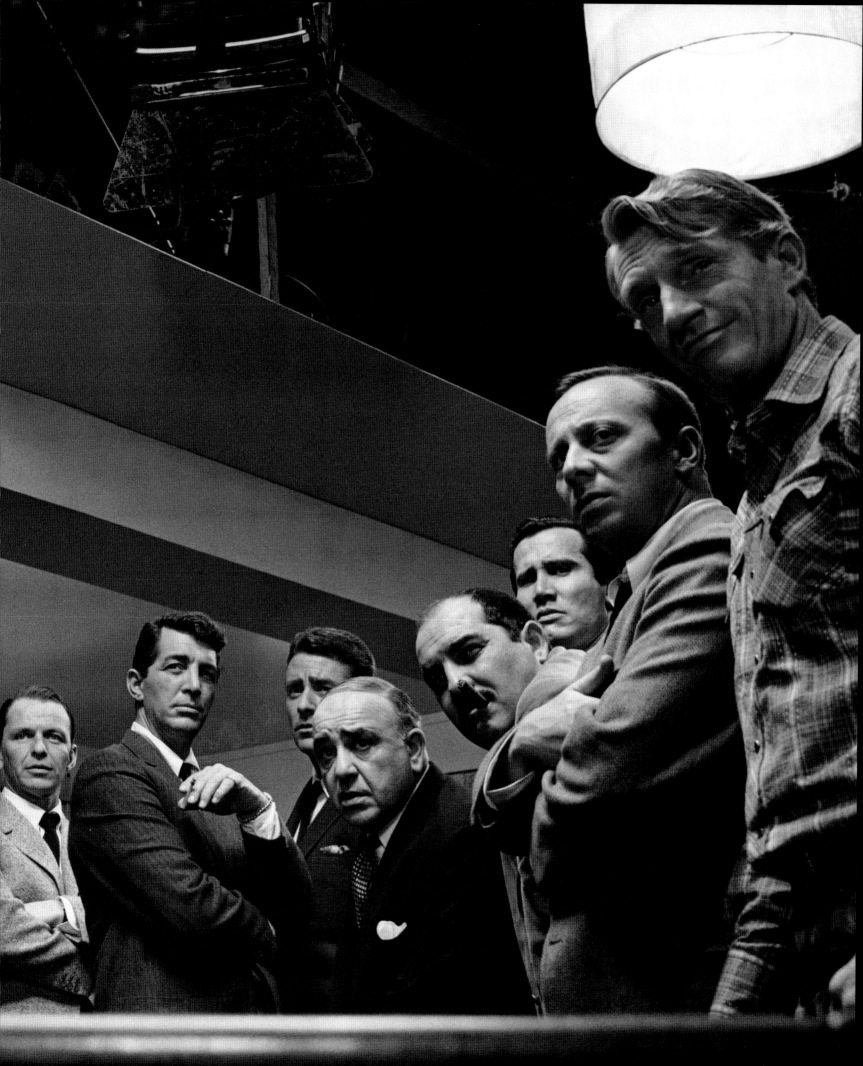

Sinatra's photographers had fun. Bernie Abramson recalled, "I took my photography seriously but not to a point where I got ulcers from it. If you get too serious, you can't capture the images as they really are."

Frank points at photographer Bernie Abramson as he and some friends look at Polaroids they had just shot. The friends include Peter Lawford, Patricia Kennedy Lawford, Marilyn Monroe, and May Britt (Sammy Davis Jr.'s wife). Over Mrs. Lawford's right shoulder is Frank's longtime valet, George Jacobs. c. 1960.

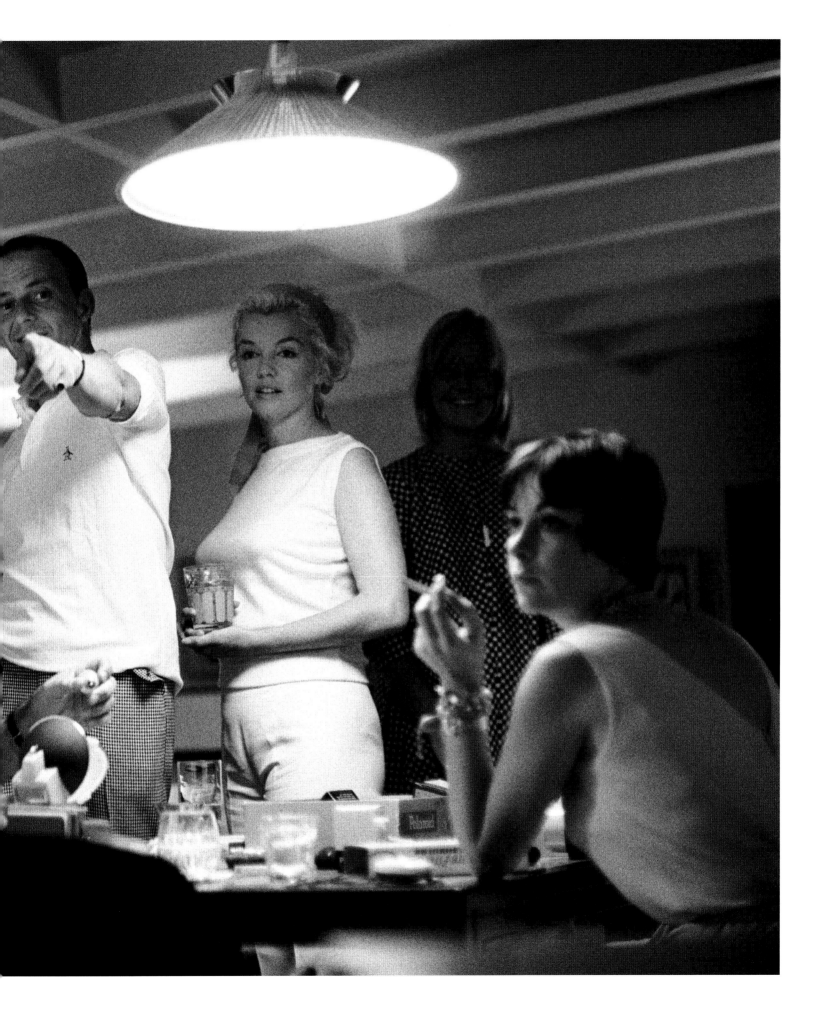

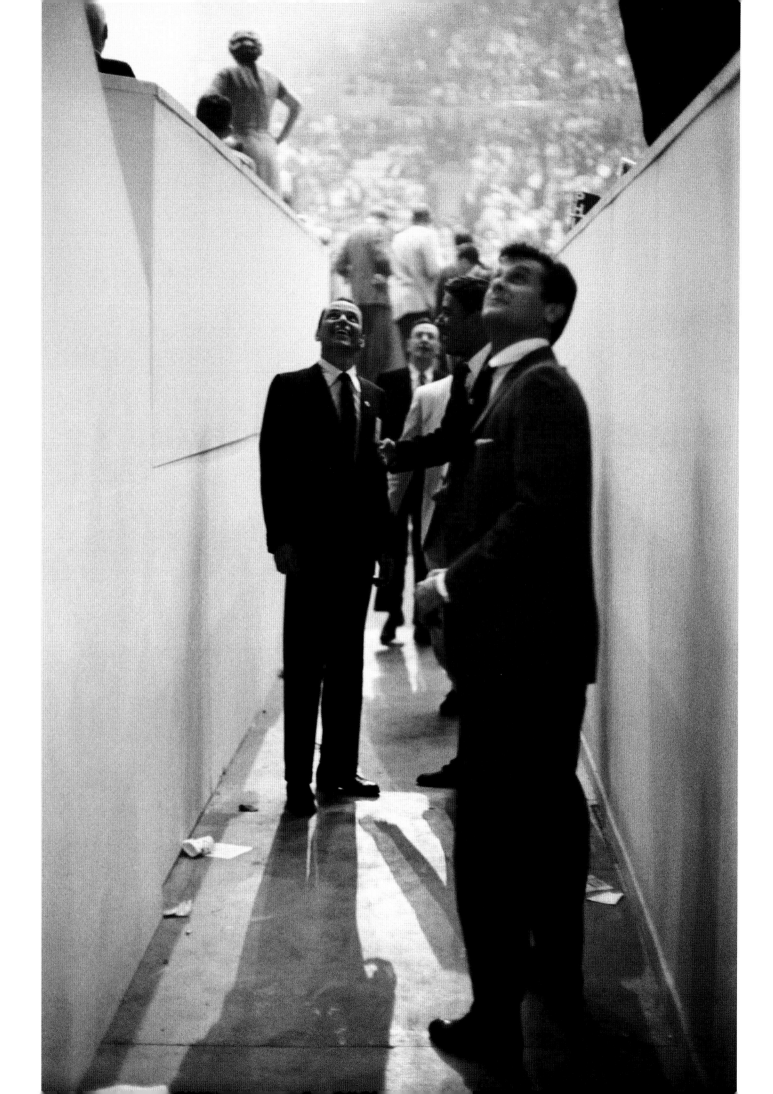

Along with most of Hollywood, Sinatra caught Kennedy fever. As his friend, singer Pat Suzuki, who was married to photographer Mark Shaw at the time, enthused, "It was a new frontier, for God's sake!" *New York Times* reporter Murray Schumach captured the scene at a Democratic fundraiser in September 1960 at the home of actress Janet Leigh, where Sinatra upstaged the candidate's brother Teddy: "He made no speeches. He merely sang three songs. While he sang, women who had sat quietly in the sun till then, began yelling 'Down in front.' When he finished, the women clamored for more songs." Sinatra shared his campaign strategy with Schumach—"just entertain."

Sinatra with Peter Lawford and Tony Curtis at the 1960 Democratic National Convention, being held at the Los Angeles Memorial Sports Arena.
PHOTO BY BERNIE ABRAMSON

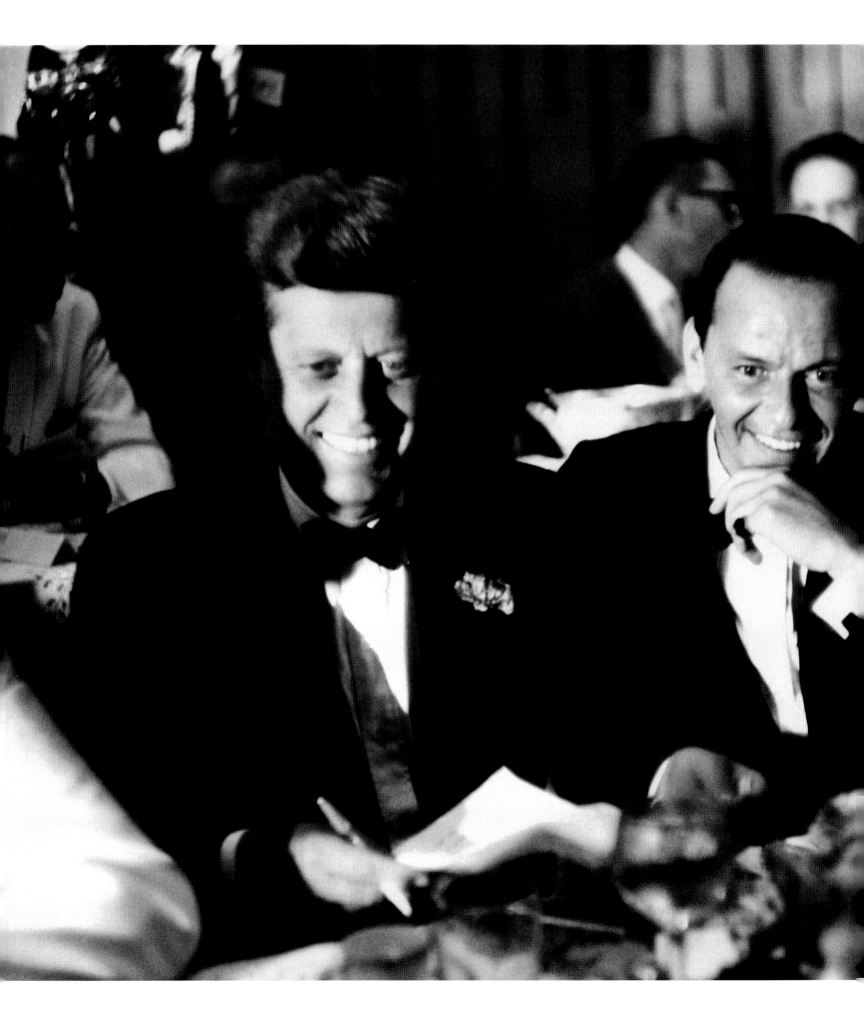

Sinatra coaxed so many entertainers to perform in Kennedy's inaugural gala on January 19, 1961, that Broadway went dark for a night. The president-elect expressed his gratitude at the event, but he proved to be a poor prognosticator: "I know we're all indebted to a great friend—Frank Sinatra. But, long before he could sing, he used to poll a Democratic precinct back in New Jersey. That precinct has grown to cover a country. But, long after he has ceased to sing, he's going to be standing up and speaking for the Democratic Party." In reality, long before he ceased to sing, Sinatra switched his political allegiance to the Republican Party.

Here the men of the hour, year, and century, John F. and Francis A., share a contagious smile at a dinner in Los Angeles on July 10, 1960, the eve of the Democratic National Convention.

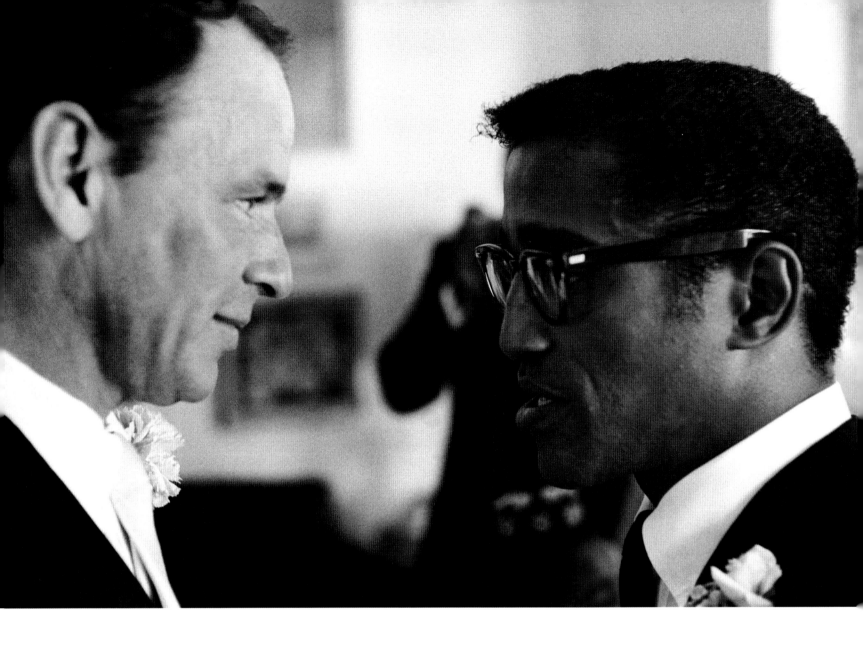

Two phenomenal entertainers share a quiet
moment at the Hollywood home of Sammy
Davis Jr. On this 13th day of November in 1960,
however, these show business giants play the
role of best friends: Frank as best man to
Sam, the groom, on his wedding day to May
Britt. The timing of Davis's wedding to a white
woman, originally scheduled for before the
presidential election, had been the subject of
much debate between the campaign and the
Davis-Sinatra camp. Finally, Davis reported
in his autobiography, he called Sinatra to tell
him that he had decided to postpone it, and
Sinatra said, "I'll be there for you whenever it
is. . . . You're a better man than I am, Charley."
PHOTO BY BERNIE ABRAMSON

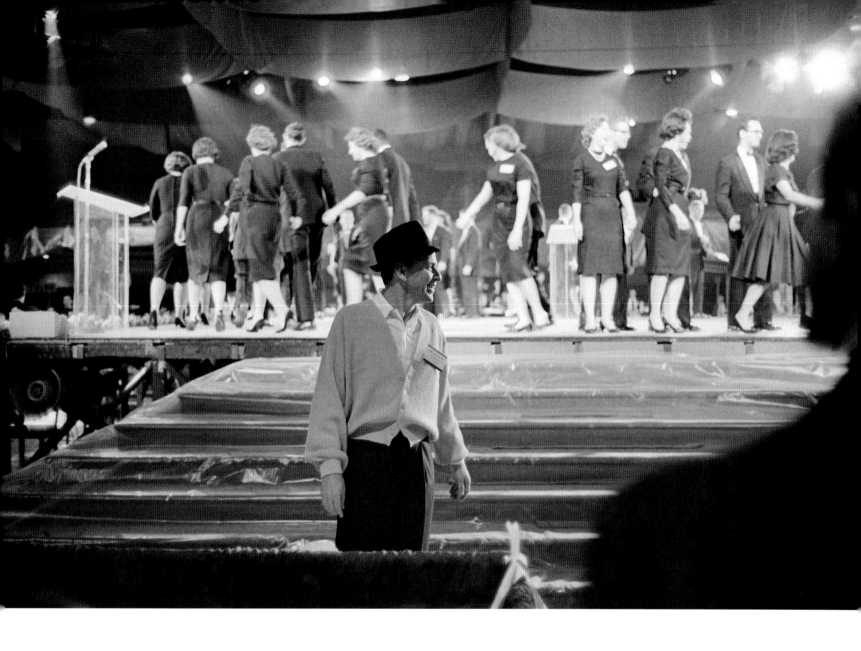

Photographer Mark Shaw snaps a photo of
Sinatra as he rehearses at the National Guard
Armory for President John F. Kennedy's
Inaugural Gala in 1961. Frank helped produce
the gala by enlisting the artistic talents of his
Hollywood friends: entertainers like Ella
Fitzgerald and Gene Kelly, or what columnist
Murray Kempton described as "the most
inescapably valuable collection of flesh this
side of the register of maharani."

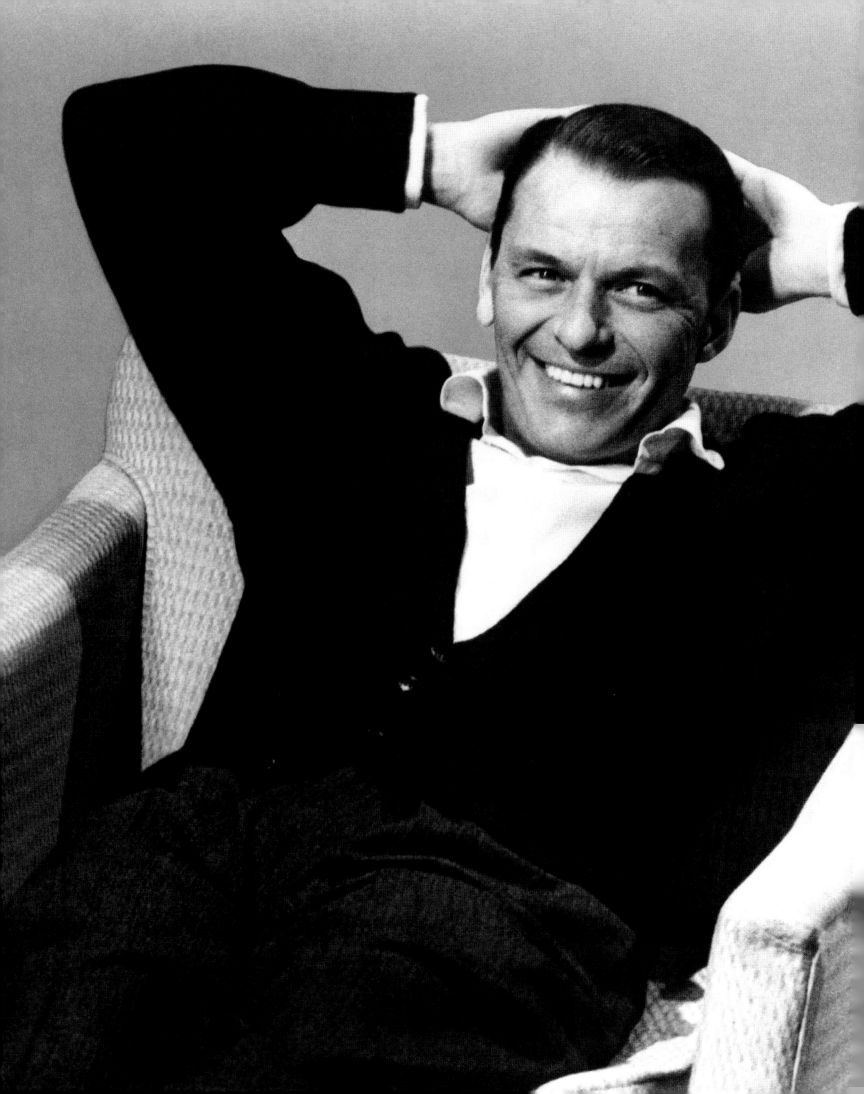

Sinatra's labels alternated between photographs and illustrations to set the right tone for his records, and many of the shots in this book adorned album covers in one form or another. To the young Jonathan Schwartz, "they assumed the effect of a continuing story, sometimes joyful, sometimes less so. They worked collaboratively with Sinatra and carried great weight, even when glimpsed in a store window from a passing taxi." When jazz singer Joe Williams walked off a Las Vegas stage improvising a gesture of Frank's from the cover of a recent album, "the audience went wild." Sinatra did not always see eye-to-eye with Capitol's designs. Future Beatles producer George Martin visited a recording session in 1957 and witnessed an "explosion" over the cover of "Come Fly with Me," which touted the airline TWA in a crass piece of product placement. Sinatra lost that one, but, Martin concluded, Sinatra was right. And as he owned his next label, approvals at Reprise were no longer an issue.

This photo by Sid Avery, used on the cover of the 1960 Capitol album *Nice 'n' Easy*, would also become the image that would come to personify Frank's "ring-a-ding ding" bachelor persona and lifestyle.

Sinatra's recording sessions were always a hot ticket. As Robert Wagner recalled, "He loved being with the musicians. He loved recording with the men actually there, and the women actually there. That was his thing." The audience made it more exciting for the musicians, but it was a risk, said trombonist Milt Bernhart, "because they could get caught up in the thing, and ruin a take."

Capitol Records recording session with Nelson Riddle in Studio A. A slight variation of this image would appear on the cover of the 1961 album *Sinatra's Swingin' Session!!!*
PHOTO BY SID AVERY

OVERLEAF

Frank, Bing, and Dean crack up during an October 27, 1963, taping of *The Bing Crosby Show*.
PHOTO BY GENE TRINDL

The Associates: Sammy, Frank, and Dean captured on film by Ted Allan at the Kanab, Utah, location of *Sergeants 3*. This being only one of the 20,000 stills Allan shot over a three-month period with his thirteen cameras (seven Rolleis, three motor-driven 35mm cameras, two 4-by-5-inch Speed Graphics, and one view camera). "I'm going to make you the best photographer in Hollywood," Sinatra told Allan. "You have only one shot, now make it good." And boy did he.

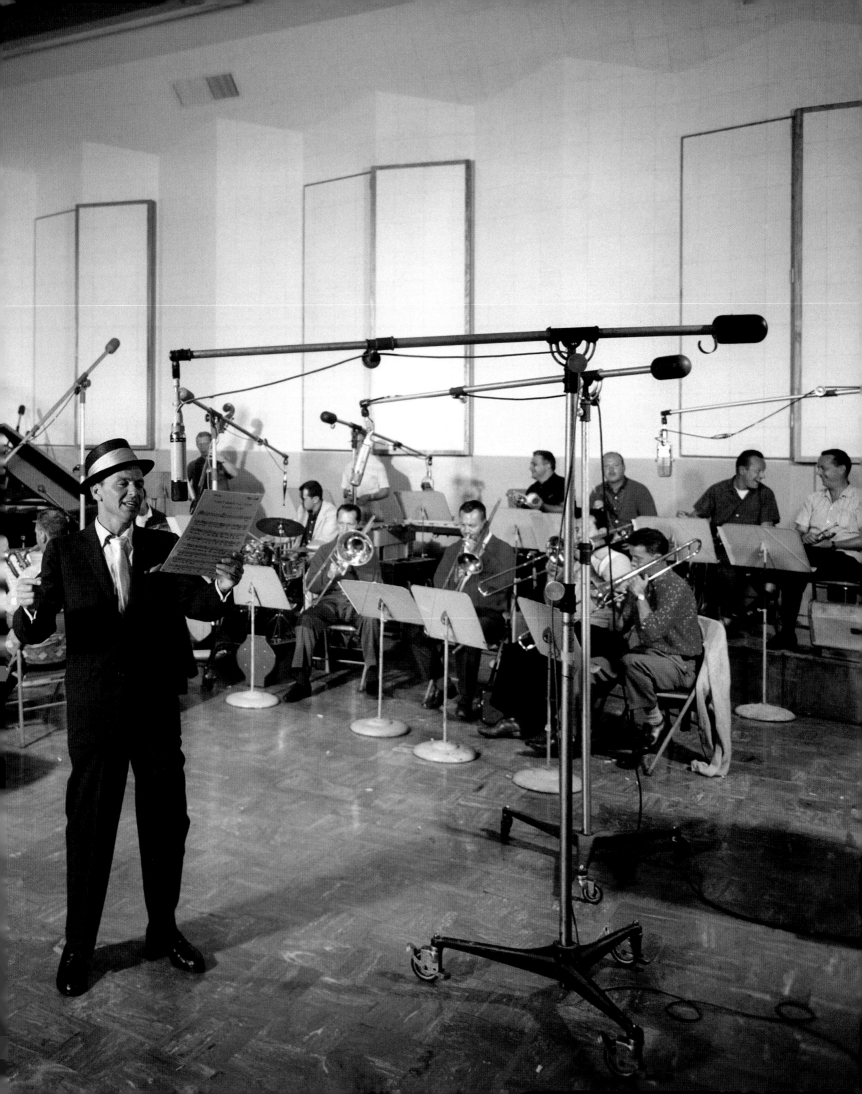

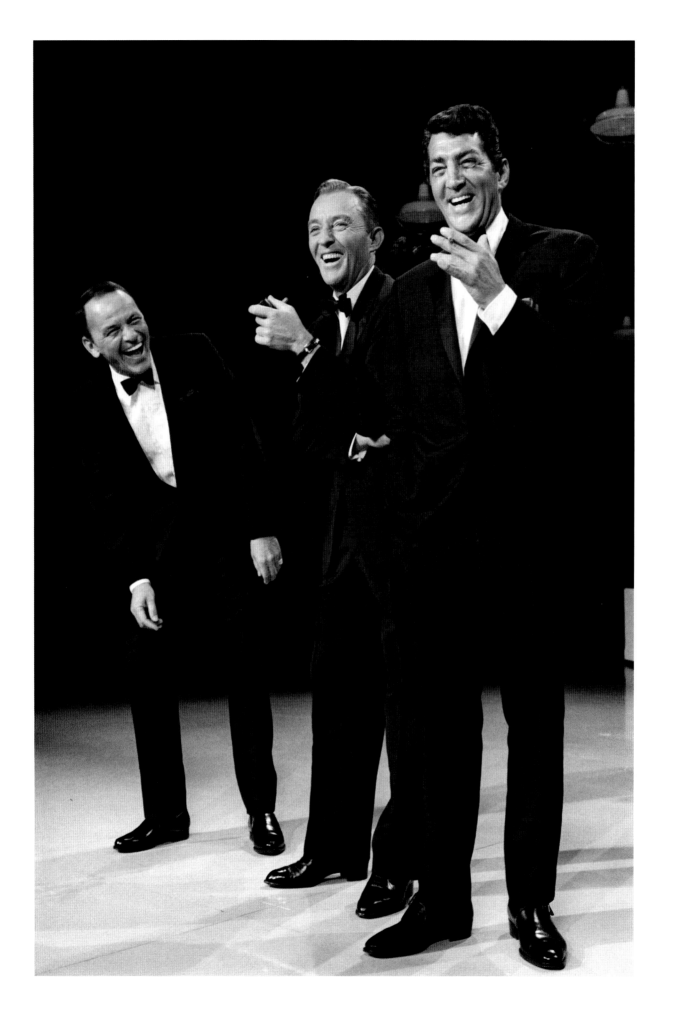

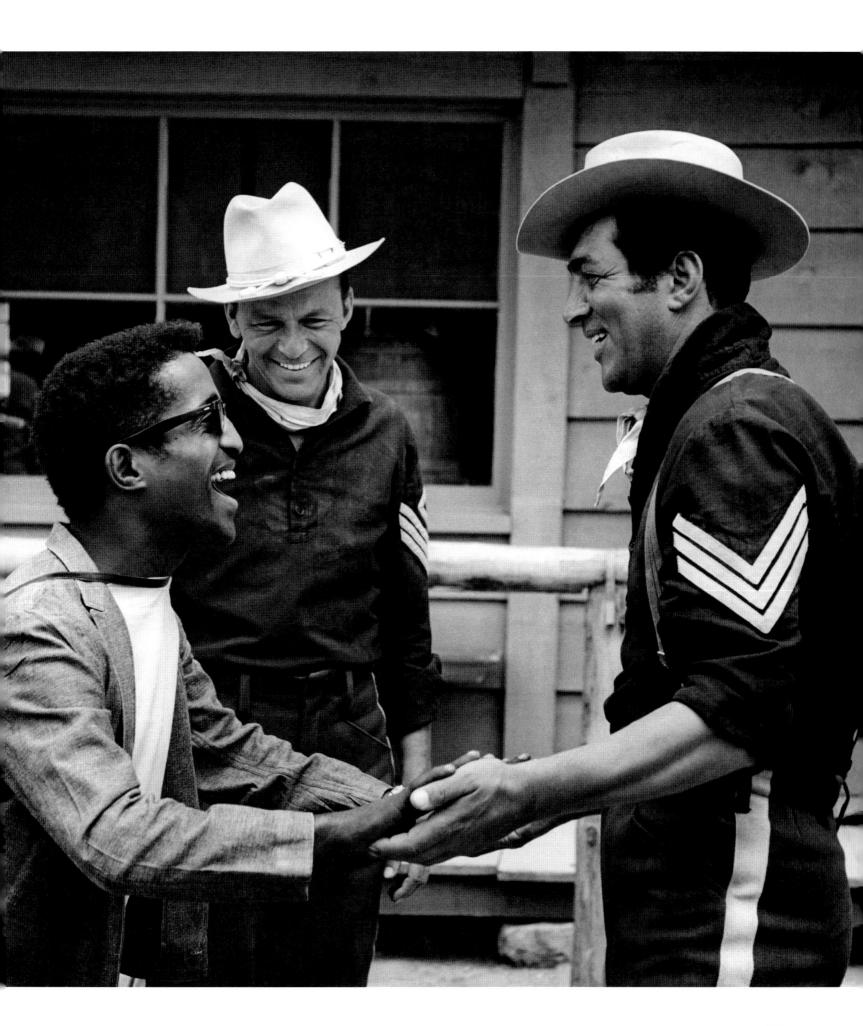

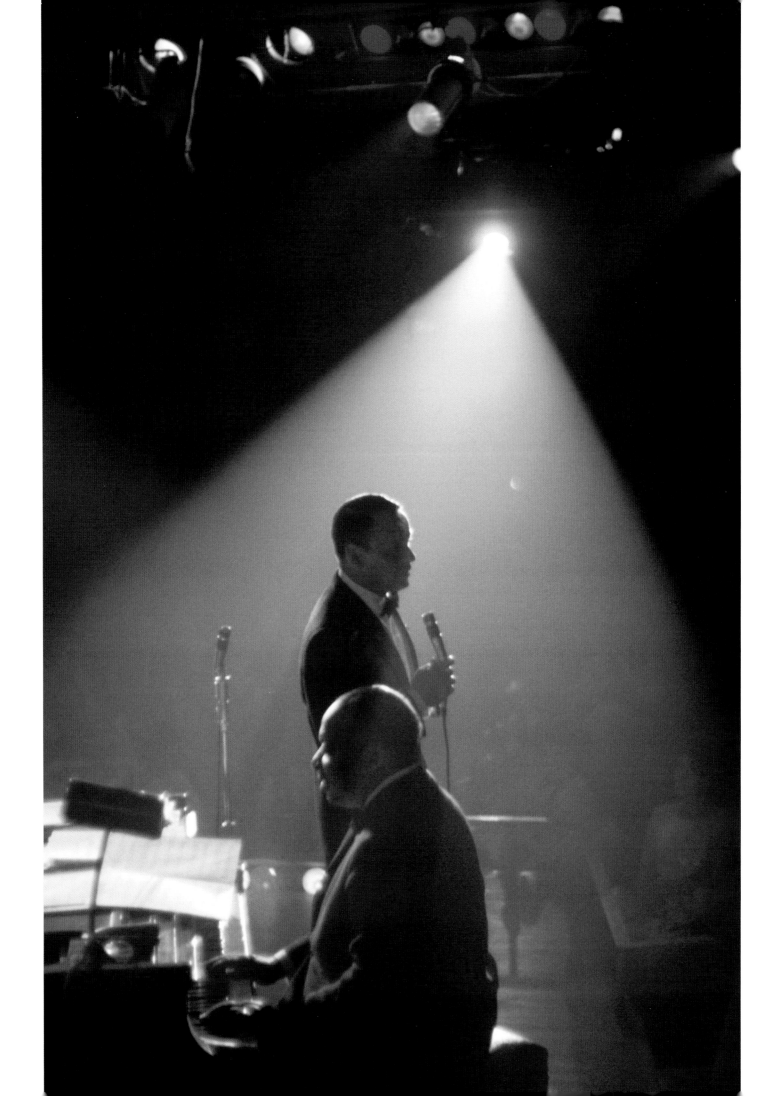

Sinatra took great care over the April 1966 gig with the Count Basie orchestra that would result in his first live album, *Sinatra at the Sands*. Basie reported that the singer even paid to fly the twenty-odd band members into Las Vegas early to have time to rehearse. In the almost half century since it was recorded, the concert, arranged and conducted by Quincy Jones, has given countless listeners a front-row seat at one of Sinatra's finest hours. For those who have wanted an even more visceral sense of the occasion, there are Stan Cornyn's Grammy Award–winning album liner notes, deftly evoking a "room has that peculiar air about it that only successful clubs have: a combination of cigarette smoke, overheated air, smouldering dust, Lysol Clorox cleaned linen, even the silverware smells different from home silverware." For the musicians, it was a treat. Trombonist Al Grey recalled Sinatra's generosity in the casino after the show. "He'd see you over there at the tables and if you'd lost all your money, he'd come over and reach in his pocket and say, here's a hundred, why don't you get on home now, and all like that."

"I waited twenty years to record with this giant of a music man," Frank would say of William "Count" Basie, another New Jersey native, during a 1981 television special. Here they're photographed, by John Bryson, performing at the Sands Hotel with "a thousand pounds of spotlight bear[ing] down" on them, as Cornyn would note. This image would become the cover of the 1966 double LP *Sinatra at the Sands*.

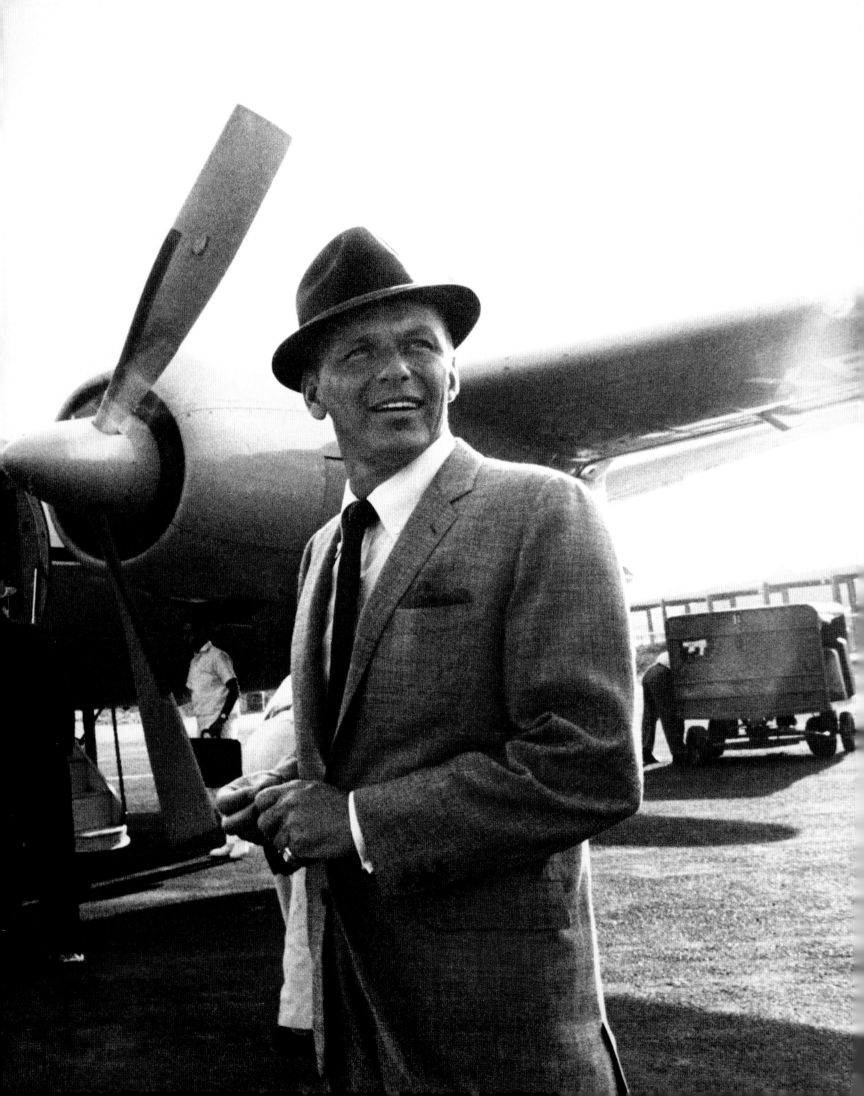

The Italian Yuri Gagarin: "I bought an airplane," Frank would joke at a November 1, 1961, performance at the Sands Hotel, and "you'd think I set off a fifty-megaton bomb the way this thing has come across." The same night he would sing a parody of the Mort Dixon/Harry Woods tune "River, Stay 'Way from My Door;" this time, however, with lyrics by Sammy Cahn: "When I'm up there wingin', I'm really ring-a-ding-a-dingin'." And you can see how in this 1962 photo by Ted Allan.

A slight variation of this Glenn Embree photo would appear in publicity materials for the 1961 album *Swing Along with Me*. The ad's copy would read in part: "No playboy kit complete without."

FOLLOWING SPREAD

Sinatra with George Jacobs, his valet for fifteen years, c. 1962.
PHOTO BY BERNIE ABRAMSON

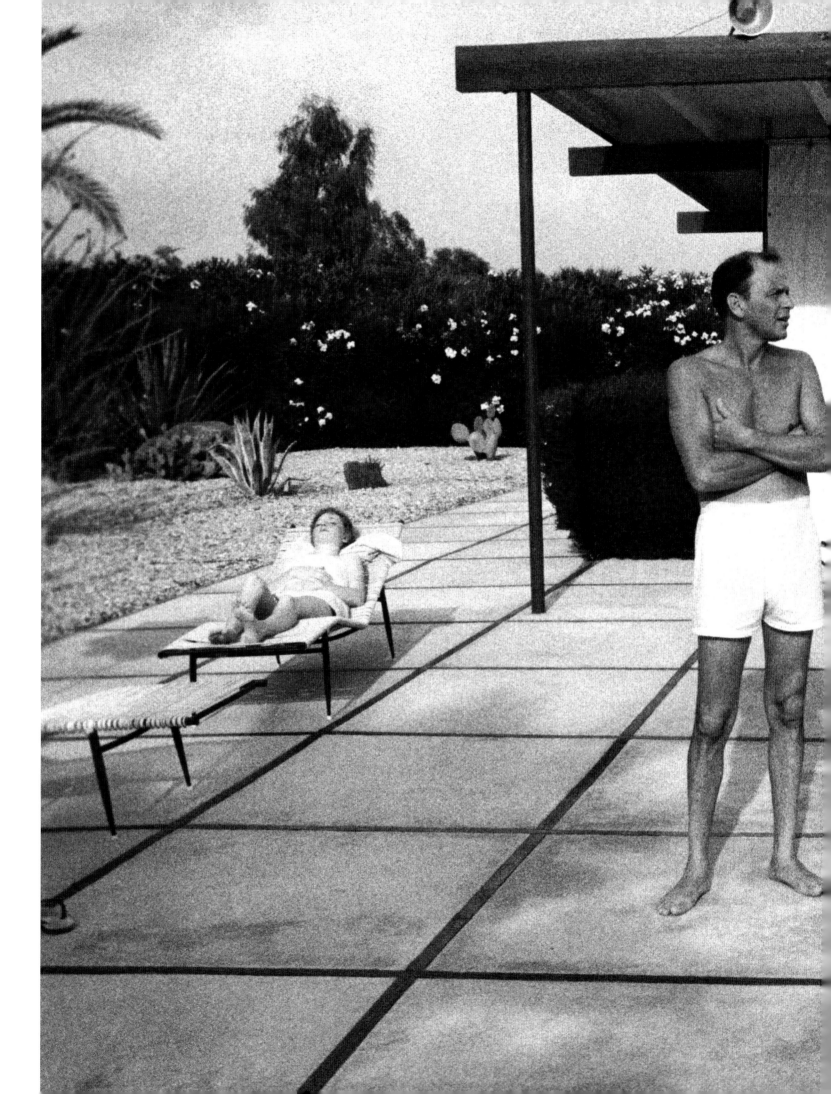

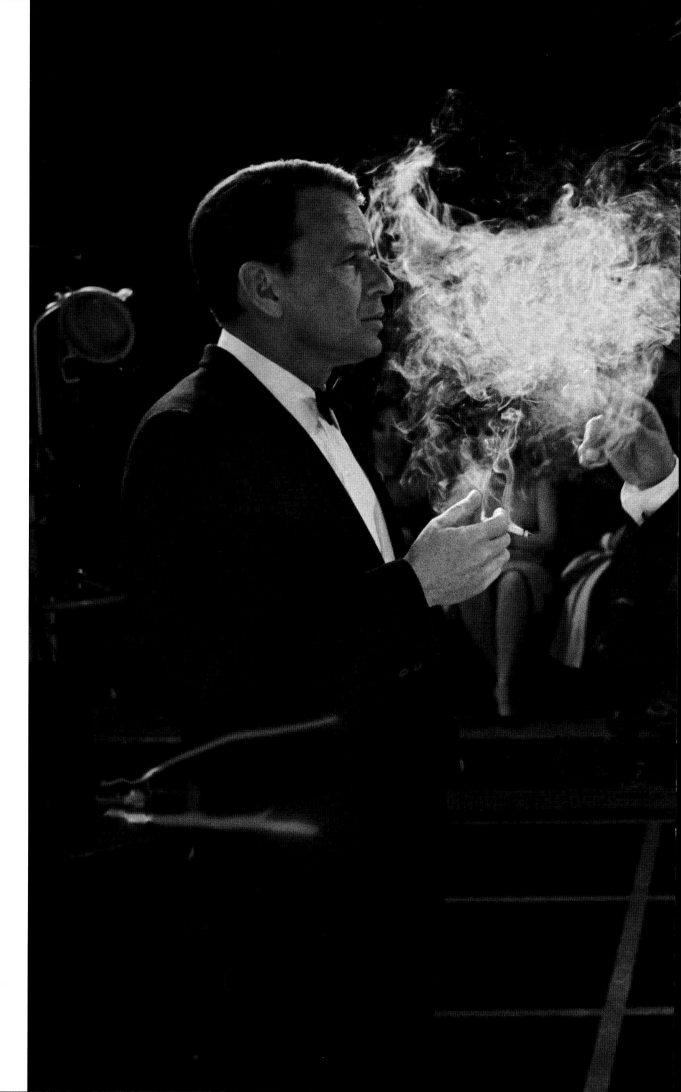

Photographer Bob
Willoughby covered
the taping of a
television special,
*The Judy Garland
Show*, in 1962. Here
Frank and Dean
are backstage waiting
for the show to begin.
PHOTO BY BOB WILLOUGHBY

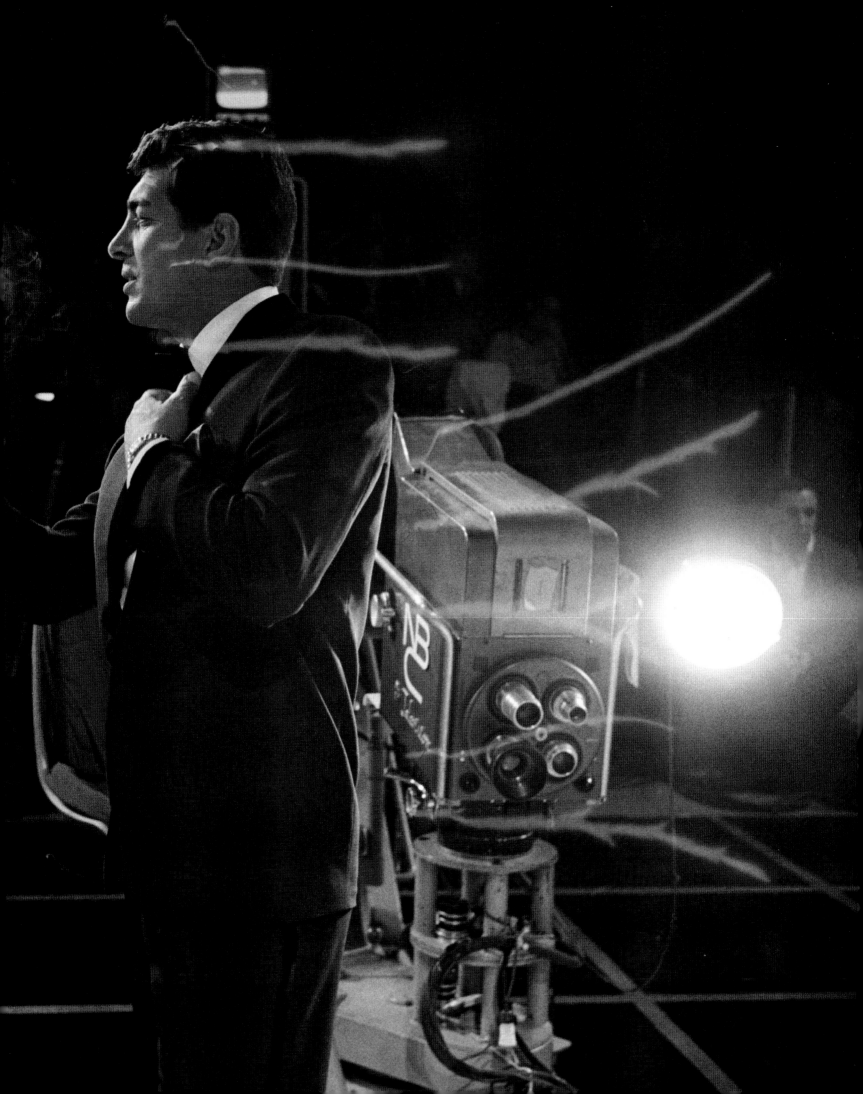

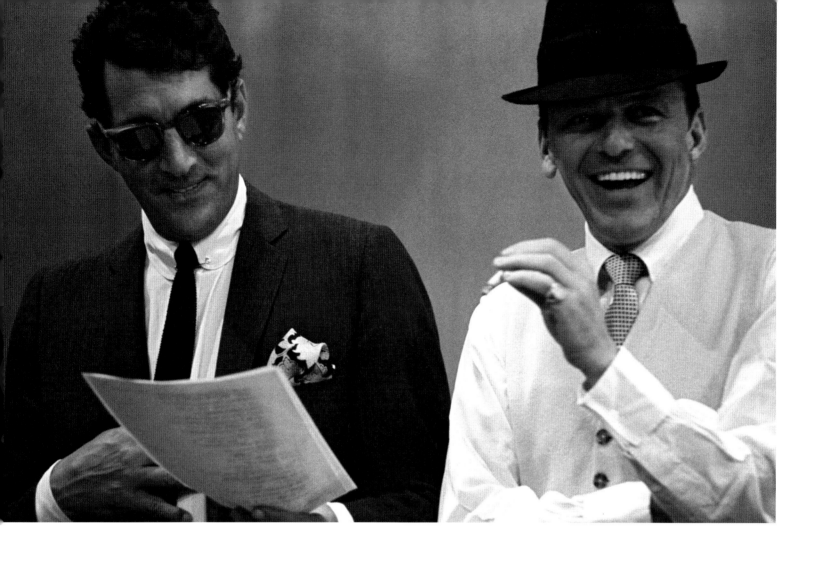

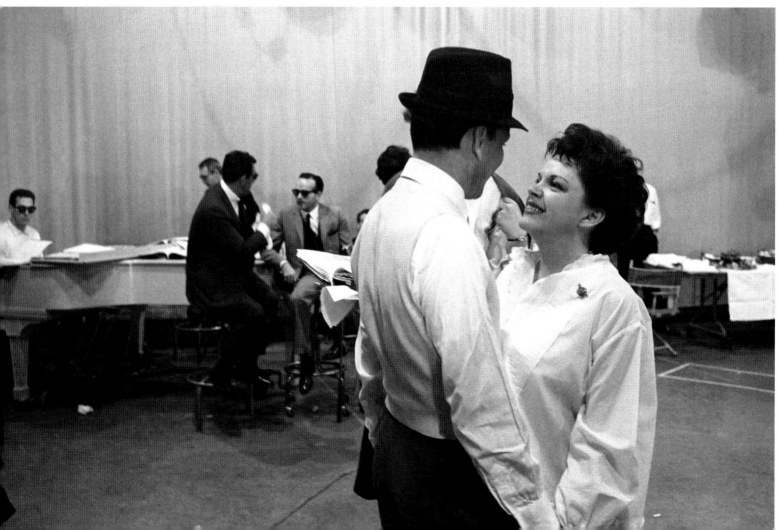

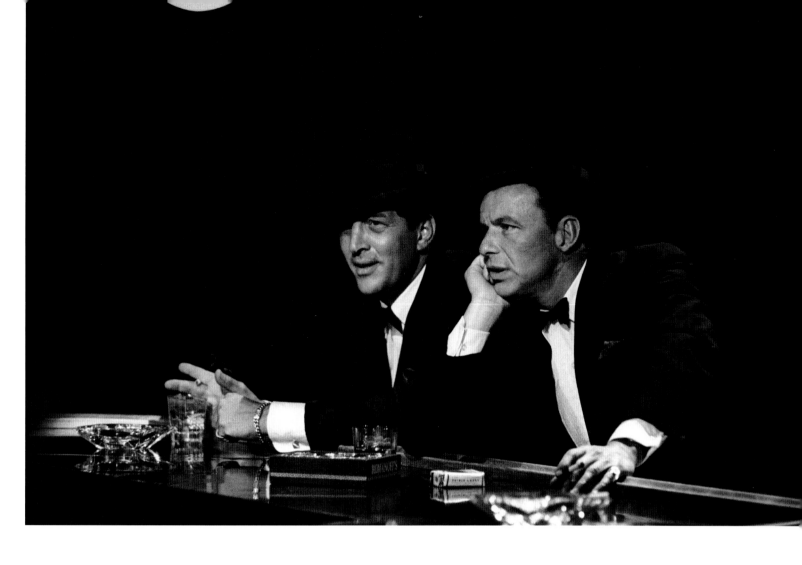

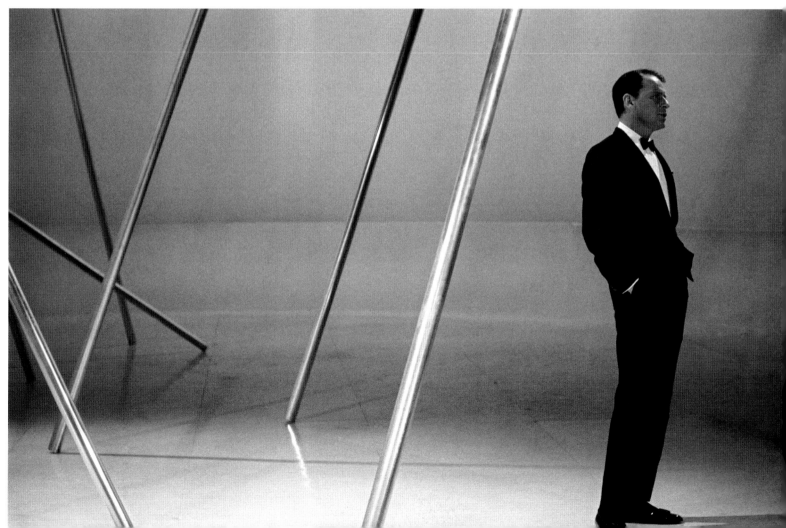

Producer George Schlatter observed Sinatra's protectiveness toward Garland: "I was booking shows at Ciro's on the Sunset Strip, which was the most famous nightclub in the world, and Sinatra walked in one night with Judy Garland. Garland was pregnant, and so she had on this coat, and as he walked through the lobby the press agent said to someone, 'Who's the broad with Sinatra?' Sinatra said, 'Excuse me' to Judy, walked over, punched the guy in the mouth, pushed him into a phone booth, closed the door, then he opened the door and he said, 'The lady's name is Garland.'" The singer was equally solicitous of Billie Holiday, whom he idolized.

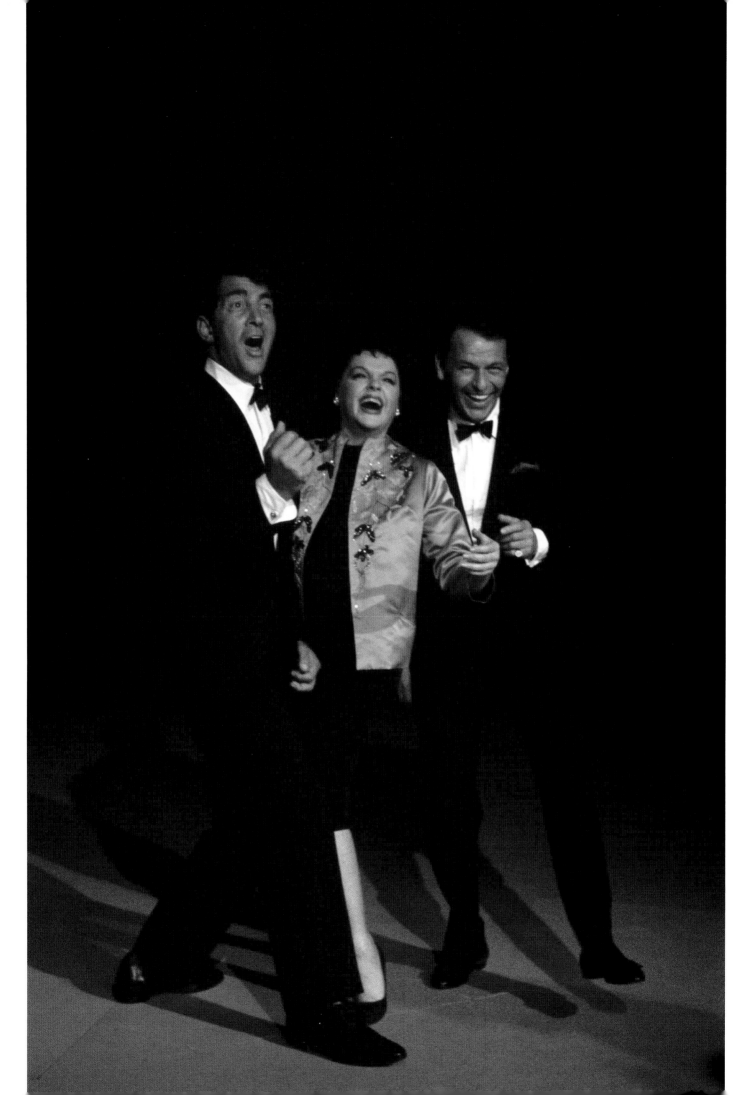

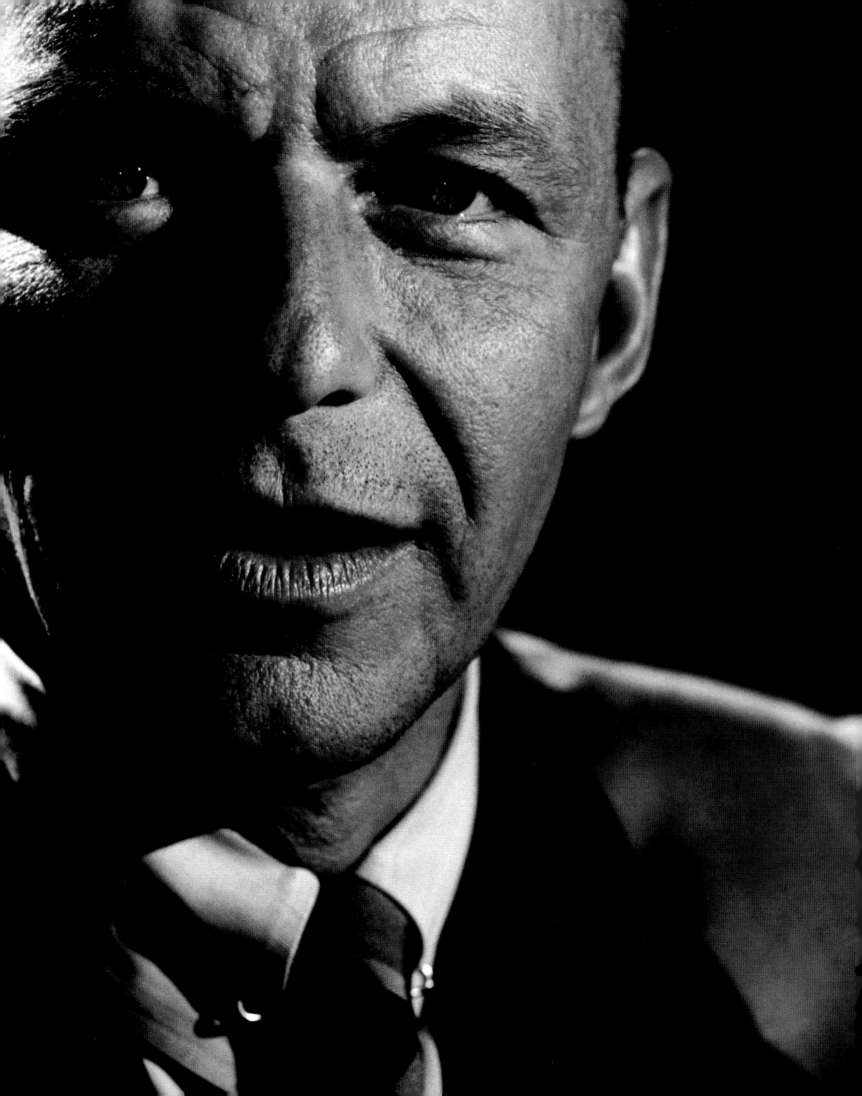

Barbra Streisand: "I remember meeting him at a party and thought he was very much like I imagined he would be, very protective... telling me if I ever had a problem with anyone to let him know."

Sinatra, c. 1962.

Frank in Tokyo, taken on a 1962
around-the-world tour raising
money for underprivileged children.
PHOTO BY TED ALLAN

Recording session for *Great
Songs from Great Britain*,
CTS Bayswater Studios, London.
Los Angeles restaurateur Mike
Romanoff, an old friend of
Sinatra's, is seated in the group
observing the session.
PHOTO BY TED ALLAN

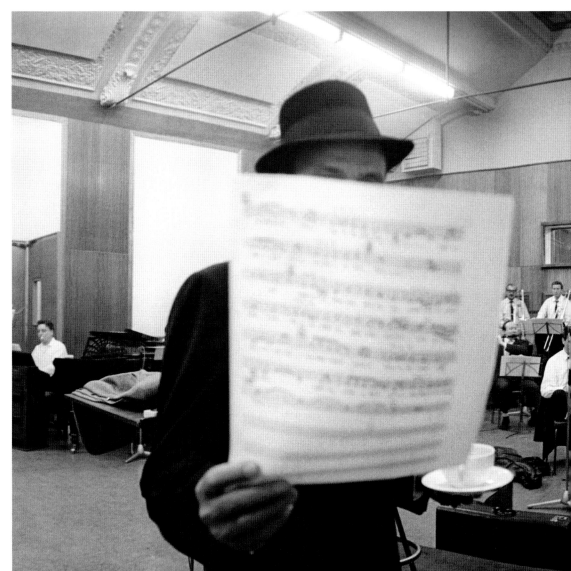

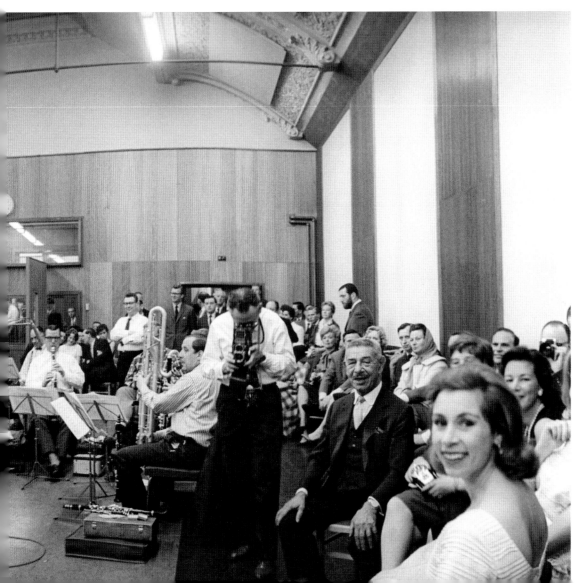

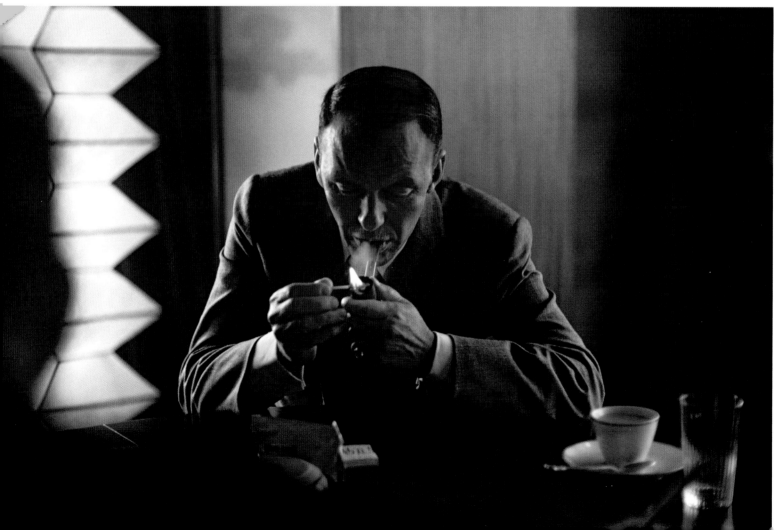

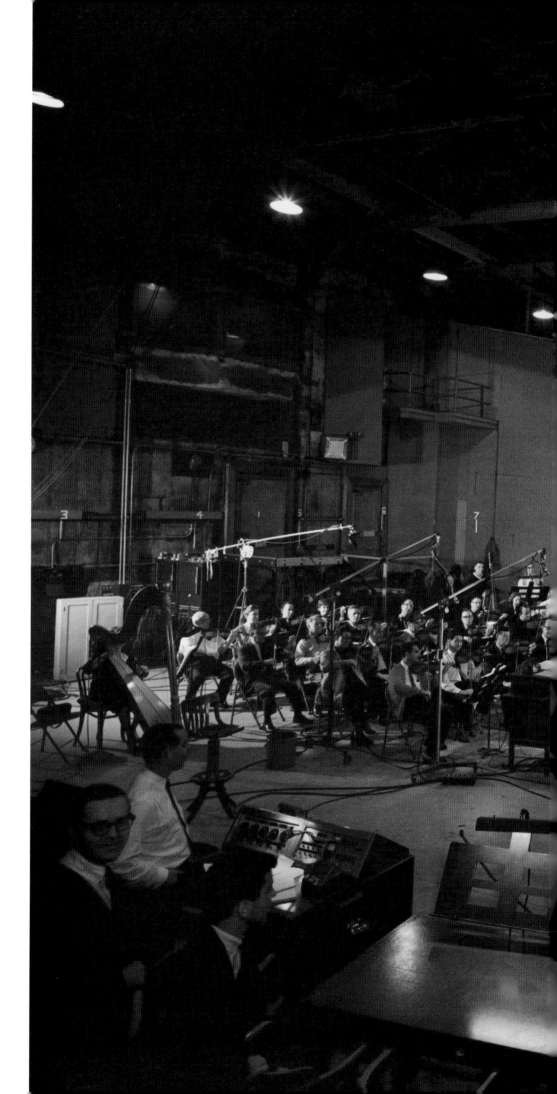

Frank, Nelson Riddle, and seventy-three musicians are on Stage 7 of the Samuel Goldwyn Studios in Hollywood, recording the album *The Concert Sinatra*. This photo, by Ted Allan, would make the 1963 album's cover.

FOLLOWING SPREAD

Waiting for shooting to commence on the Paramount set of *Come Blow Your Horn*, 1962.
PHOTO BY TED ALLAN

On the set of Warner Brothers' *Marriage on the Rocks*, 1965.
PHOTO BY BOB WILLOUGHBY

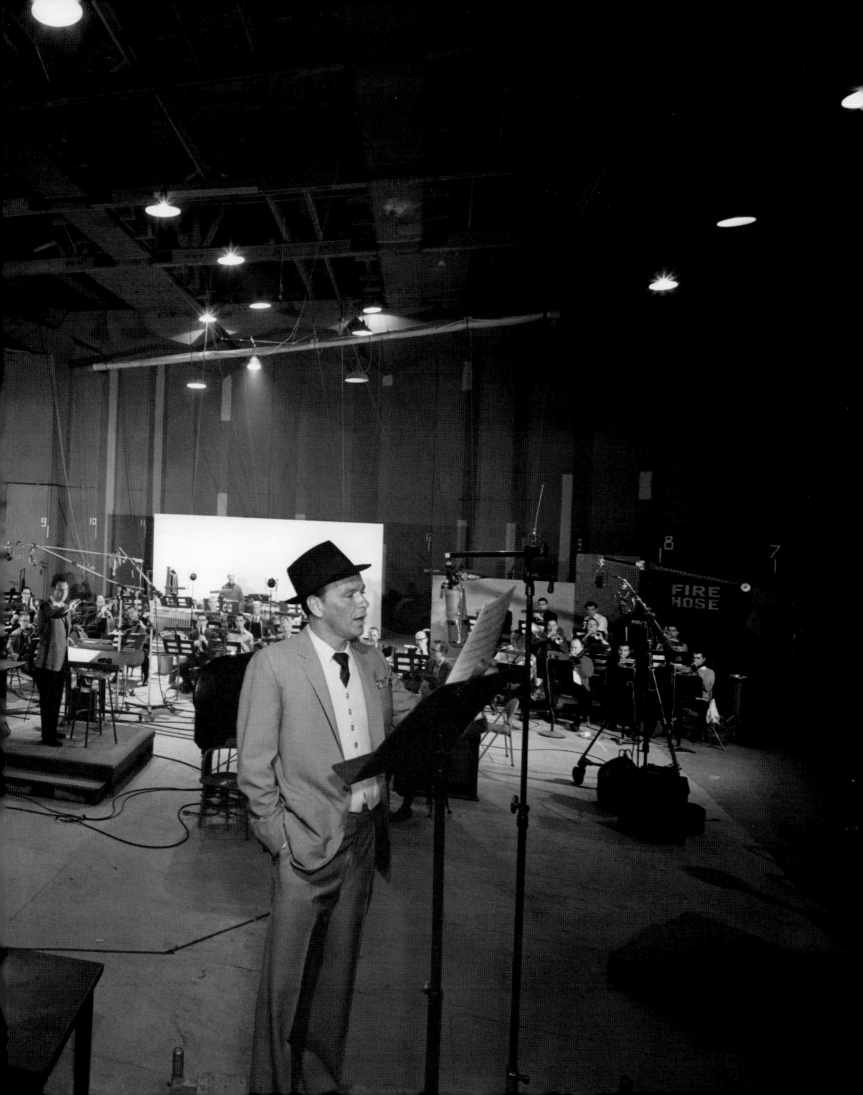

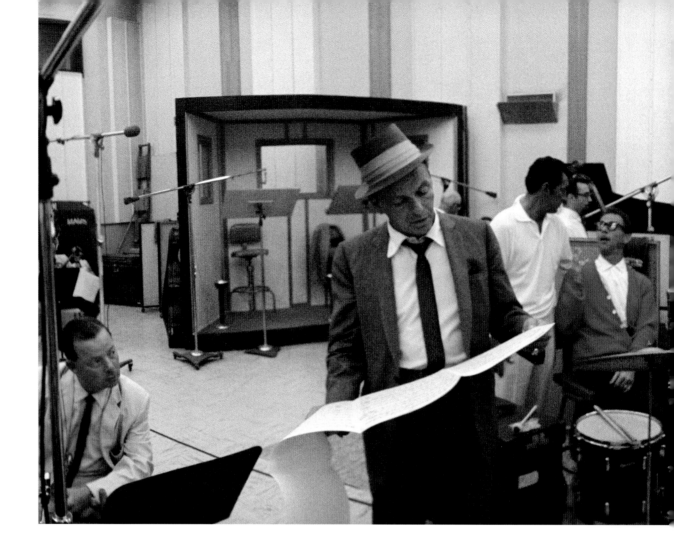

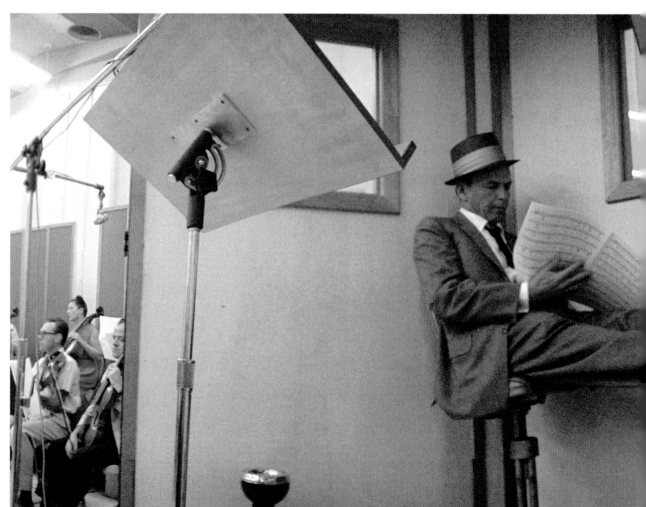

Frank Sinatra and Dean Martin (background) at a recording session, 1964.
PHOTO BY TED ALLAN

Home sweet home: Frank puts his feet up during a 1964 recording session for a special Reprise compilation album entitled *Reprise Musical Repertory Theatre Presents "Guys and Dolls."*
PHOTO BY TED ALLAN

Quincy Jones: "I treated him just like a jazz musician. He's from the big band era, and I am too. I was in the middle of it since I was thirteen years old. Four trumpets, four trombones, five saxes, and four rhythm. That was my Vatican. And that's all I ever wrote for, so I was always nervous about getting a great opportunity that I wasn't prepared to deal with, but man, when Frank called me I was ready for his ass. I mean musically I was ready for him, because if you're not you're in trouble. Guys like him will massacre you in that studio if you don't know what you're doing. He used to test me every now and then. We were doing 'The Best Is Yet to Come' and he said, 'Quincy, that first eighth is a little dense,' and I say, 'No problem, man.' I changed all the saxophones to alto flutes, and put Harmon mute trumpets for the long stem out. Let's go. Five minutes, ready to go. He tested me about three times but never again from '64 until '98. And it was just a trust that you can't believe. You feel that, you don't talk about it."

Arranger and conductor Quincy Jones with Count Basie and Frank during the June 1964 recording session for the album *It Might as Well Be Swing*. In addition to the pack of Parliaments and Wrigley gum on the podium are the charts for "The Best Is Yet to Come." Of all the tunes Frank would sing in his long career, this is the only one that would appear on the granite marker at his grave site, right above the words "Francis Albert Sinatra / 1915–1998 / Beloved Husband & Father." PHOTO BY TED ALLAN

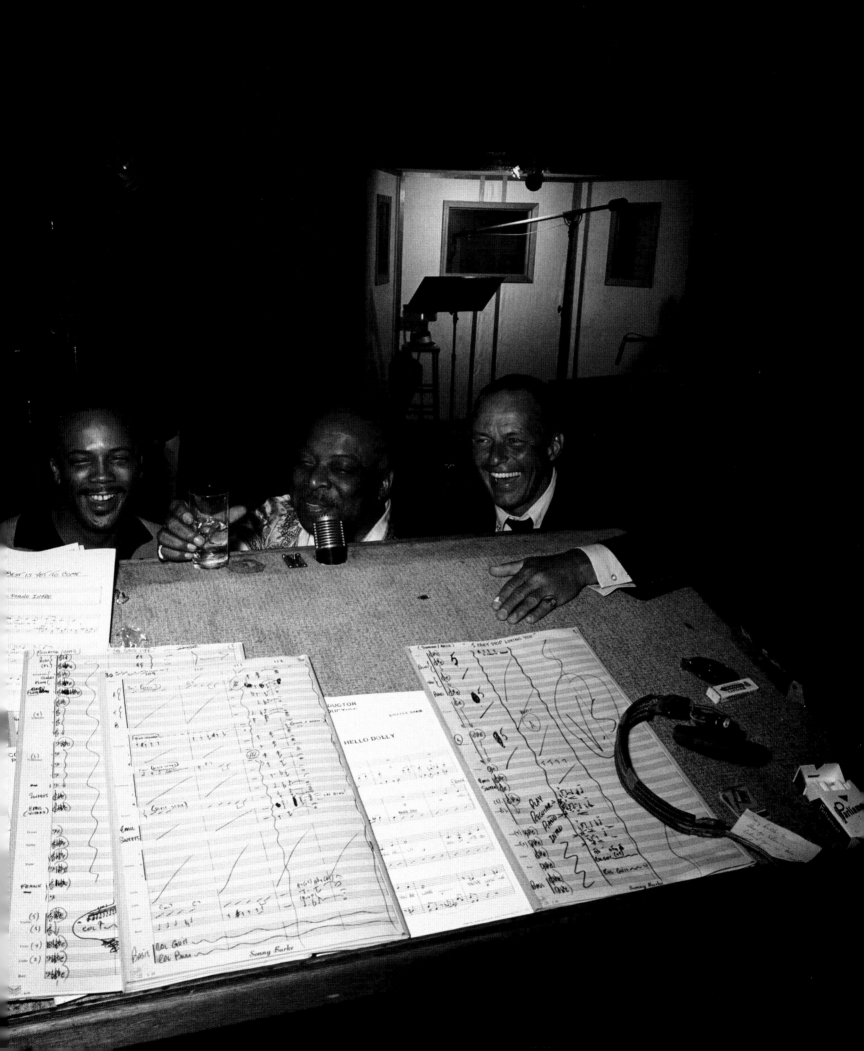

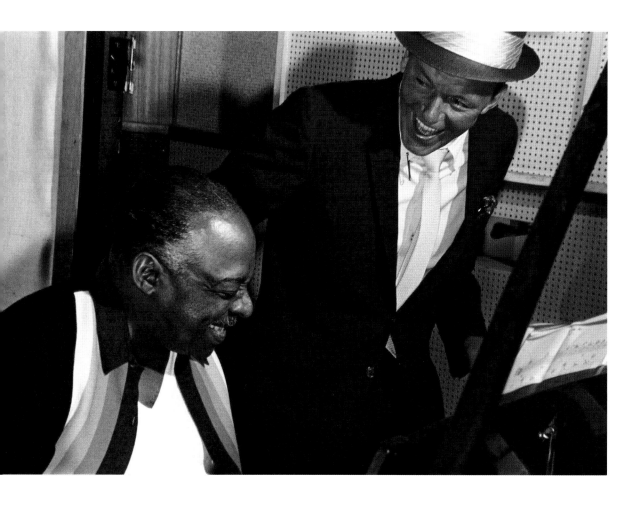

Photographer Ed Thrasher captures
the two giants sharing a laugh.
Bill Basie would recall years later,
in his autobiography, how Frank
was "a perfectionist," who "believes
in thorough preparation and hard
work," but who "also likes for things
to hang loose."

Frank Sinatra and Count Basie,
recording session, 1964.
PHOTO BY TED ALLAN

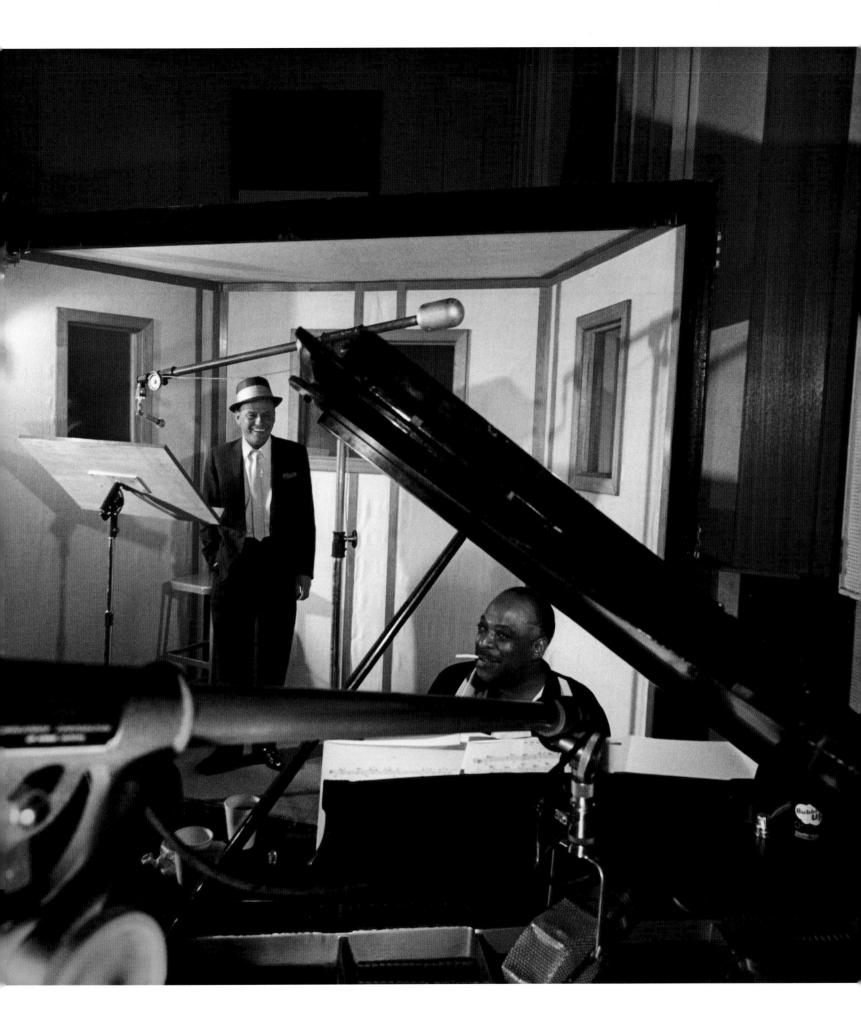

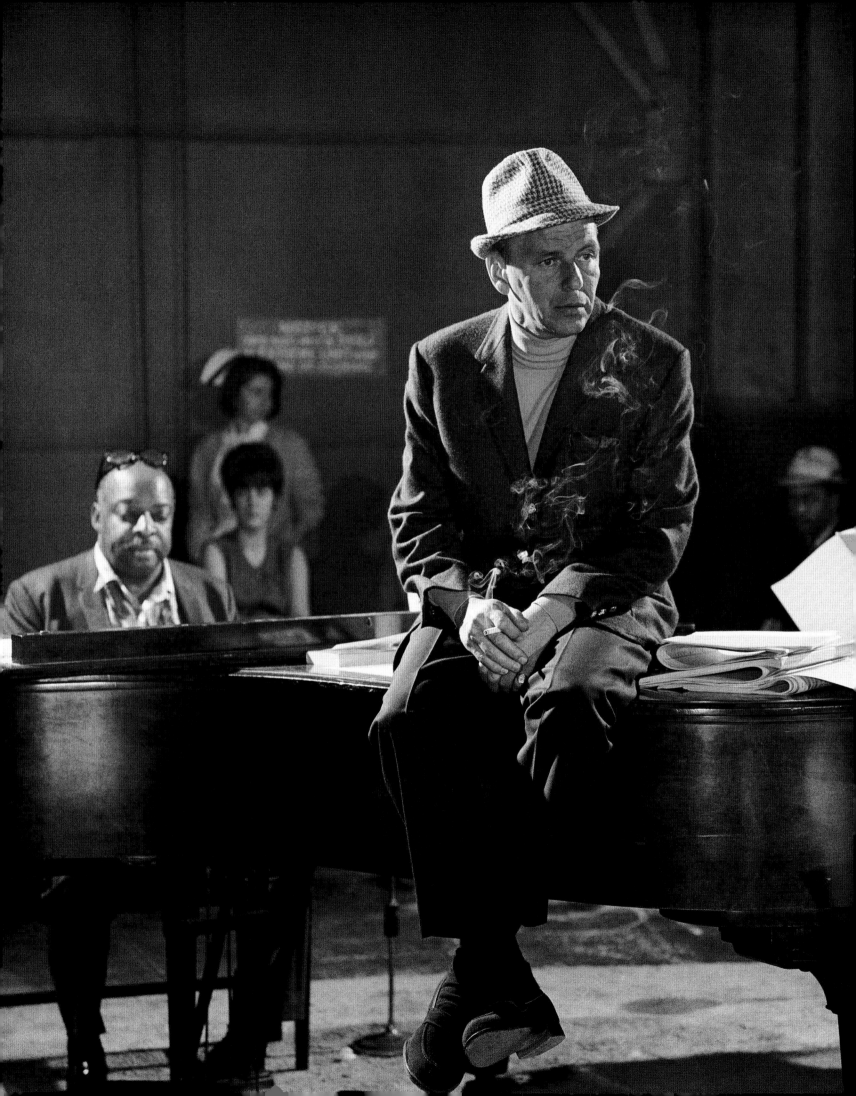

To some of his most astute commentators, Sinatra was a blues singer. Novelist and journalist Pete Hamill, who knew him well, saw the pain: "As an artist, Sinatra had only one basic subject: loneliness. His ballads are all strategies for dealing with loneliness; his up-tempo performances are expressions of release from that loneliness." So did fellow New Jerseyite Bruce Springsteen. Saluting Sinatra in a concert taped for broadcast on his eightieth birthday, the younger man offered a telling observation, suggesting that Sinatra's association with the easy and good things in life belied something deeper: "His blues voice was always the sound of hard luck, and men late at night with the last ten dollars in their pockets, trying to figure a way out."

Frank takes a break on a Los Angeles soundstage as he rehearses with Count Basie for an upcoming show in Las Vegas, 1964.
PHOTO BY TED ALLAN

OVERLEAF

Sinatra's neatly arranged music stand on an evening in June 1964 during the *It Might as Well Be Swing* sessions. The tunes, from left to right: "I Wanna Be Around," "Wives and Lovers," "Fly Me to the Moon," "The Best Is Yet to Come," and "I Believe in You."
PHOTO BY ED THRASHER

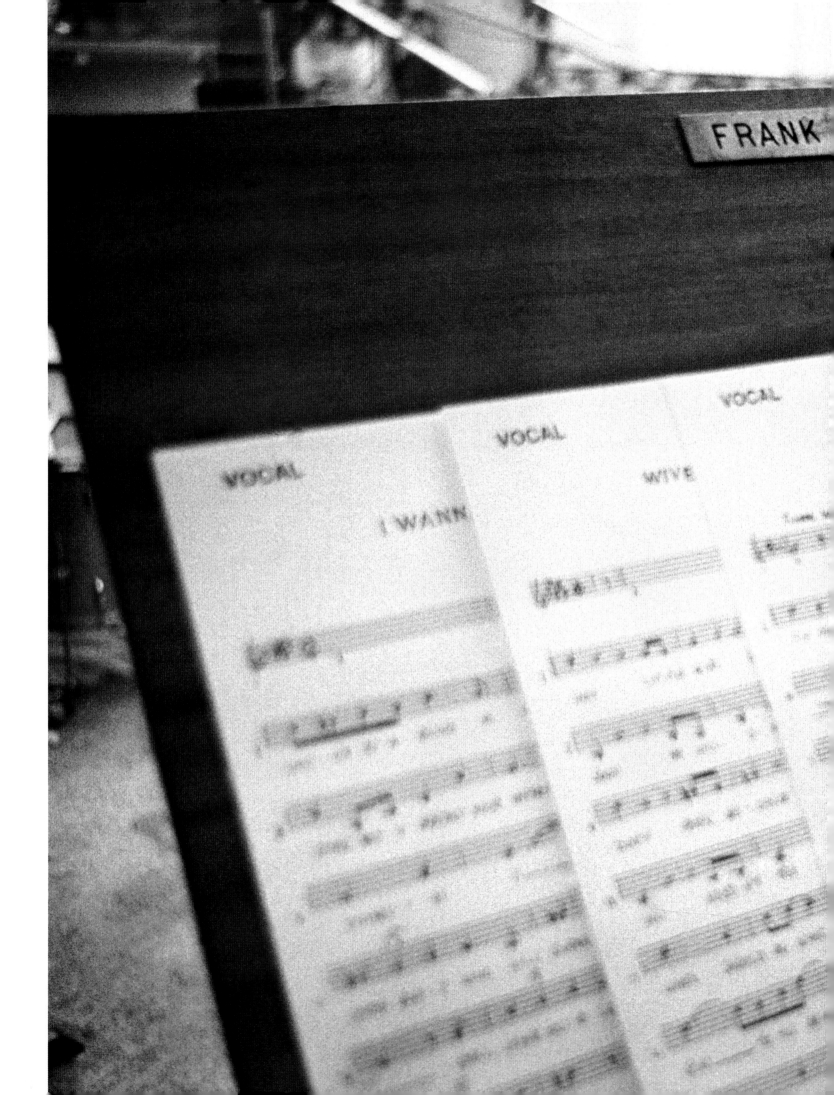

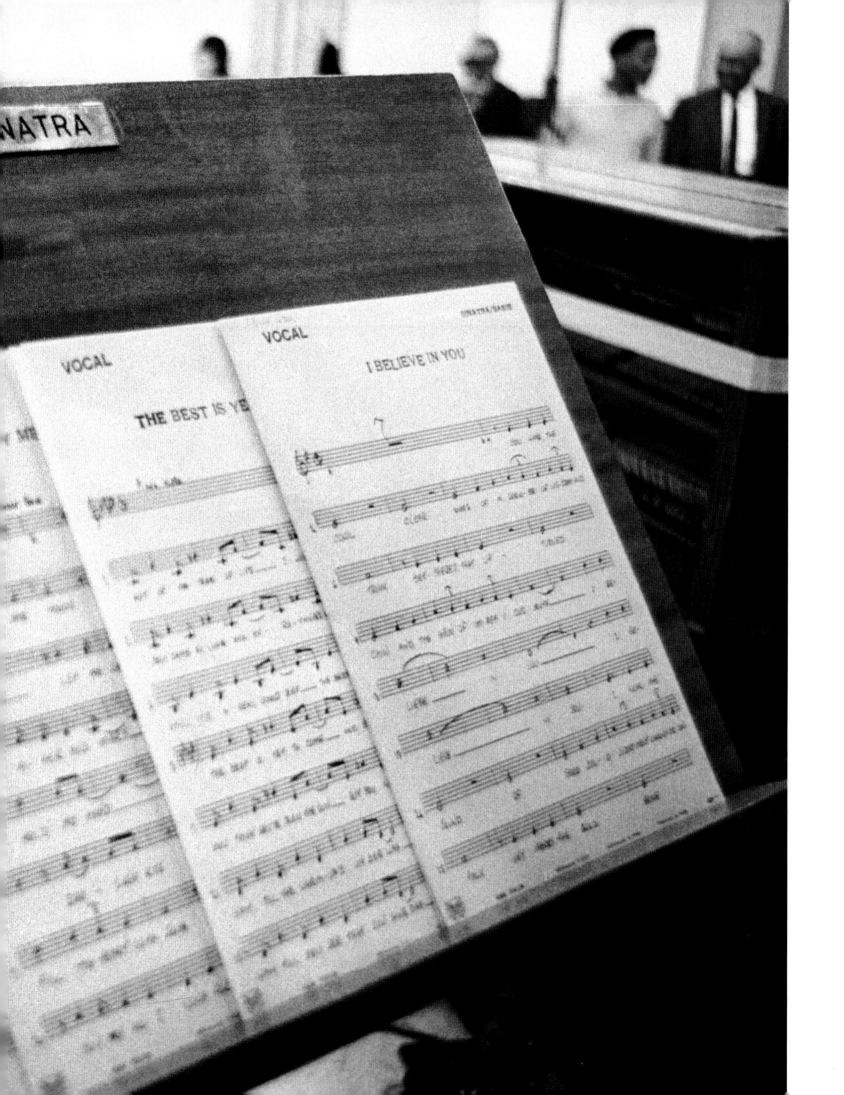

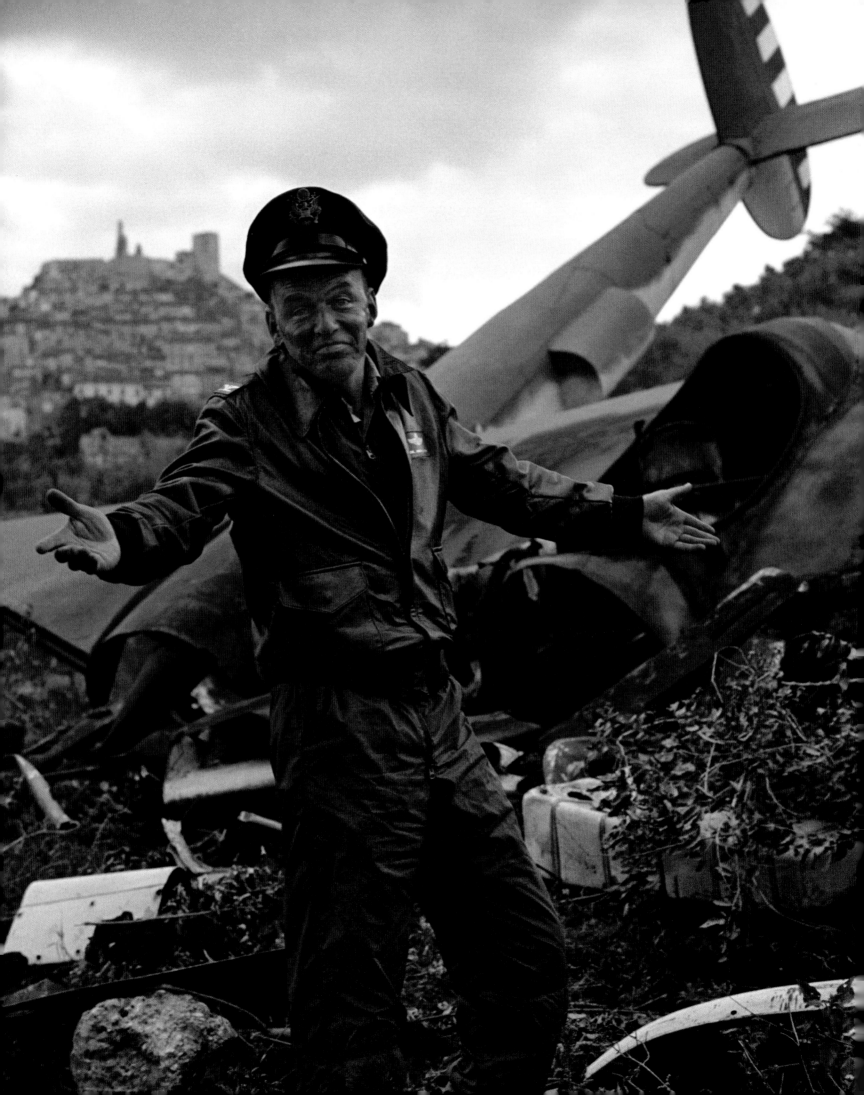

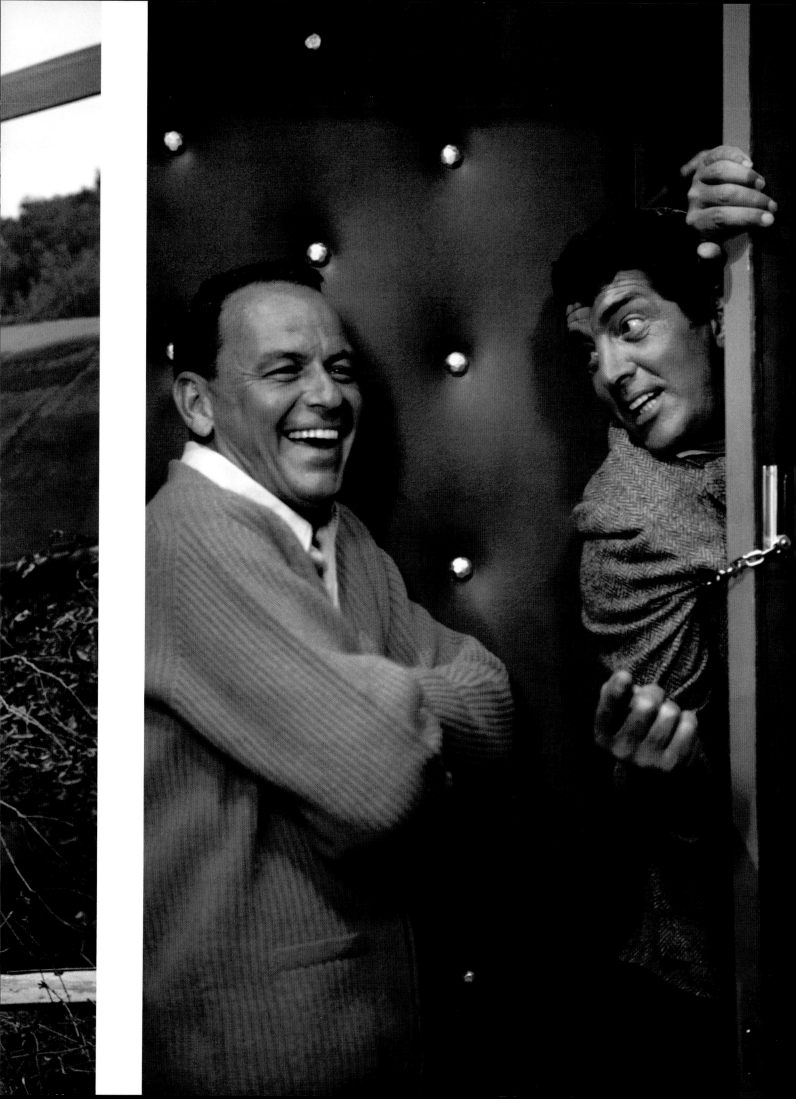

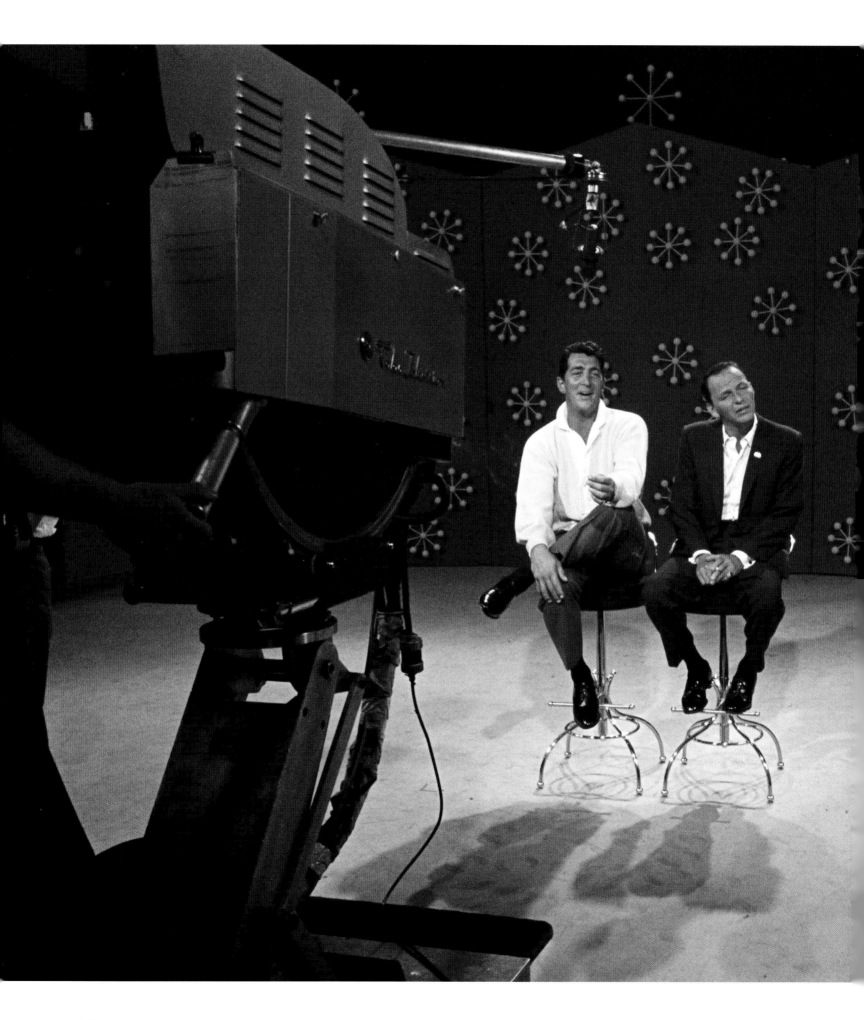

Dean Martin was only two years younger than Sinatra, but the two didn't join forces until 1958, when Martin talked his way into the Sinatra vehicle *Some Came Running.* Sinatra admired Martin's comic talents, not to mention his ability to hold his drink. Deana Martin describes the magic: "See, my dad and Frank, they would connect with the audience. You felt like you were in their party; you felt like you were in their living room. It's like they were sharing something with you. They weren't up there doing a show and just entertaining you, they were welcoming you into their whole situation."

PREVIOUS SPREAD, LEFT

According to a note on the print, Sinatra joked, "So I goofed," as he posed in front of a wrecked airplane on the set of *Von Ryan's Express,* 1964.
PHOTO BY TED ALLAN

PREVIOUS SPREAD, RIGHT

In an unscripted moment on the set of *Marriage on the Rocks,* 1965, Dean cracks Frank up as he tries to "squeeze through the chained door—which definitely wasn't in the script," photographer Bob Willoughby would note.

LEFT

Dean and Frank during a 1965 rehearsal for an episode of *The Dean Martin Show.*
PHOTO BY GERALD SMITH

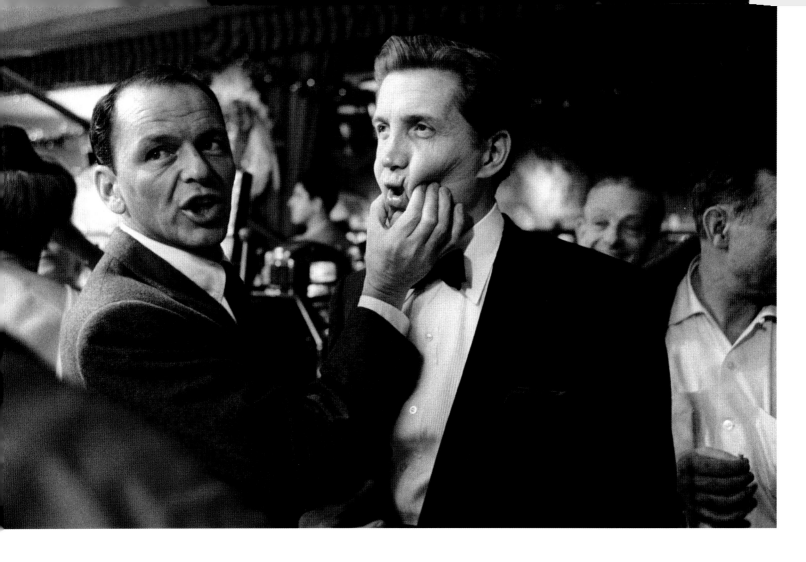

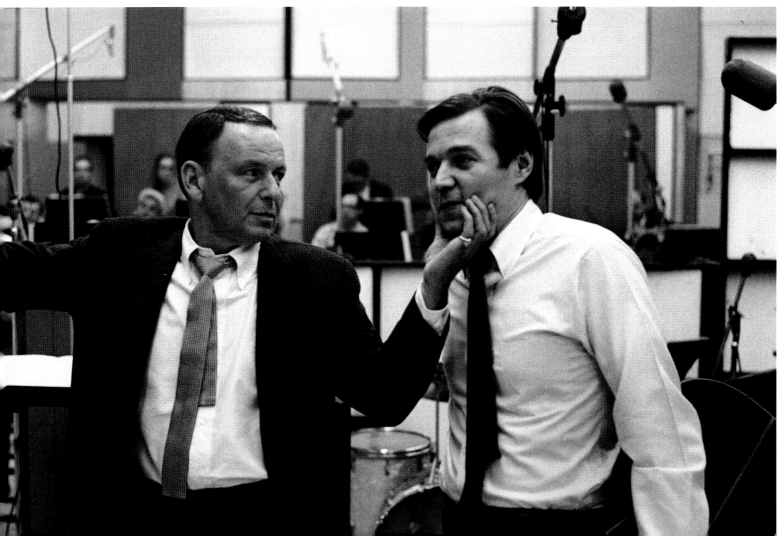

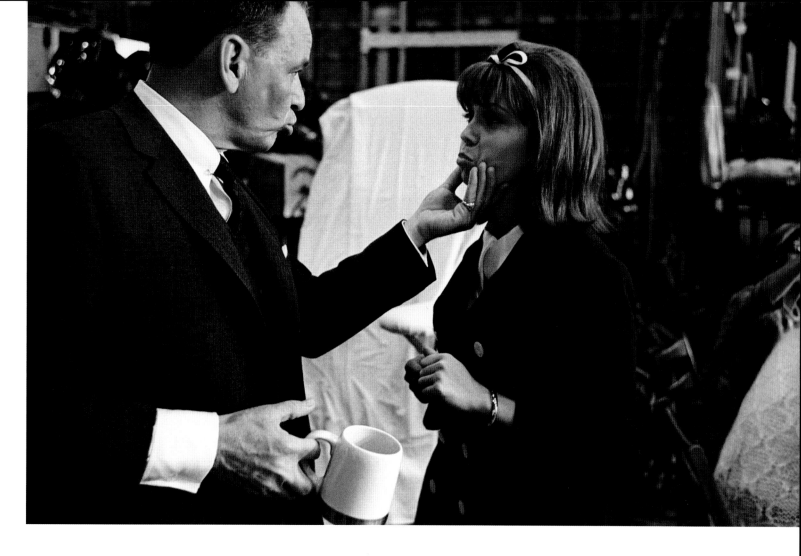

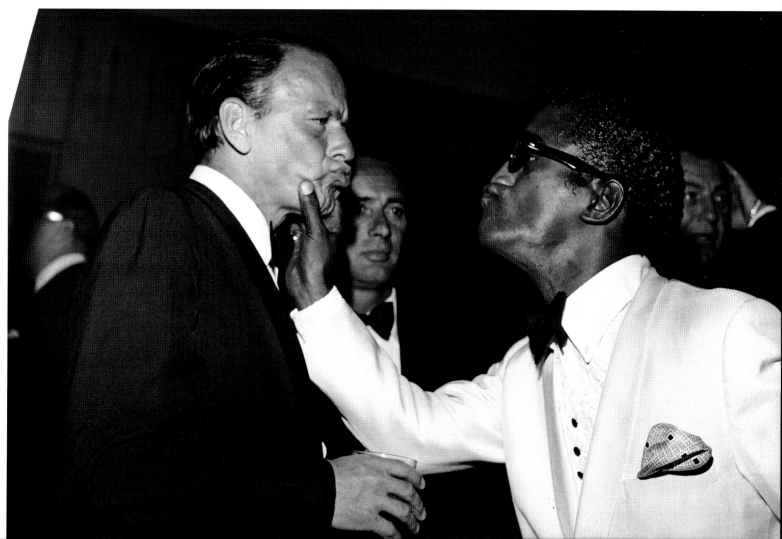

Musicians who worked with Sinatra felt the depth of his musicianship. Bill Miller, who worked with him most intimately for the longest time, a man of few words and stinting in his praise, said, "He doesn't read music, but he feels it, he understands it, he knows what it's all about. It's there. You just have to see him to know how musically exceptional he is. Watch him perform, and listen." Bassist Chuck Berghofer, like many others, called attention to Sinatra's way of conducting orchestras with his voice: "He's the only singer I know who makes the band swing instead of the other way around." Often, of course, they talked about that voice as if it was an instrument. Clarinetist Ken Peplowski explained how, as he aged, Sinatra worked around his diminishing vocal resources: "He got more into the pure emotion of the song, the pure feeling, which a lot of instrumental musicians also do. . . . There's a parallel in all art forms; Picasso, for example. As these great artists got older, they got simpler. They pared everything."

PREVIOUS SPREAD

Cheek pinchers: Frank gives it to Bill Miller, 1960 (photo by Bob Willoughby); and Nancy Sinatra, Jr., 1965 (photo by Bob Willoughby); and Antonio Carlos Jobim, 1967 (photo by Ed Thrasher). Sammy gives it back, 1961.

Away from the Warner Brothers set of *Marriage on the Rocks*, Frank takes a moment with his pianist, accompanist, conductor, and twenty-five-plus-year collaborator, Bill Miller, or as Frank affectionately referred to him, "Suntan Charlie," due to his pale complexion, 1965. To Bob Willoughby, who took this photo, he was "the faithful Bill Miller."

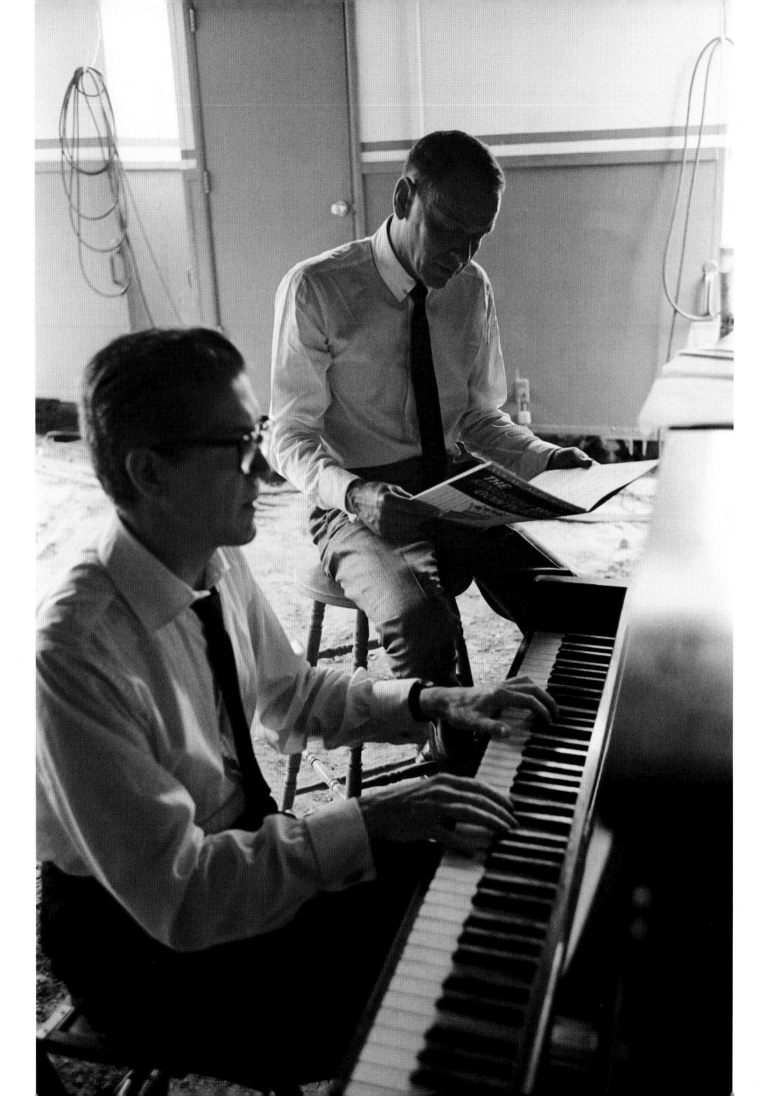

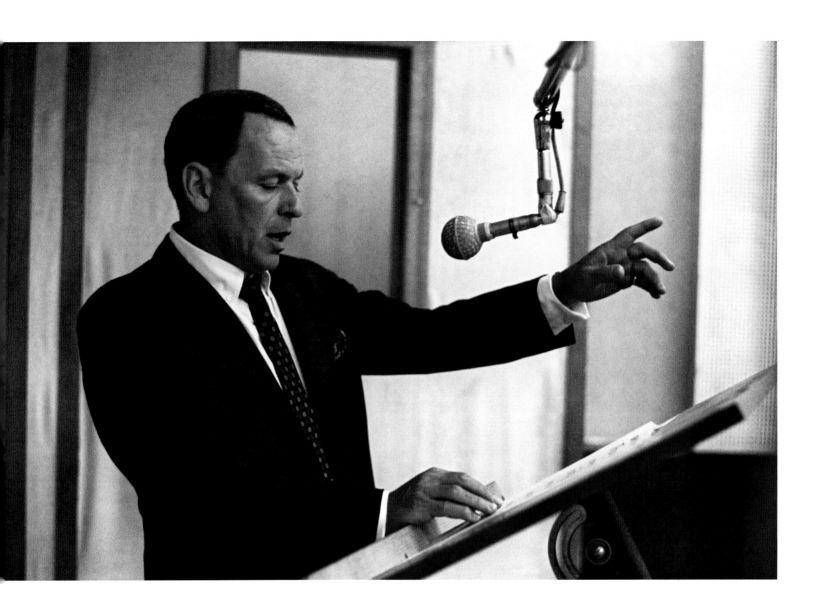

An October 1965 recording session
photo by Ed Thrasher. This particular
image would make the cover of
the album *Strangers in the Night*.

Listening to playback.

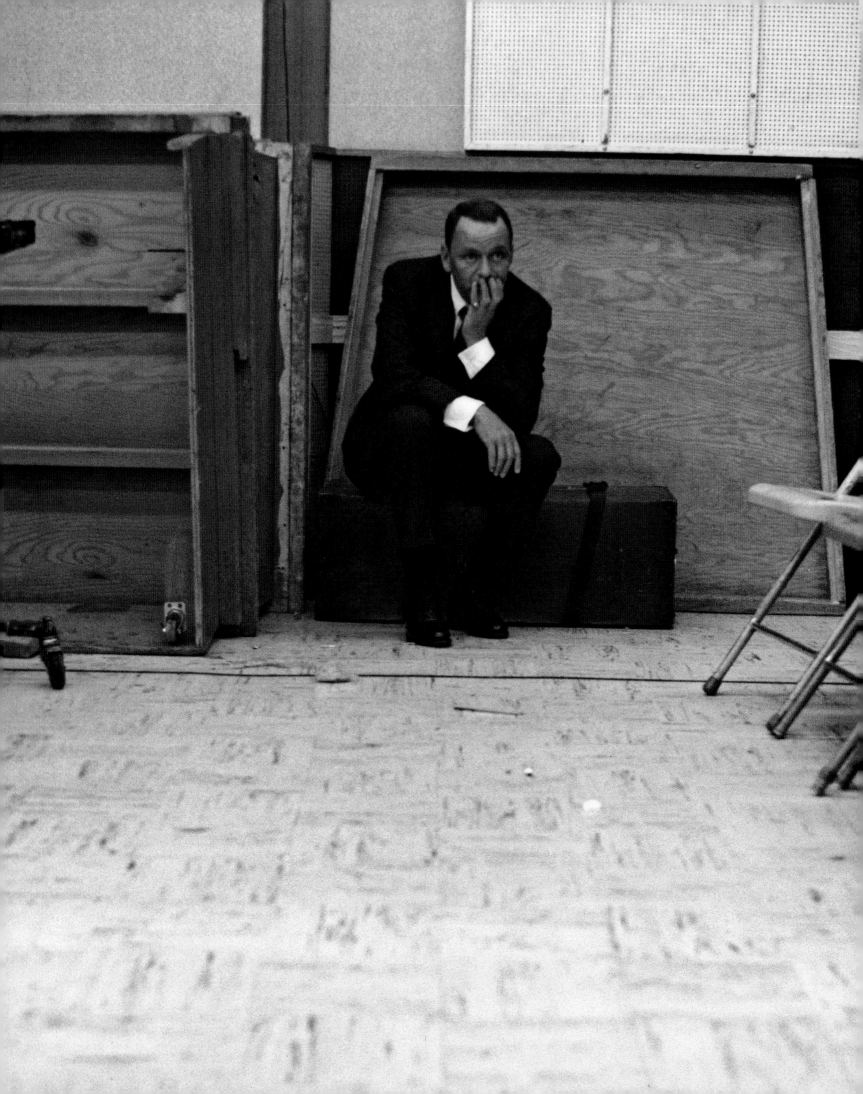

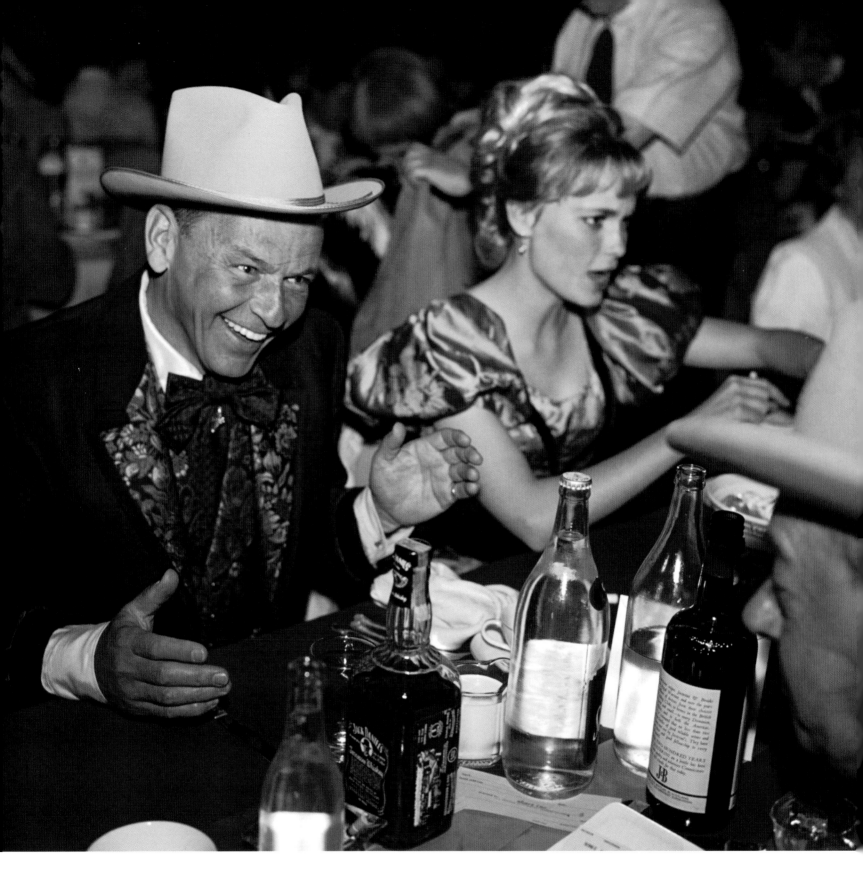

Frank Sinatra in 1965 at a charity party, seated next to the woman who would briefly become his third wife, Mia Farrow. The theme on the night of this charity event is Western attire, and within arm's reach of Frank is a bottle filled with what he affectionately called the "nectar of the gods," Jack Daniel's (his octane of choice).
PHOTO BY BERNIE ABRAMSON

Frank Sinatra and Jill St. John, 1963.

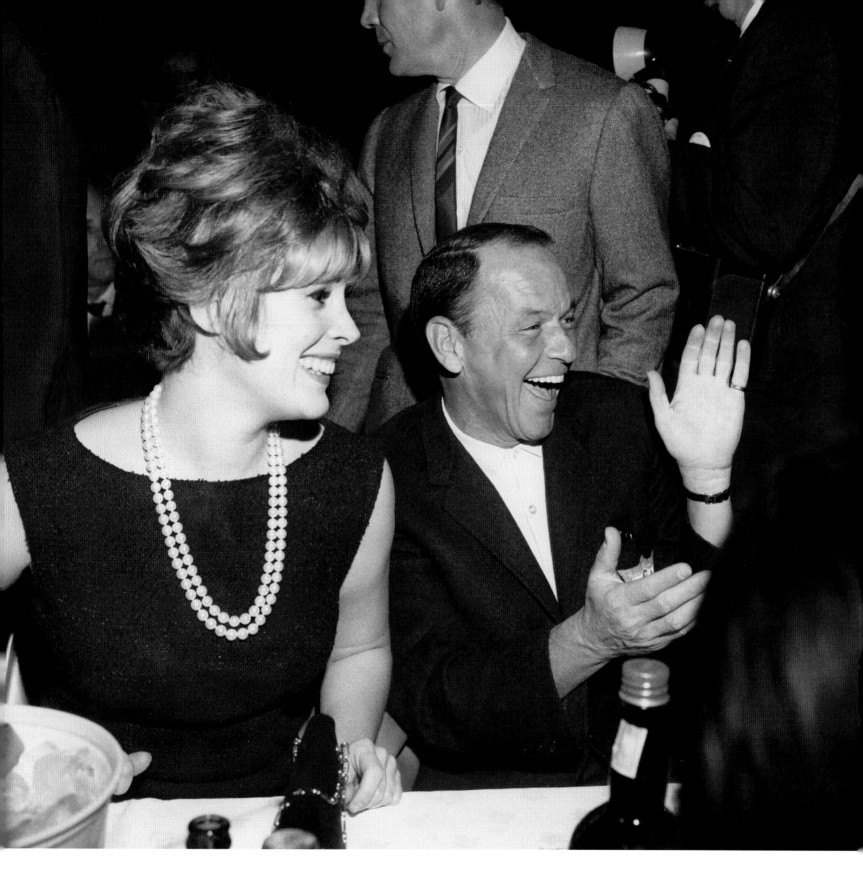

Volumes have been written on the subject of Frank Sinatra and women. George Frazier, writing in *Life* in 1943, noted the primary datum, quoting a fellow in a nightclub who said, "what Sinatra's singing does to girls is immoral." Humphrey Bogart offered ironic commentary on the often explosive mixture that resulted when the prying press came into the orbit of the singer's colorful private life: "Sinatra's idea of paradise is a place where there are plenty of women and no newspapermen. He doesn't know it, but he'd be better off if it were the other way around." Sinatra's friend Jill St. John looked at the matter from a woman's perspective. "When Frank walked into a room, the room changed," she recalled. "You could be the most beautiful woman in the world, everyone was looking at Frank. Everyone was talking to Frank, everybody was listening to Frank. And you were just glad to be there." Said Quincy Jones, "He had the swagger of death."

On the golf course, c. 1965.
PHOTO BY TED ALLAN

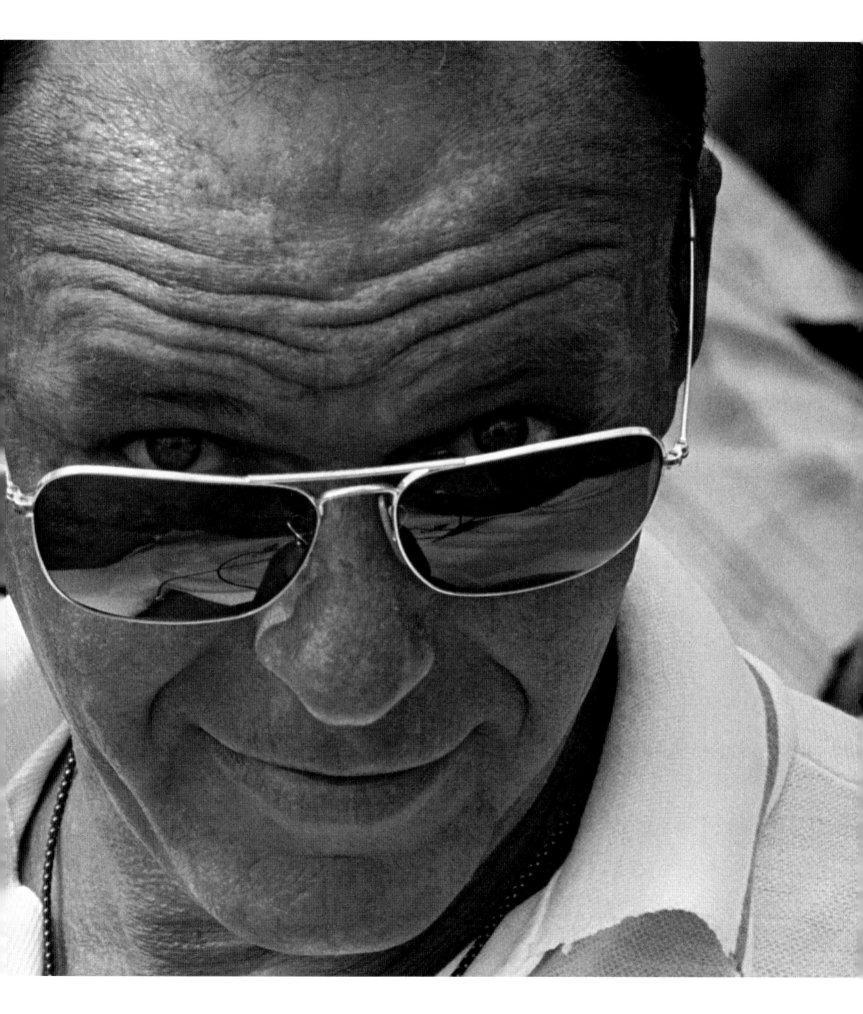

A Man and His Music

A premature retirement that lasted only two years would be followed by recordings, concerts, awards, and honors that propelled him into living icon status. As his voice became richer and the well of life experience deeper, he added new classics to the American songbook. Ol' Blue Eyes was back—and here to stay for all time.

3.

Frank at a Cedars-Sinai Medical Center benefit at the Beverly Hilton Hotel, 1966.
PHOTO BY CHESTER MAYDOLE

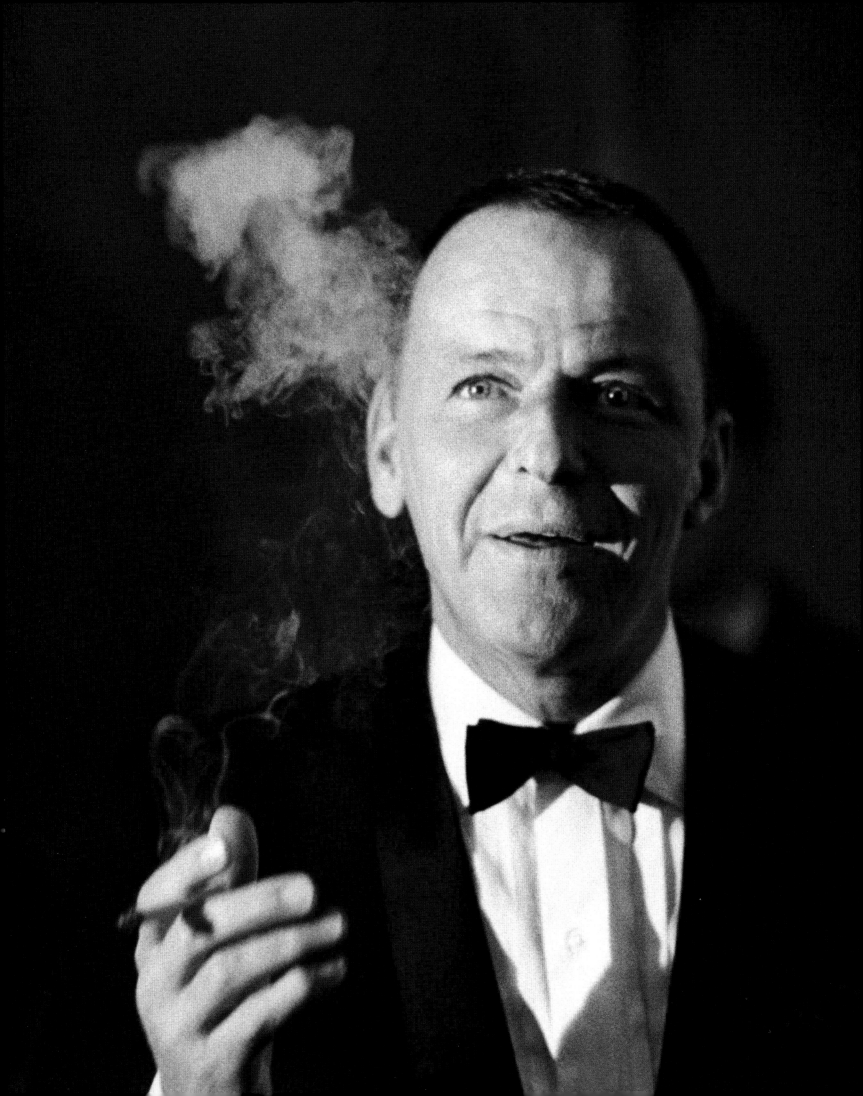

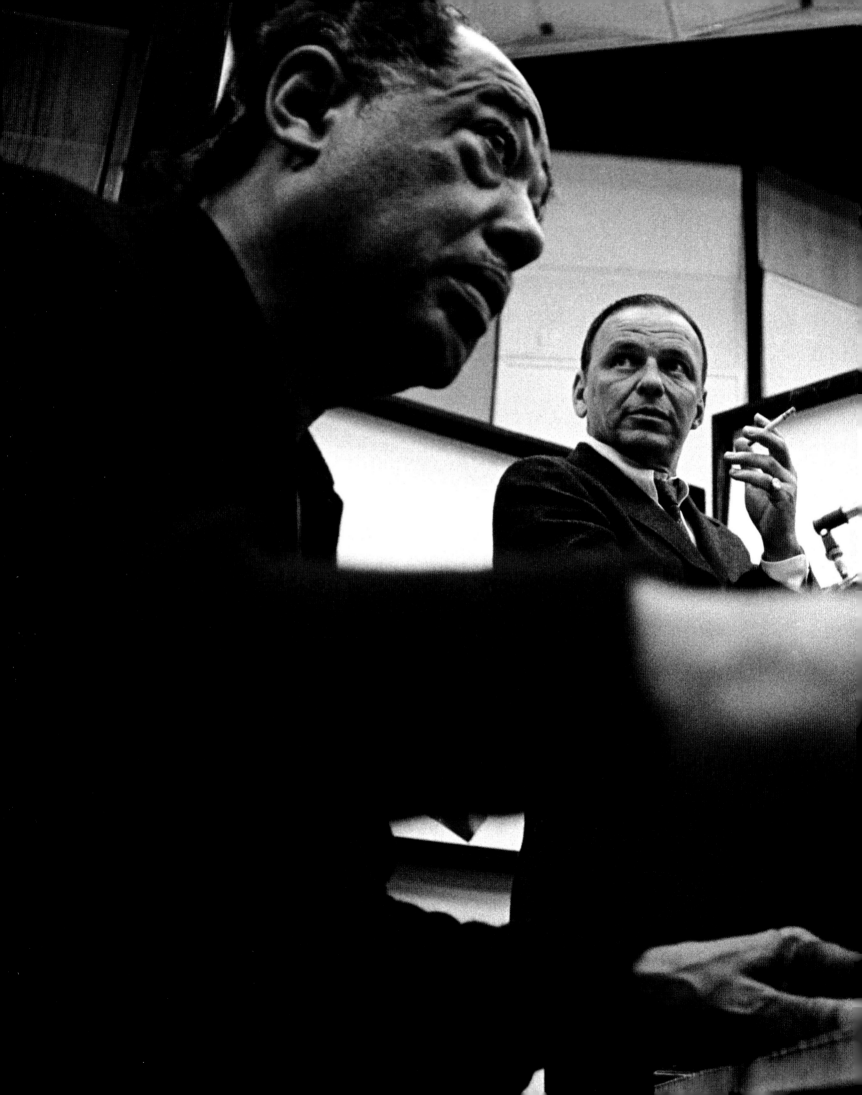

December 12, 1967:
The birthday boy,
Francis A., 52,
records for the first
time with Edward
Kennedy Ellington, the
Duke, 68. As Stan
Cornyn would
elegantly write in the
album's notes: "The
singer today is one
year older. His singing,
one more year
profound."
PHOTO BY ED THRASHER

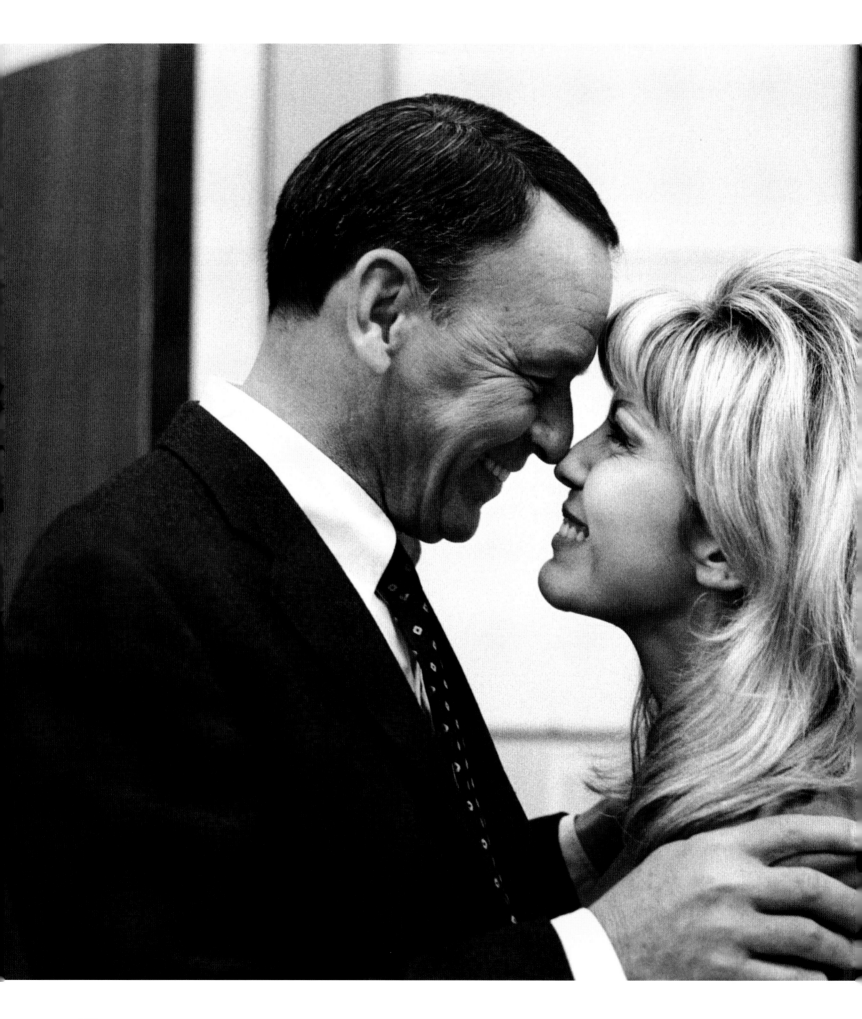

Frank and daughter Nancy, in the studio, to
record the song "Somethin' Stupid" during a
January 1967 Reprise recording session.
Not only did the song go to number one, but
it brought Frank his second gold record.
PHOTO BY ED THRASHER

Reprise recording session, January 1967.
PHOTO BY ED THRASHER

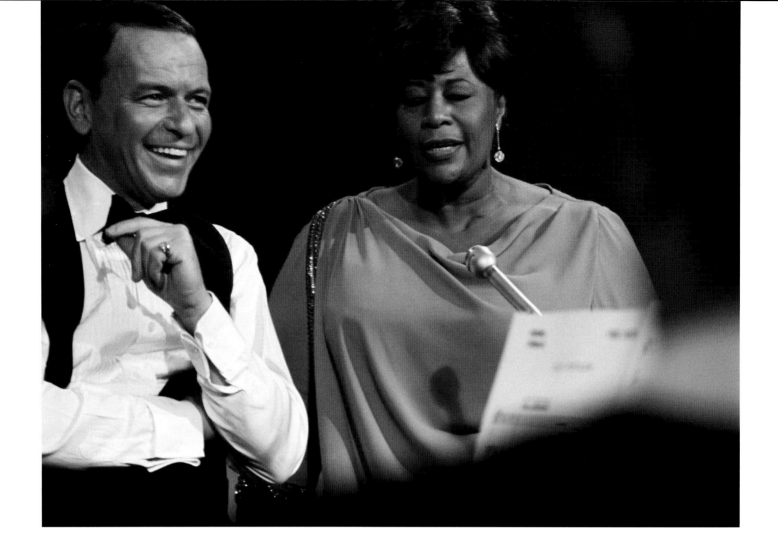

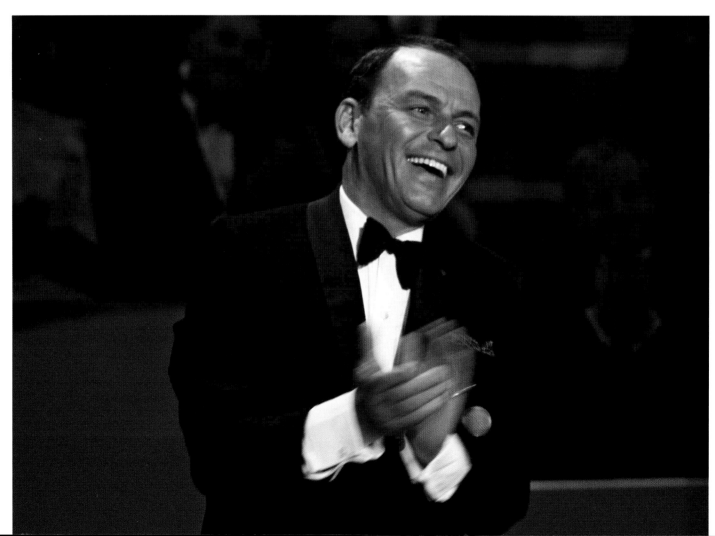

Sinatra worked with the leading jazz musicians of his generation, intensively in the case of Count Basie, of whom he said, "I'm never happier than when Bill Basie and I are cutting the same track." He famously told *Ebony* magazine in 1958 that, "It is Billie Holiday, whom I first heard in 52nd Street clubs in the early 1930s, who was, and still remains, the greatest single musical influence on me." In the same article, he praised Ella Fitzgerald as "the greatest of all contemporary jazz singers." He did not cross paths in the recording studio or the concert hall with the leading postwar jazz musicians, but Miles Davis offered telling testimony in his memoirs of Sinatra's larger contribution to jazz. While admitting that, "I wasn't into what he was into," he went on to say, "I learned how to phrase from listening to Frank, his concept of phrasing."

Never shy to cut his chops with other top artists of the day, Frank welcomed Miss Ella Fitzgerald to the ladies and gentlemen viewing this television special entitled *Frank Sinatra: A Man and His Music + Ella + Jobim*, which would air on November 13, 1967—"and what a girl" she was, he would remark while introducing her.
PHOTOS BY ED THRASHER

OVERLEAF

Sinatra at a 1968 rehearsal for his Caesars Palace performance. The left image in the third row on the contact sheet was used on the cover of the album *My Way*, 1969.
PHOTOS BY ED THRASHER

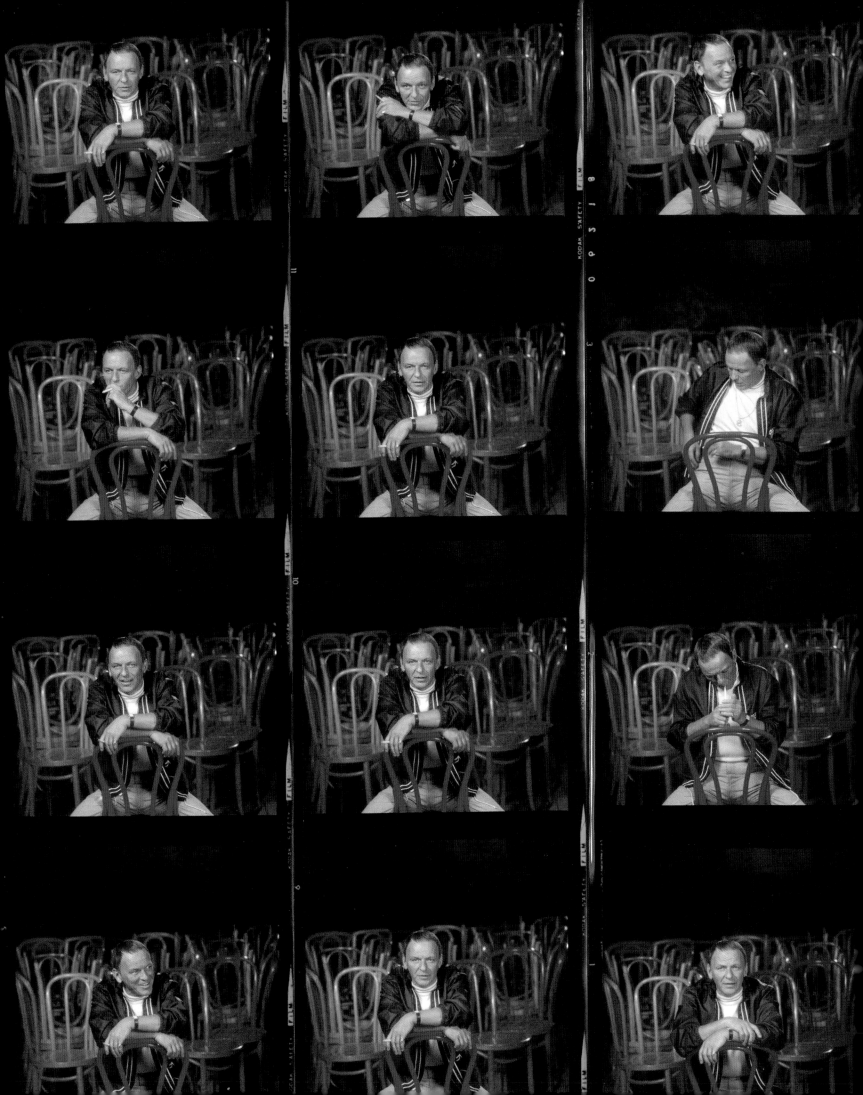

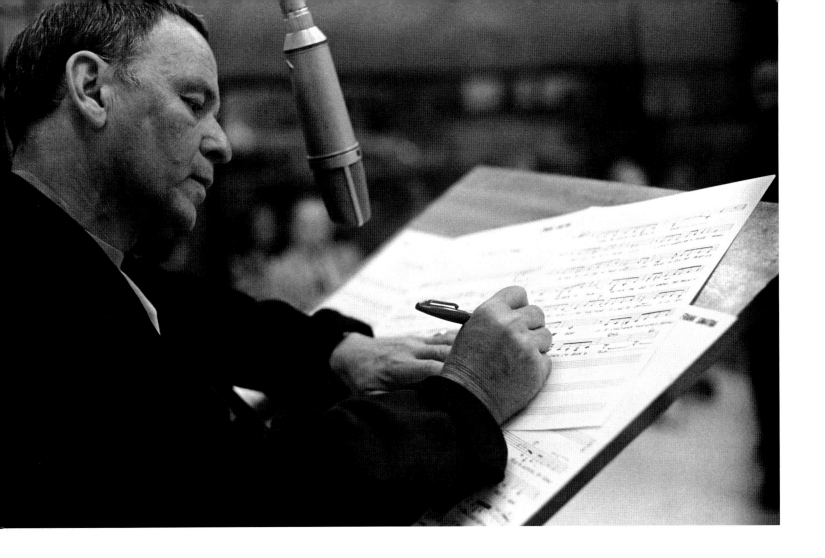

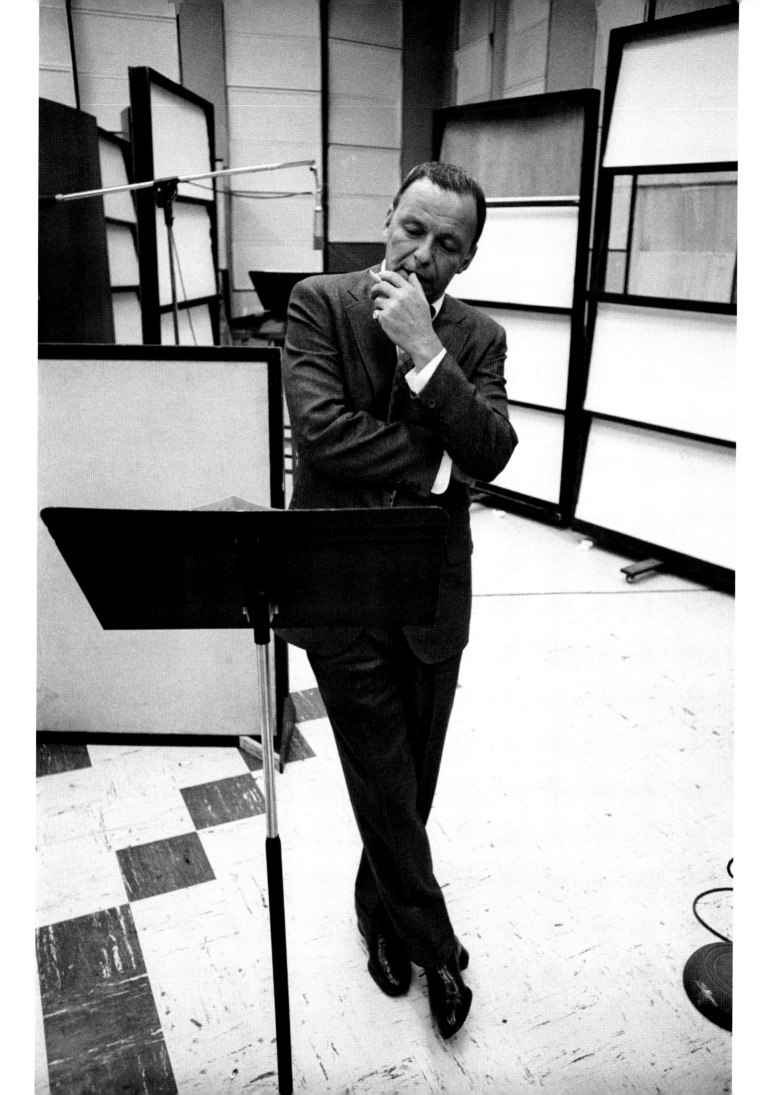

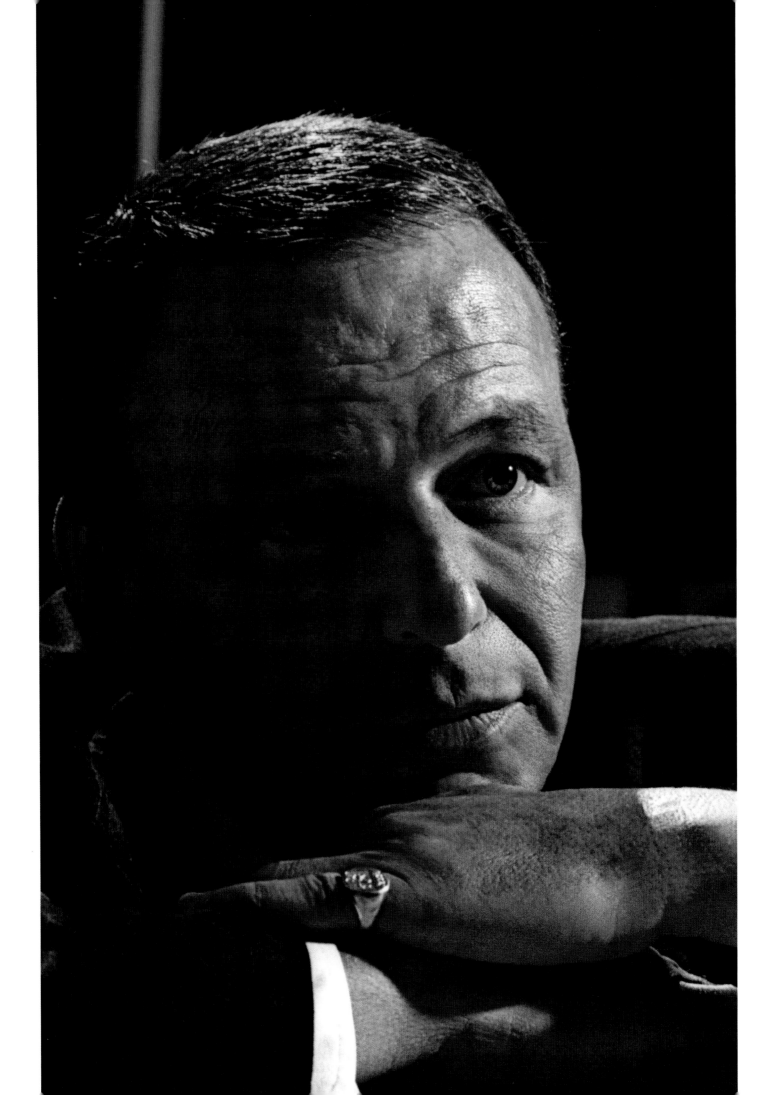

Sinatra, who began the decade of the 1960s on the highest plane, struggled with the rise of the youth culture and ultimately prevailed. As early as 1966, Gay Talese, in what was to be the most influential journalistic essay about Sinatra, written for *Esquire* magazine, framed his place in American life: "In an age when the very young seem to be taking over, protesting and picketing and demanding change, Frank Sinatra survives as a national phenomenon, one of the few prewar products to withstand the test of time." Eight years later, in an irresistibly exuberant introduction to Sinatra in Madison Square Garden, sports announcer Howard Cosell called him, "a man who has bridged four generations and somehow never found the gap."

A Man Alone: This beautiful color portrait by John Bryson would make the cover of Frank's 1969 album of the same name.

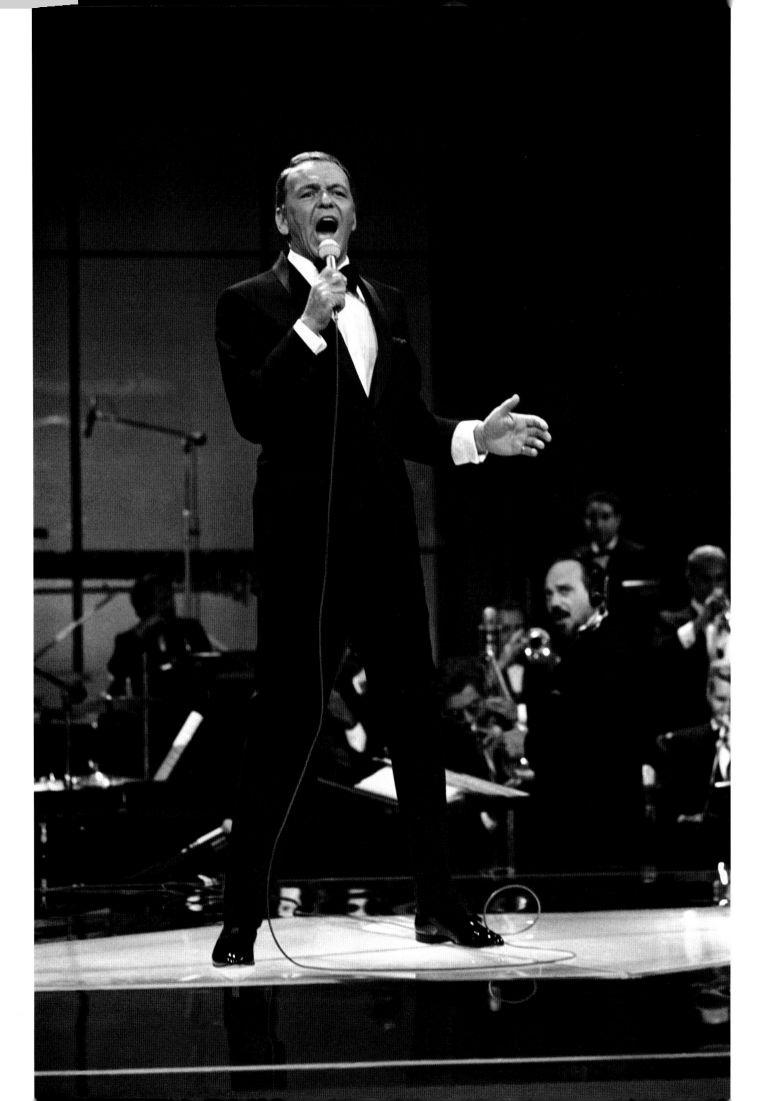

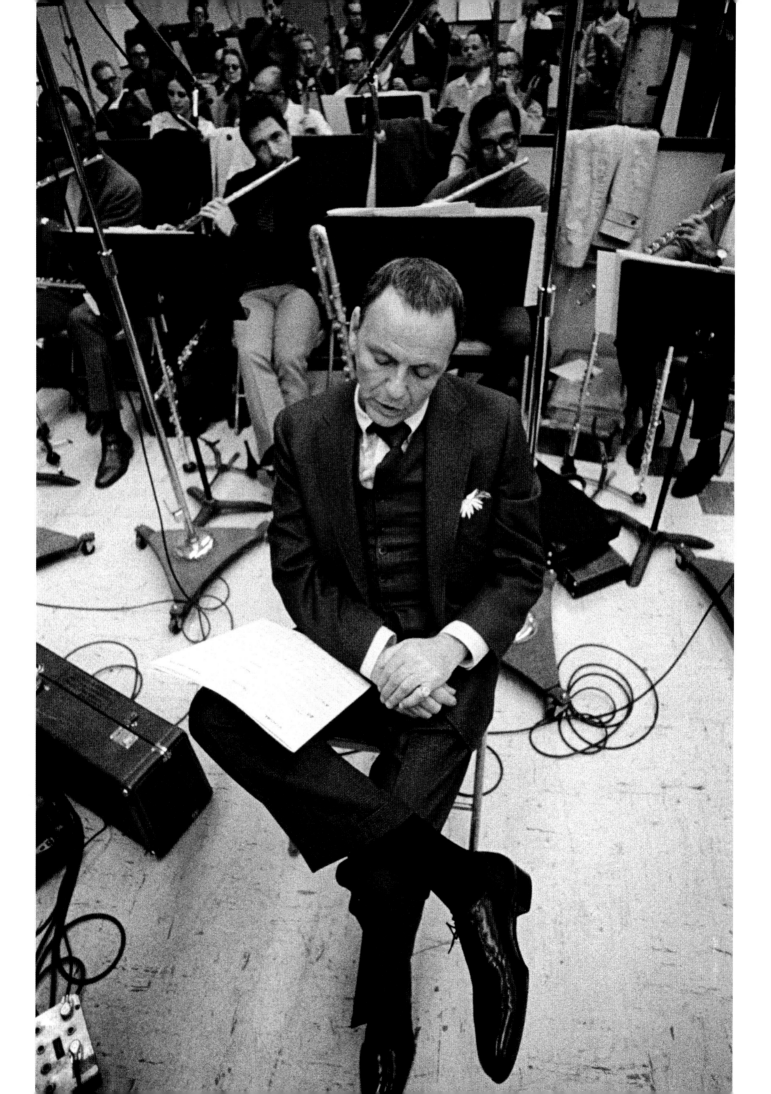

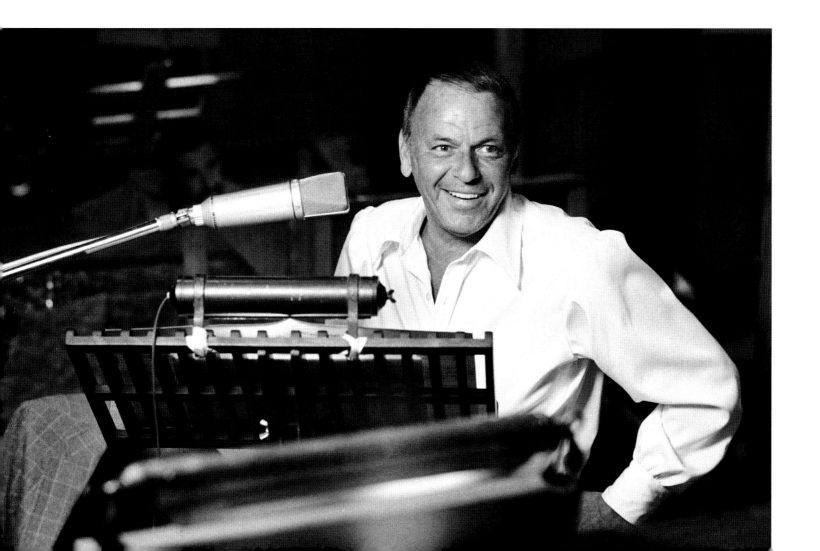

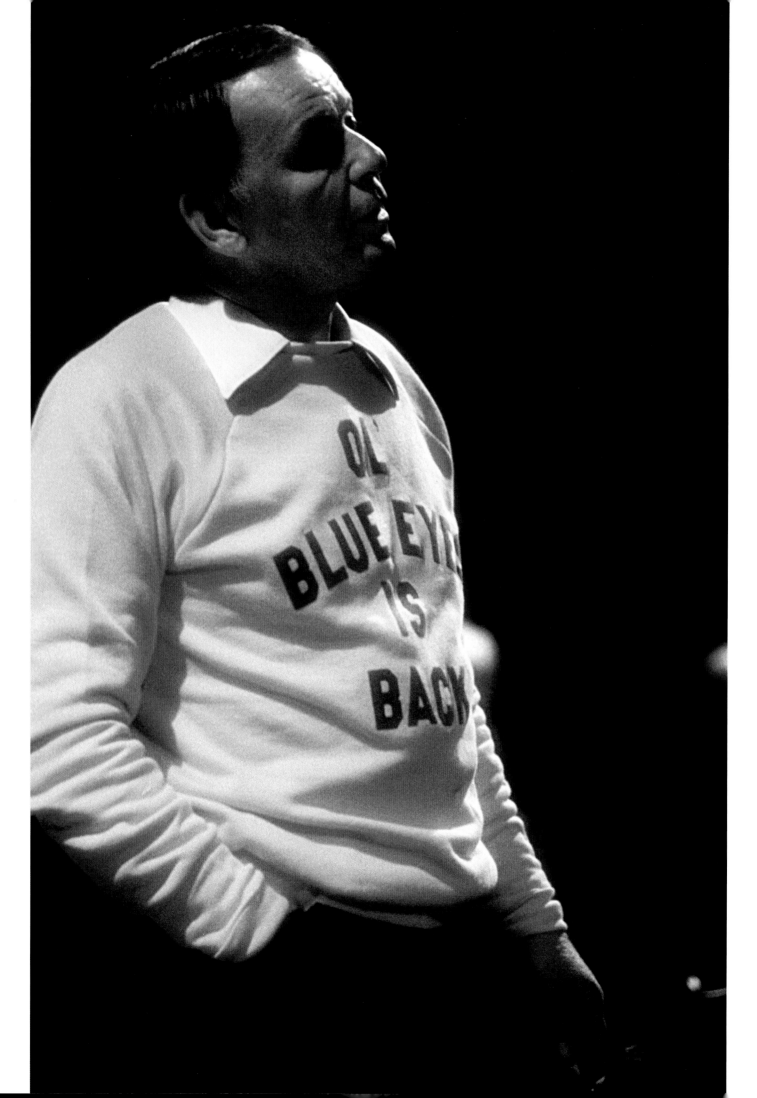

Jill St. John: "He didn't change; people's perception of him changed. He himself, the man, did not change." Deana Martin: "I watched him so many years, from when I was a young girl, to his last shows, and I could see the change in the way he would sing a song. He had told me about that years ago—he'd say, 'You know, you want to live with a song. And as you age the song will have a different meaning for you because you go through things in your life and you can interpret it differently.' Watching him interpret these unbelievable songs, the Great American Songbook, and to see him change was remarkable for me."

Sinatra would inscribe a print of a slight variation of this shot to the longtime Reprise art director and photographer Ed Thrasher. It read: "For Ole Smart Ass Thrasher who started the whole goddam thing! Francis Albert '78." This photo was taken by Ed in August 1973 during rehearsals for the *Ol' Blue Eyes Is Back* television special.

OVERLEAF

Sinatra with Gordon Jenkins at an August 1973 Reprise recording session. In his liner notes for *September of My Years*, recorded in 1965, Stan Cornyn reported the following exchange between the two friends: Sinatra: "You ready Gordie?" Jenkins: "I'm ready. I'm always ready. I was ready in 1939." Sinatra: "I was ready when I was nine."
PHOTO BY ED THRASHER

Reprise recording session, August 1981.
PHOTO BY ED THRASHER

Sinatra and Jenkins together again at the recording session for the album *Trilogy*, 1979.
PHOTO BY ED THRASHER

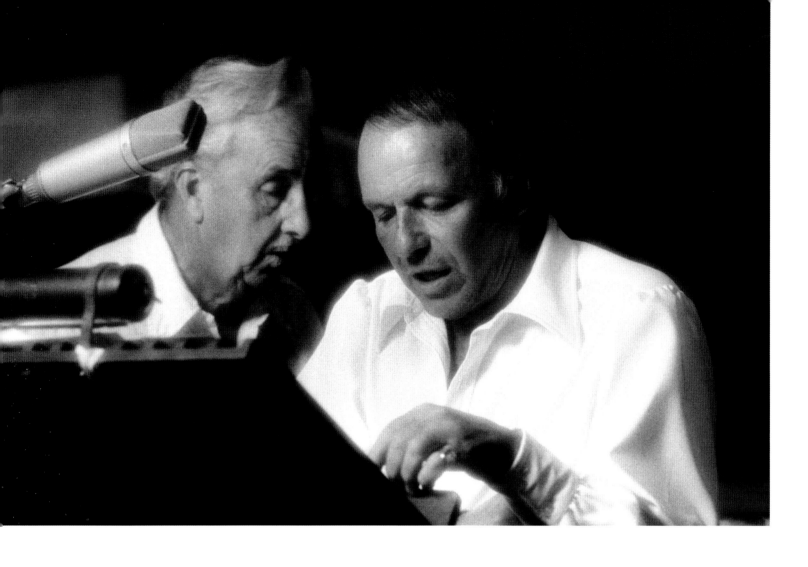

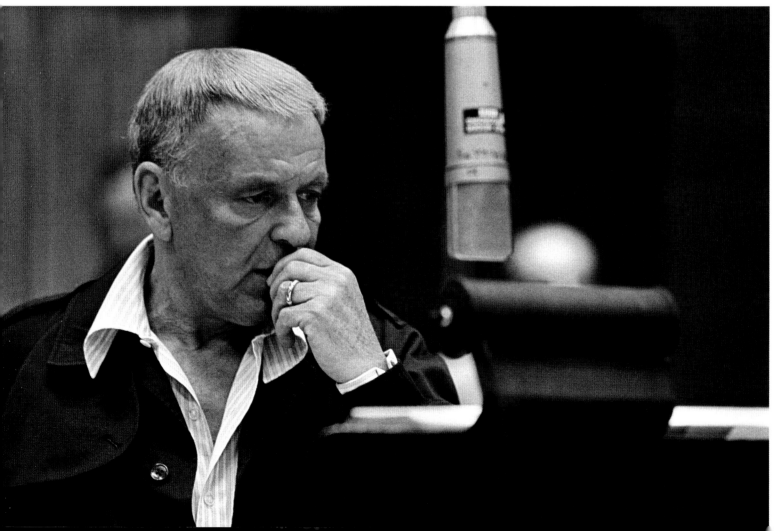

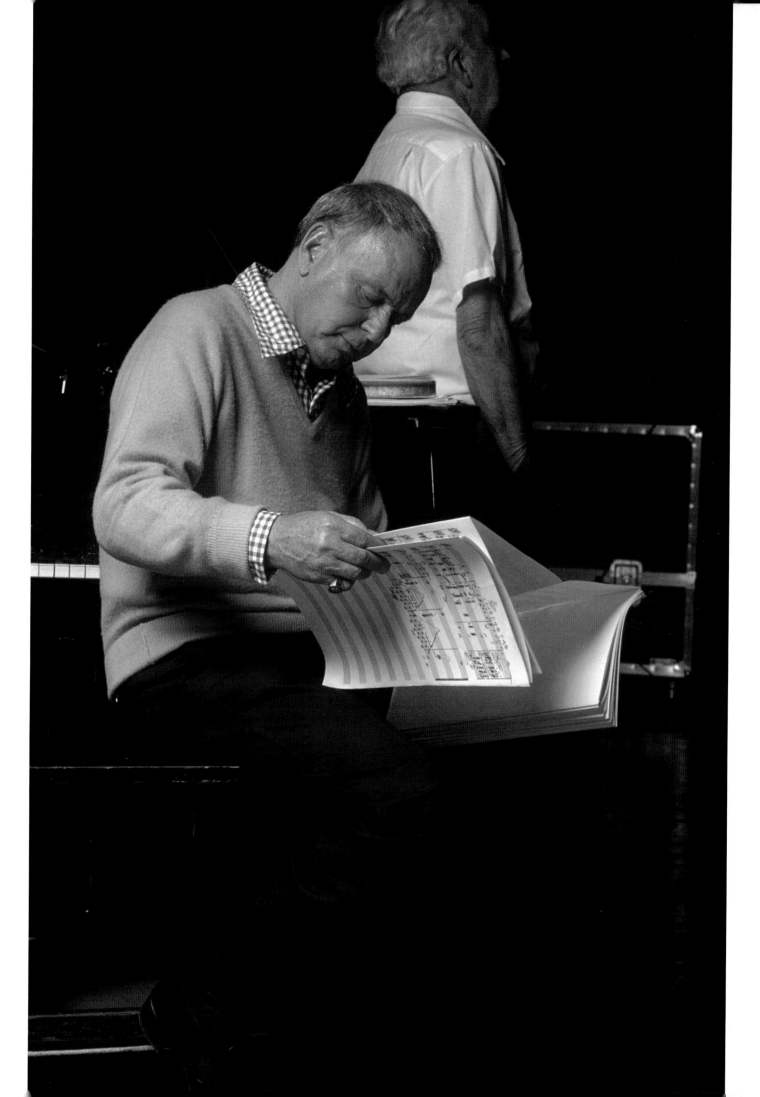

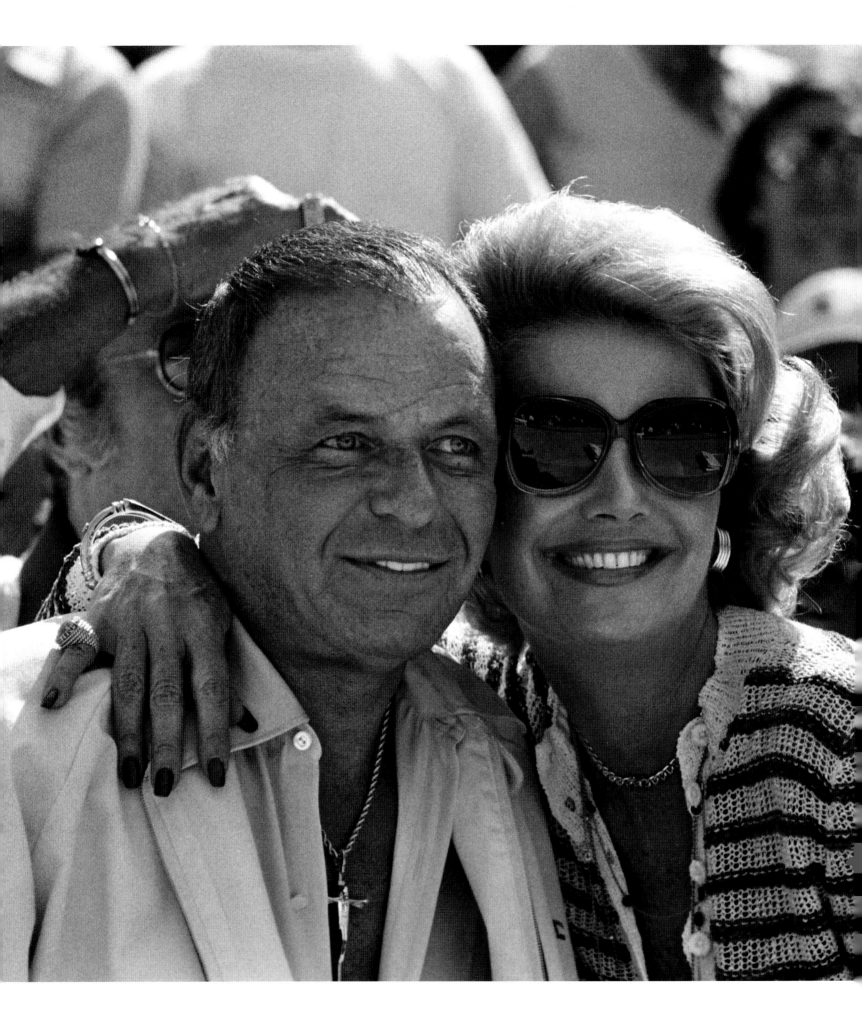

"I couldn't be better, I couldn't be happier, and I couldn't be younger." Frank's answer to Johnny Carson's question, "How you feelin'?" on a November 12, 1976 broadcast of *The Tonight Show*, just four months after he married Barbara. At their wedding reception she was approached by a friend: "'Please, Barbara,' he said, 'do me a favor. Stay married for at least three months.'

"'This is our wedding day, for Pete's sake! What are you saying?' I asked. Then I figured it out. 'So who do you have a bet with?'"

The friend won easily. The marriage lasted twenty-two years, until Sinatra's death in 1998.

OVERLEAF

"She's a marvelous girl, a lovely lady, and everything has been so wonderful in the past few months," Sinatra would say to Carson. Here Frank enjoys a day at the ballpark with his wife Barbara, as the Dodgers play a home game during the 1977 World Series against the Yankees.
PHOTO BY CURT GUNTHER

Past, Present, Future, and Always: From left to right, arrangers Billy May (the past), Don Costa (the present), and Gordon Jenkins (the future) flank Frank Sinatra at the Shrine Auditorium in 1979 and pose for photographer Ed Thrasher. The four men would go on to realize producer Sonny Burke's brainchild, the *Trilogy* album.

Quincy Jones: "I remember we were going up once and he said, 'You think you can get an arrangement on Johnny [Mandel's] "Shadow of Your Smile"? Do you think you can arrange it in one day?' I said, 'Yeah, can you learn the words by then?' He said, 'By the time you finish the arrangement I'll know the words.' That's when I saw him write down the words on eighteen pages of a legal pad, you know, it was like mainlining the subconscious mind to memorize the thing. I've never seen that kind of stuff before, you know. He was just miraculous, man. Miraculous."

Friday, April 13, 1984: Recording the album *L.A. Is My Lady* at A&R Studios in New York with Quincy Jones.

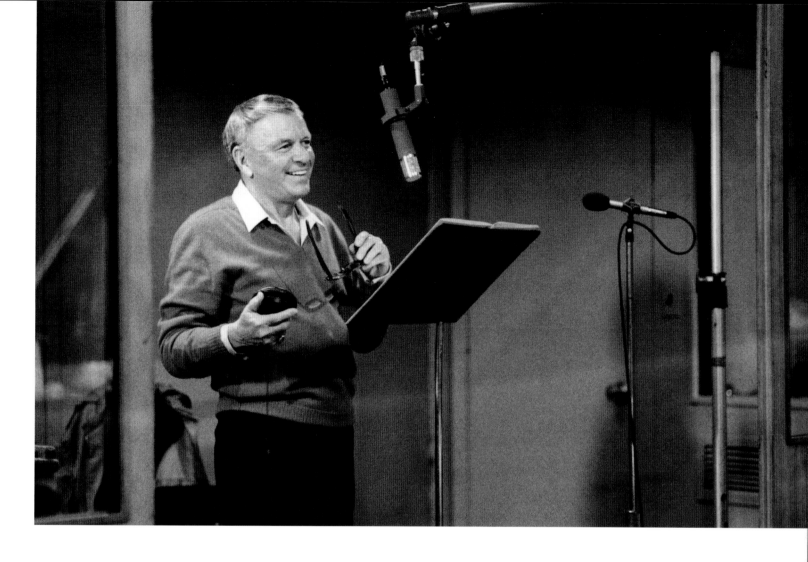

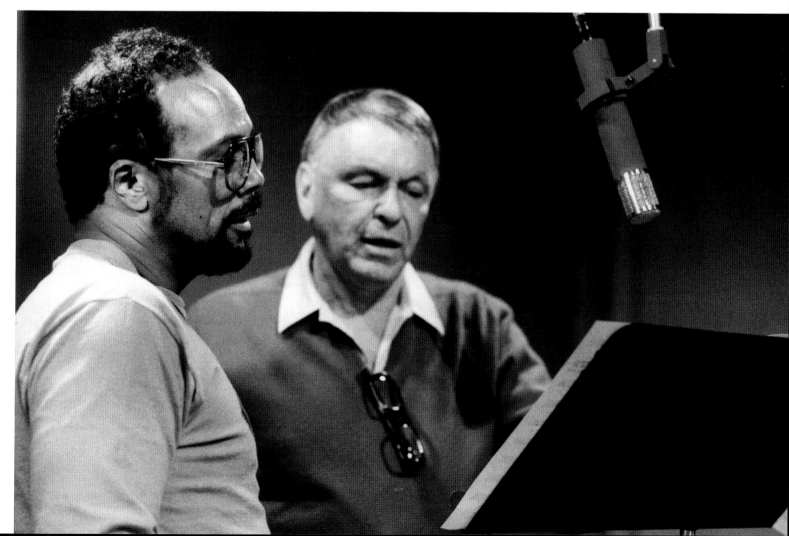

This photograph of old friends was taken almost fifty years after their first meeting, in 1941, when the fifteen-year-old singing and dancing Davis, with twelve years of performing under his belt, appeared on a bill with the Tommy Dorsey Orchestra and its sensational vocalist. Sinatra was a mature twenty-six at the time. Over the years, they came together, drifted apart, and came together again. They even performed a "Together Again" tour in 1988, with Dean Martin. When a reporter asked if this was to be an annual event, Sinatra answered, "Sammy is sixty-two, and he's the kid. I'm seventy-two and Dean is seventy. At our ages the only annual event you hope for is your birthday." When Davis died two years later, a reporter asked a haggard Sinatra how Davis should be remembered: "Well, from my standpoint he should be remembered as one of the finest human beings I ever knew in my life."

Frank and Sammy during a Harry Langdon photo shoot at the Waldorf Astoria in New York, 1989.

Sinatra was a staunch supporter and friend of Ronald Reagan. At a Dean Martin Celebrity Roast of Sinatra in 1978, Reagan imagined Sinatra as president: "Frank Sinatra will make a president who is strong on defense, but again will have concern for humanity. Scientists at his urging have developed an intercontinental ballistic missile that is not a weapon of mass destruction, it only hits photographers. . . . But I don't know if we can get him to run. Is it worth it, if you have to give up being a king?" Instead, it was Reagan who became president, welcoming Sinatra into the White House and bestowing on him in 1985 the Presidential Medal of Freedom, among other honors.

Harry Langdon captures Frank and his King Charles spaniel before they get into his limousine, c. 1989.

Frank strikes a familiar pose during a Harry Langdon photo session for the magazine *Palm Springs Life*, 1990.

George Schlatter: "We had a white Rolls-Royce and Frank and Barbara had a white Rolls-Royce. The cars looked exactly alike. Late one night, we come out of La Dolce Vita restaurant and they're parked out front because everybody but us has gone home. And so we get in and we start to drive. And he says to Barbara, 'Push him.'

Barbara says, 'What do you mean?'

'No, push him, he'll love it, push him.'

She pushes me a little ways, and I say, 'That's funny, ha ha.' But she keeps pushing until we're in the middle of the intersection of Wilshire and Santa Monica. I've had it by now, right? I'm a quiet, friendly guy, but I have kind of a short fuse too.

So I go to get out of the car, and my wife, Jolene, says, 'Hold it just a second, George. There are two drunks in the middle of Wilshire and Santa Monica Boulevards in white Rolls-Royces playing bumper tag. One of you is going to go to jail. Who do you think that's going to be?'

So I got back in the car and drove away, and they went up Whittier Boulevard, honking at me."

Sometime in the early 1960s.

Sources+Credits

SOURCES

PAGE 1: *May we all live to be a hundred* . . . Liner notes, *Frank Sinatra: The Complete Reprise Studio Recordings*, Reprise Records, 1998.

PAGE 13: *good picture sense* . . . Charles A. Moses, "Sinatra's 'Farley Focus,'" Rogers & Cowan press release, 1962; *Ed showed the artwork to Frank* . . . Dennis McLellan, "Ed Thrasher, 74; Veteran Art Director Worked on Hundreds of Albums," *Los Angeles Times*, August 21, 2006.

PAGE 16: *Simple, easily recognizable* . . . James Kaplan, *Frank: The Voice* (New York: Doubleday, 2010), 158.

PAGE 19: *The Barefoot Venus of Smithfield* . . . Ezra Goodman, "The Kid from Hoboken," *Time* magazine, August 29, 1955, 58; *Frank was one of the greatest singers of this century* . . . Ava Gardner, *Ava: My Story* (New York: Bantam, 1990), 217.

PAGE 20: *Frank Sinatra scores a decided hit* . . . William Brogdon, "Review: 'From Here to Eternity,'" *Variety*, July 29, 1953; *By blending small parts* . . . Tom Santopietro, *Sinatra in Hollywood* (New York: Macmillan, 2009).

PAGE 25: *I felt my guardian angel* . . . Bob Willoughby, *Sinatra: An Intimate Collection* (London: Vision On Publishing, 2002), 6.

PAGE 29: *You knew that this was a raging little man* . . . Nancy Sinatra, *Frank Sinatra, My Father* (New York: Simon & Schuster, 1986), 99; *I ducked the party* . . . Arnold Shaw, *Sinatra: The Entertainer* (New York: Delilah Books, 1982), 32.

PAGE 30: *He was at the lowest ebb* . . . Will Friedwald, *Sinatra! The Song Is You: A Singer's Art* (New York: Da Capo Press, 1997), 207; *Jesus Christ, I'm back* . . . Peter J. Levinson, *September in the Rain: The Life of Nelson Riddle* (New York: Taylor Trade Publications, 2005), 113; *The greatest album of music* . . . Bret Primack, "Frank Sinatra: Through the Lens of Jazz," *JazzTimes* magazine, May 1998, 33.

PAGE 33: *Try not to sit down* . . . Bill Zehme, "And Then There Was One," *Esquire*, March 1999; *I don't wear funny clothes* . . . Neil Hickey, "Hardly the Retiring Kind," *TV Guide*, April 16, 1977, 24ff.

PAGE 34: *being a part of a film* . . . "The Tonight Show," NBC TV, November 12, 1976; *The thin, unhandsome one-time crooner* . . . Arthur Knight, "Quick, Frankie, the Needle," *Saturday Review*, December 17, 1955, 26.

PAGE 43: *It was interesting to see Frank* . . . Willoughby, *Sinatra: An Intimate Collection*, 26.

PAGE 46: *I got permission* . . . Foster Hirsch, *Otto Preminger: The Man Who Would Be King* (New York: Knopf Doubleday Publishing Group, 2011); *Then Preminger yelled* . . . Jerry Lewis with James Kaplan, *Dean & Me (A Love Story)* (New York: Doubleday, 2005), 225.

PAGE 51: *He was a high-liver* . . . Shaw, *Sinatra: The Entertainer*, 47; *an animal tension* . . . "Frank Sinatra: Living With the Legend," CBS television special, 1965; *had the immanence of the hip* . . . John Lahr, "Sinatra's Song," *The New Yorker*, November 3, 1997, 88; *Thousands of us* . . . Pete Hamill, "Sinatra: the Legend Lives," *New York*, April 28, 1980; *Bobby, this is what I do* . . . Willoughby, *Sinatra: An Intimate Collection*, 85.; *Do you know what I really am?* . . . Robin Douglas-Home, *Sinatra* (New York: Grosset & Dunlap, 1962), 40.

PAGE 52: *I was never intimidated* . . . Bernie Abramson, "The Shootists," *Los Angeles Magazine*, March 2003, 104.

PAGE 64: *When he controlled his breathing* . . . Douglas-Home, *Sinatra*, 1962), 16; *If he had a clam* . . . Author interview; *I'm not much* . . . Levinson, *September in the Rain*, 136.

PAGE 69: *My first week* . . . Author interview.

PAGE 70: *Let's be real* . . . Author interview; *Sammy's words fit* . . . Lahr, "Sinatra's Song," 89; *Frank undoubtedly brought out* . . . Douglas-Home, *Sinatra*, 33.

PAGE 73: *I always have* . . . Douglas-Home, *Sinatra*, 34-35; *To Sinatra, a microphone* . . . [E. B. White], "Notes and Comment," *The New Yorker*, March 15, 1952.

PAGE 76: *His life was a creative tsunami* . . . Author interview; *Occasionally, if he likes* . . . Les Tomkins, "Frank Sinatra: The Critics," http://jazzpro.nationaljazzarchive.org.uk/ interviews/Frank%20Sinatra_2.htm; *about taking a flying trip* . . . Sammy Cahn, *Sammy Cahn's Rhyming Dictionary*, (New York: Hal Leonard Corporation, 2002), xxii.

PAGE 79: *When Frank sang that song* . . . Bob Dylan, *Chronicles, Volume One*, (New York: Simon & Schuster, 2004), 81.

PAGE 82: *I loved to watch him* . . . Shirley MacLaine, *I'm Over All That: And Other Confessions* (New York: Atria Books, 2011), 63; *a little afraid of her* . . . Hamill, "Sinatra: The Legend Lives," 30.

PAGE 84: *That's when the evening* . . . Willoughby, *Sinatra: An Intimate Collection*, 110.

PAGE 86: *After a meteoric beginning* . . . Shaw, *Sinatra: The Entertainer*, 23.

PAGE 88: *when he first knocked out a man* . . . Pete Hamill, *Why Sinatra Matters* (New York: Little, Brown, 2009), 99.

PAGE 93: *Dolly was a very strong woman* . . . Author interview; *Frank Sinatra once saved my life* . . . Joann Biondi, *Miami Beach Memories: A Nostalgic Chronicle of Days Gone By* (Guilford, Connecticut: Globe Pequot, 2006), 109.

PAGE 94: *He's trying to demean his gift* . . . Lahr, "Sinatra's Song," 90; *He only drank tea* . . . George Jacobs and William Stadiem, *Mr. S: My Life with Frank Sinatra* (New York: HarperCollins, 2003), 192; *We feel sorry for people* . . . Monologue, *Sinatra at the Sands*, Reprise Records, 1966.

PAGE 100: *We'd been in Vegas* . . . Sammy Davis Jr. and Jane and Burt Boyar, *Sammy: An Autobiography, with Material Newly*

Revised from Yes I Can and Why Me? (New York: Farrar, Straus and Giroux, 2000), 342; *It was sauce and vinegar . . .* Shawn Levy, *Rat Pack Confidential: Frank, Dean, Sammy, Peter, Joey and the Last Great Show Biz Party* (New York: Crown Publishing Group, 1999), 10.

PAGE 115: *It was the greatest accumulation . . .* Bob Willoughby, unpublished notes, 1960; *To watch them together . . .* Author interview; *Frank had just run . . .* Bob Willoughby, unpublished notes, 1960.

PAGE 119: *I was at the bar . . .* William B. Williams, "The Capitol Sinatra," *Billboard*, November 20, 1965, 345; *I watched them . . .* Sid Avery interview with Entertainment Tonight, 2001.

PAGE 122: *I took my photography seriously . . .* Abramson, "The Shootists," 104.

PAGE 125: *It was a new frontier . . .* Author interview; *He made no speeches . . .* Murray Schumach, "Hollywood Wing in Kennedy Drive; Janet Leigh Opens Home to 2,000 Women as Group Kicks Off Its Campaign," *New York Times*, September 8, 1960, 40.

PAGE 127: *I know we're all indebted . . .* see https://www.youtube.com/watch?v=D-njyFk861k

PAGE 128: *I'll be there . . .* Davis and Boyar, *Sammy*, 379.

PAGE 129: *the most inescapably valuable . . .* Todd S. Purdum, "From That Day Forth," *Vanity Fair*, February 2011.

PAGE 131: *they assumed the effect . . .* Jonathan Schwartz, *All in Good Time: A Memoir* (New York: Random House, 2004), 105; *the audience went wild . . .* Primack, "Frank Sinatra," 34; *explosion . . .* George Martin, *All You Need Is Ears* (New York: St. Martin's Press, 1994), 144.

PAGE 132: *He loved being . . .* Author interview; *because they could get caught up . . .* Charles L Granata, *Sessions with Sinatra: Frank Sinatra and the Art of Recording* (Chicago: Chicago Review Press, 2003), 109; *I'm going to make you . . .* Alta Maloney, "He Focuses On The 'Rat Pack,'" *Boston Traveler*, September 25, 1961, 32.

PAGE 137: *room has that peculiar air . . .* Liner notes, *Sinatra at the Sands*; *He'd see you . . .* Primack, "Frank Sinatra," 34; *I waited twenty years . . . Sinatra: The Man and His Music*, NBC television special, 1981.

PAGE 139: *I bought an airplane . . .* Monologue, *Sinatra: Vegas* (concert recording, November 2, 1961), Reprise Records, 2006; *When I'm up there wingin' . . .* Parody lyrics by Sammy Kahn, *Sinatra: Vegas*, Reprise Records, 2006.

PAGE 146: *I was booking shows . . .* Author interview; *The boys loved . . .* Willoughby, *Sinatra: An Intimate Collection*, 178.

PAGE 149: *I remember meeting him . . .* Author interview.

PAGE 155: *It helps me think straight . . .* Douglas-Home, *Sinatra*; *I'm an overprivileged adult . . .* "Frank Sinatra's Tour For Tots," Globe Photos press release, 1962.

PAGE 162: *I treated him just like a jazz musician . . .* Author interview.

PAGE 164: *A perfectionist . . .* Albert Murray, *Good Morning Blues* (New York: Random House, 1985), 343.

PAGE 167: *As an artist . . .* Hamill, *Why Sinatra Matters*, 69; *His blues voice . . .* see https://www.youtube.com watch?v=5QtjLEqK20M.

PAGE 173: *See, my dad and Frank . . .* Author interview.

PAGE 176: *He doesn't read music . . .* Tomkins, "Frank Sinatra: The Critics"; *He's the only singer . . .* Paul Kreibich, "Frank Sinatra: The Man and His Musicians," see www.paulkreibich.com/paul/articles/PKfranksinatra.html; *He got more into the pure emotion . . .* Primack, "Frank Sinatra," 33.

PAGE 182: *what Sinatra's singing does . . .* George Frazier, "Frank Sinatra," *Life*, May 3, 1943, 58; *When Frank walked into a room . . .* Author interview; *He had the swagger of death . . .* Author interview.

PAGE 187: *The singer today . . .* Liner notes, *Francis A. & Edward K.*, Reprise Records.

PAGE 191: *It is Billie Holiday . . .* Frank Sinatra (as told to Allan Morrison), "The Way I Look at Race," *Ebony*, July, 1958; *I wasn't into what he was into . . .* Miles Davis with Quincy Troupe, *Miles: The Autobiography* (New York: Touchstone, 1990), 395.

PAGE 199: *In an age when the very young . . .* Gay Talese, "Frank Sinatra Has a Cold," *Esquire*, April 1966; *a man who has bridged . . .* see https://www.youtube.com/watch?v=HeWZ1_o6QEI

PAGE 205: *He didn't change . . .* Author interview; *I watched him so many years . . .* Author interview.

PAGE 209: *Please, Barbara . . .* Barbara Sinatra, *Lady Blue Eyes: My Life with Frank* (New York: Crown/Archetype, 2011), 181.

PAGE 212: *I remember we were going up . . .* Author interview.

PAGE 215: *Sammy is sixty-two . . .* Davis and Boyar, *Sammy*, 524.

PAGE 216: *Frank Sinatra will make a president . . . The Dean Martin Celebrity Roast: Frank Sinatra*, NBC television special, 1978.

PAGE 219: *We had a white Rolls-Royce . . .* Author interview.

Index

A

Abramson, Bernie, 13, 52, 122
Academy Award, *28*, 29
acting, 20
album covers, 131
Allan, Ted, 12–13, 132, 139, 155
"All the Way," 70
"Angel Eyes," 9
Archerd, Army, 29
Armstrong, Louis, 74
Avery, Sid, 12, 13, 30, 119, 131

B

Bacall, Lauren, 52, *52*
Barbara Sinatra Children's Center for Victims of Abuse, 9
Barnett, Larry, 69
Basie, William "Count," 13, 119, *136*, 137, 162, *163*, 164, *164–65*, *166*, 167, 191
Benedict, Richard, 119, *120*
Bennett, Tony, 76
Berghofer, Chuck, 176
Bernhart, Milt, 132
Bernstein, Elmer, 51
"The Best Is Yet to Come," 162, 167
Billboard, 8
The Bing Crosby Show, 75, *75*, 132, *134*
Bishop, Joey, 13, *97*, 100, *101*, *110–11*, 115, *118*, 119, *120*
Bloom, Rube, 79
Bogart, Humphrey, 13, 20, 33, 182
boxing, 90, *90–91*
Boyd, Pattie, *194–95*, 196
Brendan Byrne Arena, 9
Britt, May, 122, *122–23*, 128
Brogdon, William, 20
Bryson, John, 137, 199
Burke, Sonny, 209
Bushkin, Joe, 75, *75*

C

Cahn, Sammy, 70, *71*, 76, 139
Callas, Maria, 19
Can-Can, 82, *83*, 84, 88, *88–89*
 recording sessions, *84*, *86–87*, 87
Capitol Records, 12, 13, 14, 30, 94, 131
 recording sessions, *6–7*, *30*, *63–65*, 64, 70, *71*, *72*, *73*, 132, *132–33*
Capra, Frank, 93

Carson, Johnny, 34, 209
Chaplin, Saul, *86–87*, 87
Chevalier, Maurice, 84, *85*
Chronicles (Dylan), 79
Clift, Montgomery, 29
Cole, Nat King, 13, 53, *53*
Come Blow Your Horn, 156, *158*
"Come Fly with Me," 70, 76, 131
Come Swing with Me!, 13
The Concert Sinatra, 156, *156–57*
Conte, John, 36, *38–39*
Conte, Richard, 119, *120*
Cornyn, Stan, 137, 187, 205
Cosell, Howard, 199
Costa, Don, 209, *210–11*
Crosby, Bing, 74, *74*, 75, *75*, 79, 88, 132, *134*
Cummings, Jack, 84, *84*
Curtis, Tony, 94, *124*, 125

D

D'Amore, Patsy, 52
D'Amore, Rose, 52
Davis, Miles, 191
Davis, Sammy, Jr., 12, 52, *52*, *97*, 99, *99*, 100, *101*, *102–3*, 103, *104*, 105, *110–11*, 115, *116–17*, 117, *118*, 119, *120*, 128, *128*, 132, *134*, *175*, 176, *214*, 215
"Day In—Day Out," 79
Dean, James, 52, *52*
Democratic National Convention of 1960, *124*, 125
Democratic Party, 127
Dietz, Howard, 146
Dixon, Mort, 139
Dorsey, Tommy, 14
Douglas, Kirk, 8
Douglas-Home, Robin, 62, 70
Dreesen, Tom, 8
drinking, 94
Dudas, Bill, 16
Durante, Jimmy, 79
Dylan, Bob, 79

E

"Ebb Tide," 79
80 Years My Way, 9
Ellington, Edward Kennedy, "Duke," 119, *186–87*, 187
Embree, Glenn, 139
Entratter, Jack, 99, 99, 108, *108–9*

F

Farrow, Mia, 180, *180*
Fell, Norman, 119, *120*
Fitzgerald, Ella, 129, *190*, 191
"Fly Me to the Moon," 167
Frankenheimer, John, *154–55*, 155
Frank Sinatra: A Man and His Music + Ella + Jobim, 191
The Frank Sinatra Timex Show, 76, *77–79*, 79
Frazier, George, 182
From Here to Eternity (film), 13, 20, *21–27*

G

Gardner, Ava, *18*, 19, *19*
Garland, Judy, 19, *144*, 146, *147*
Gaynor, Mitzi, 79
Gleason, Ralph, 12
Goodman, Ezra, 19
Grant, Cary, 8
Great Songs from Great Britain, 150, *150–51*
Greene, Shecky, 93
Grey, Al, 137

H

Hamill, Pete, 51, 82, 90, 167
Harrison, George, *194–95*, 196
Hart, Al, *102–3*, 103
Harvey, Clem, 119, *120*
Henry, Pat, 8
A Hole in the Head, 79, *81*, *92–93*, 93
Holiday, Billie, 146, 191
Hollywood at Home (Avery), 13
Horne, Lena, 105

I

"I Believe in You," 167
"I Left My Heart in San Francisco," 76
In the Wee Small Hours, 30
"I See Your Face Before Me," 146
It Might as Well Be Swing, 162, 167
"I've Been to Town," 196
"I've Got the World on a String," 30
"I Wanna Be Around," 167